HISTORIC PHOTOS OF
HOUSTON

TEXT AND CAPTIONS BY BETTY TRAPP CHAPMAN

TURNER
PUBLISHING COMPANY
NASHVILLE, TENNESSEE PADUCAH, KENTUCKY

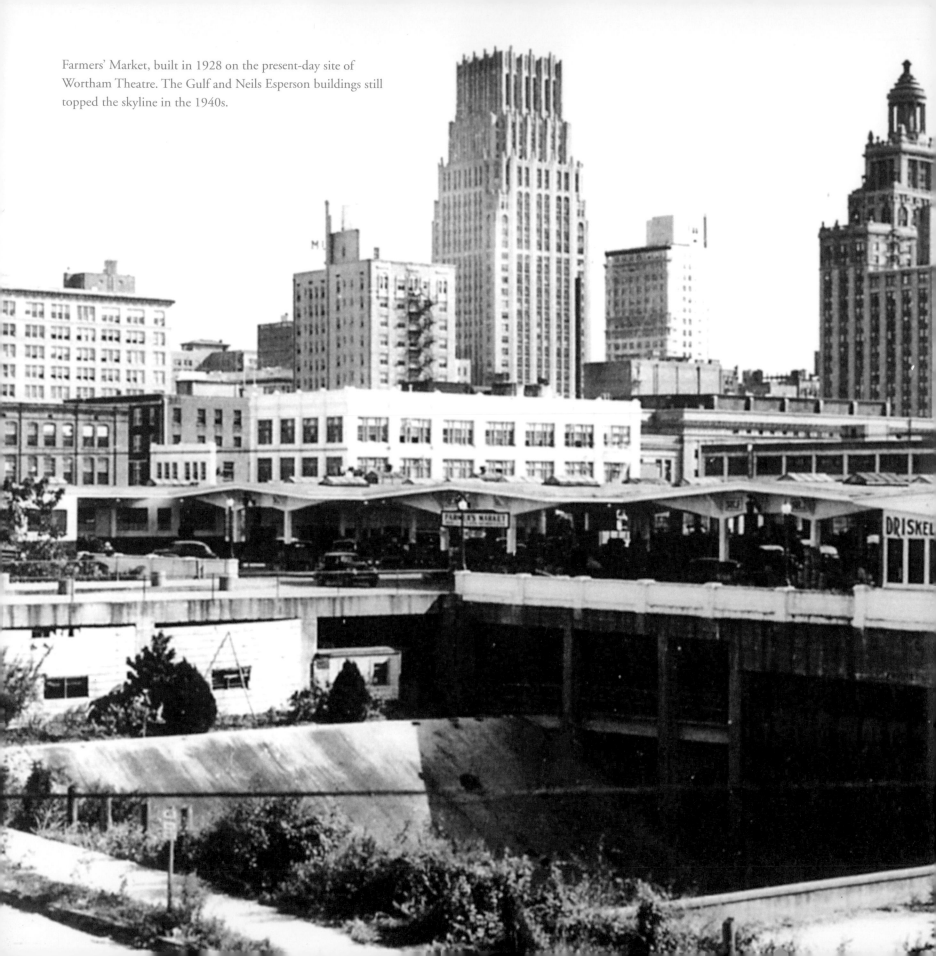

Farmers' Market, built in 1928 on the present-day site of Wortham Theatre. The Gulf and Neils Esperson buildings still topped the skyline in the 1940s.

HISTORIC PHOTOS OF
HOUSTON

Turner Publishing Company

200 4th Avenue North • Suite 950 412 Broadway • P.O. Box 3101
Nashville, Tennessee 37219 Paducah, Kentucky 42002-3101
(615) 255-2665 (270) 443-0121

www.turnerpublishing.com

Historic Photos of Houston

Copyright © 2007 Turner Publishing Company

Library of Congress Control Number: 2006909503

ISBN: 978-1-59652-310-4

Printed in the United States of America

08 09 10 11 12 13 14—0 9 8 7 6 5 4

CONTENTS

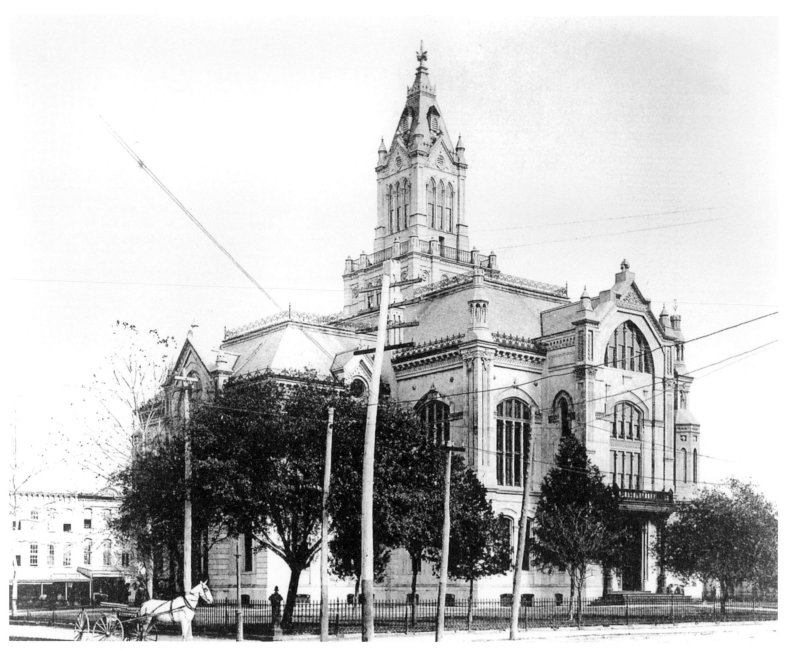

Harris County Courthouse, a unique Gothic-styled structure built in 1884 and razed in 1909.

Acknowledgments

This volume, *Historic Photos of Houston,* is the result of the cooperation and efforts of many individuals and organizations. It is with great thanks that we acknowledge in particular the valuable contribution of the Houston Public Library–Houston Metropolitan Research Center.

We would also like to thank:

Betty Trapp Chapman, historian, for organizing, researching, and writing this history
Joel Draut, archival photographer at the Houston Metropolitan Research Center
Barfield Photography

PREFACE

Houston has thousands of historic photographs that reside in archives, both locally and nationally. This book began with the observation that, while those photographs are of great interest to many, they are not easily accessible. During a time when Houston is looking ahead and evaluating its future course, many people are asking, "How do we treat the past?" These decisions affect every aspect of the city—architecture, public spaces, commerce, infrastructure—and these, in turn, affect the way that people live their lives. This book seeks to provide easy access to a valuable, objective look into the history of Houston.

The power of photographs is that they are less subjective than words in their treatment of history. Although the photographer can make decisions regarding subject matter and how to capture and present it, photographs do not provide the breadth of interpretation that text does. For this reason, they offer an original, untainted perspective that allows the viewer to interpret and observe.

This project represents countless hours of review and research. The researchers and author have reviewed thousands of photographs in numerous archives. We greatly appreciate the generous assistance of the archivists listed in the acknowledgments of this work, without whom this project could not have been completed.

The goal in publishing this work is to provide broader access to this set of extraordinary photographs that seek to inspire, provide perspective, and evoke insight that might assist people who are responsible for determining Houston's future. In addition, the book seeks to preserve the past with adequate respect and reverence.

With the exception of touching up imperfections caused by the damage of time and cropping where necessary, no other changes have been made. The focus and clarity of many images is limited to the technology and the ability of the photographer at the time they were taken.

The work is divided into eras. Beginning with some of the earliest known photographs of Houston, the first section

records photographs from before the Civil War through the end of the nineteenth century. The second section spans the first two decades of the twentieth century. Section Three moves from the 1920s to World War II. The last section covers the World War II era to the 1970s.

In each of these sections we have made an effort to capture various aspects of life through our selection of photographs. People, commerce, transportation, infrastructure, religious institutions, and educational institutions have been included to provide a broad perspective.

We encourage readers to reflect as they go walking in Houston, strolling through the city, its parks, and neighborhoods. It is the publisher's hope that in utilizing this work, longtime residents will learn something new and that new residents will gain a perspective on where Houston has been, so that each can contribute to its future.

Todd Bottorff, Publisher

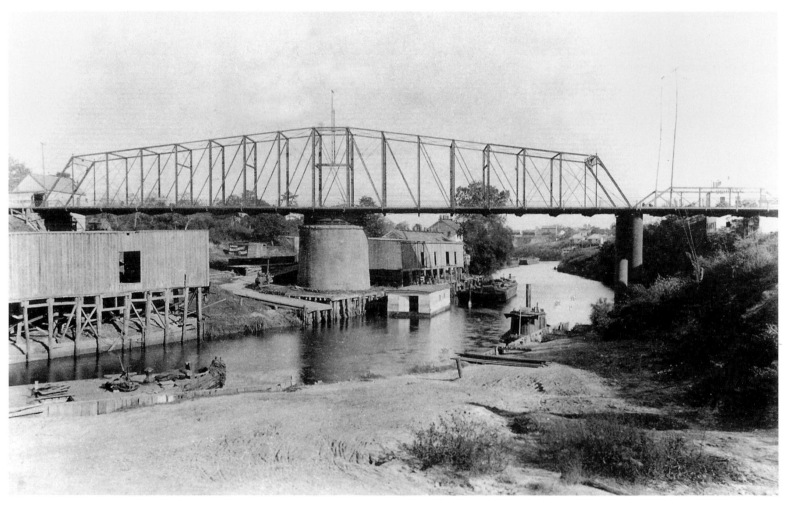

The San Jacinto Bridge, seen here in 1894, was built
in 1886 to connect downtown with the Fifth Ward on
the north side of Buffalo Bayou.

A City Plants Its Roots

1856–1899

Two enterprising brothers from New York were lured to Texas in the 1830s by plentiful cheap land. When a new nation was established in 1836, Augustus and John Kirby Allen saw an opportunity to capitalize on that event by founding a town, which they predicted would become "the great commercial emporium of all Texas." They selected land at the juncture of two bayous as the site for their speculative real estate venture. The fledgling entrepreneurs then named the town for the hero of the hour, Sam Houston, who would soon be elected president of the Republic of Texas. The town gained another advantage when it was named as the temporary capital of this new nation.

During the town's formative years, the greatest emphasis was placed on improving transportation facilities. On the eve of the Civil War, 350 miles of railroad track ran through Houston, and Buffalo Bayou had been dredged to a depth of 9 feet, allowing trade between Houston and Galveston. Cotton was the primary export, with timber of secondary importance. Befitting a trade center, the streets were filled with mercantile establishments. They also had their share of saloons.

Since Houston was distant from the Civil War battlefields, it suffered little physical deterioration. The demand for wartime goods actually stimulated factory production. Thus, by the end of the war, the city's industrial base had greatly expanded.

By the mid 1870s, Houston was a well-established commercial center with a network of railroads and a navigable waterway. It had grown in population and witnessed the decline of yellow fever. Although city government was dominated by white businessmen, the Reconstruction era saw a number of African Americans placed in positions of leadership.

The latter part of the nineteenth century was a period of transition for the city. Having established some prominence in the business arena, leaders began to address amenities that had largely been ignored. Trained architects began to design handsome structures, both public and private. A public school system was established in 1876; the first general hospital opened in 1887; an elegant opera house was built in 1890; and attempts were made to lessen the ever-present mud and dust by surfacing the streets.

By the end of the century, Houston was positioned to become a major force along the Gulf Coast.

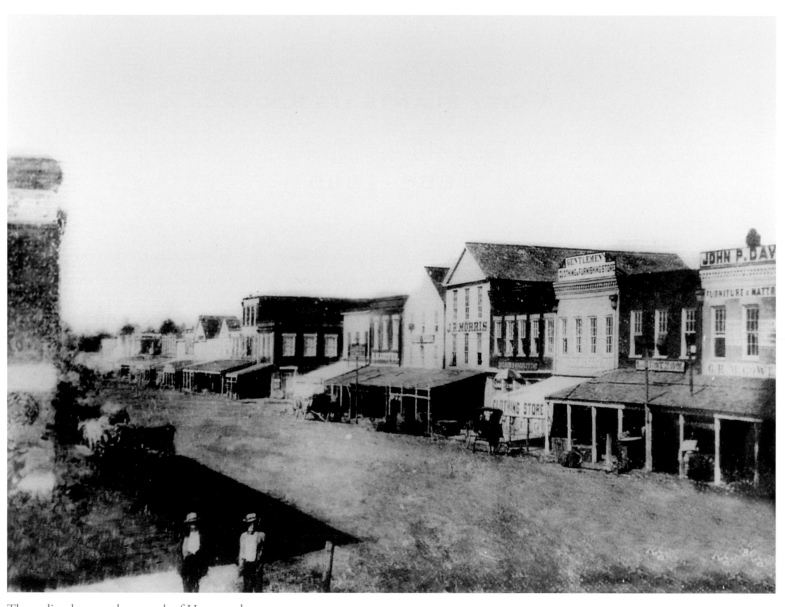

The earliest known photograph of Houston shows
the 300 block of Main Street, 1856.

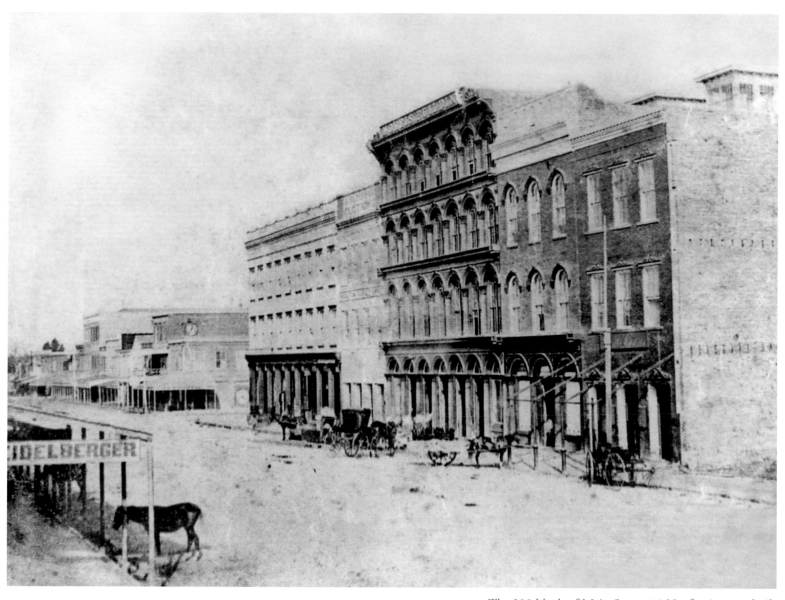

The 300 block of Main Street, 1866, after it was rebuilt following a fire. The Morris Building was Houston's first four-story structure.

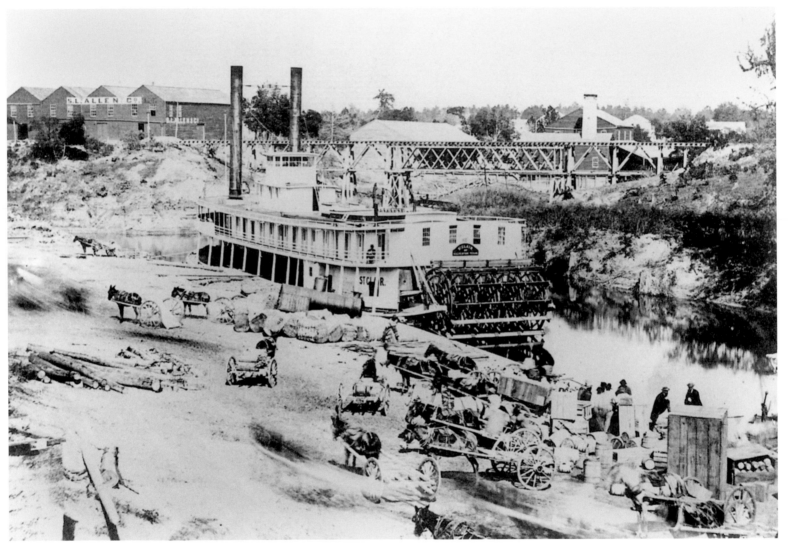

The sternwheeler *St. Clair*, loading cotton at the foot
of Main Street shortly after the Civil War.

Volkfest parade, an annual
celebration held by the city's
German residents, 1870s.

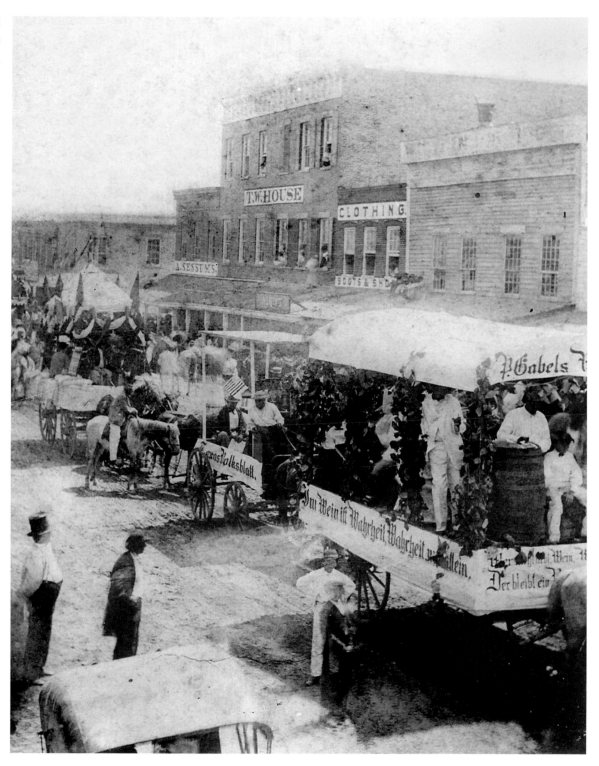

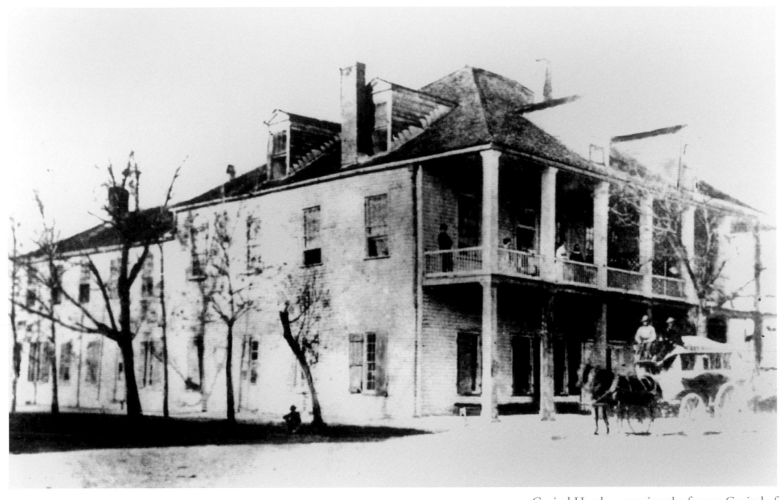

Capitol Hotel, occupying the former Capitol of the Republic of Texas at the corner of Main and Texas, ca. 1870.

Market House, which held the farmers' market, offices of city
government, the telephone exchange, and a circulating library
until it was destroyed by fire in 1901.

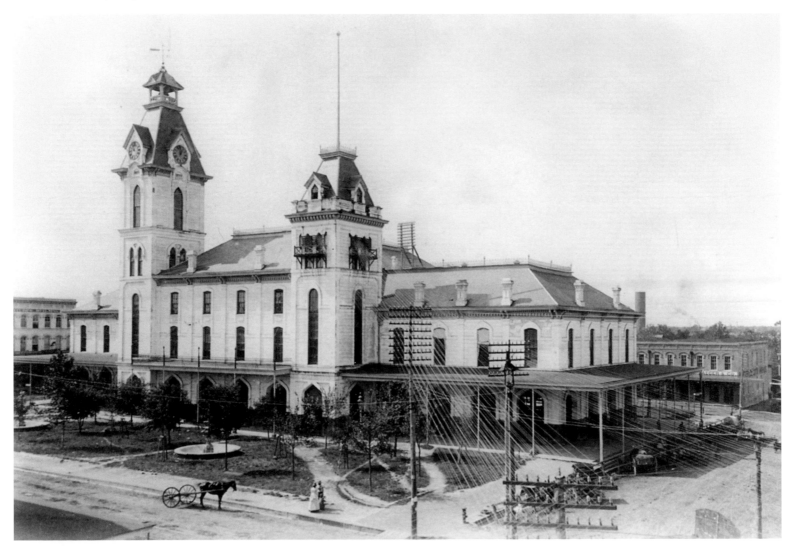

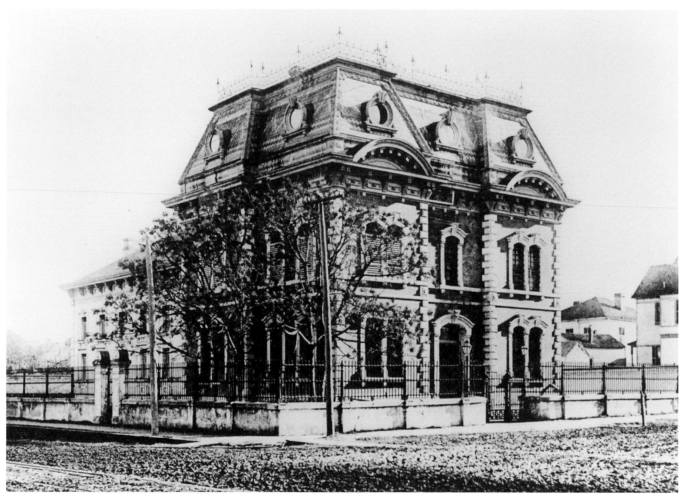

Harris County Jail, 1879.

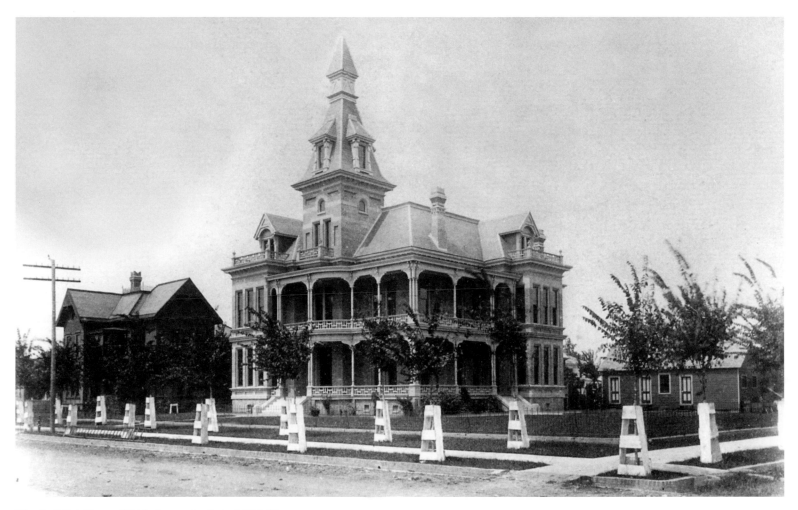

The Jedidiah Porter Waldo home, built in 1884-85 on
Rusk Avenue and later moved to the Westmoreland
Addition where it was redesigned by the family.

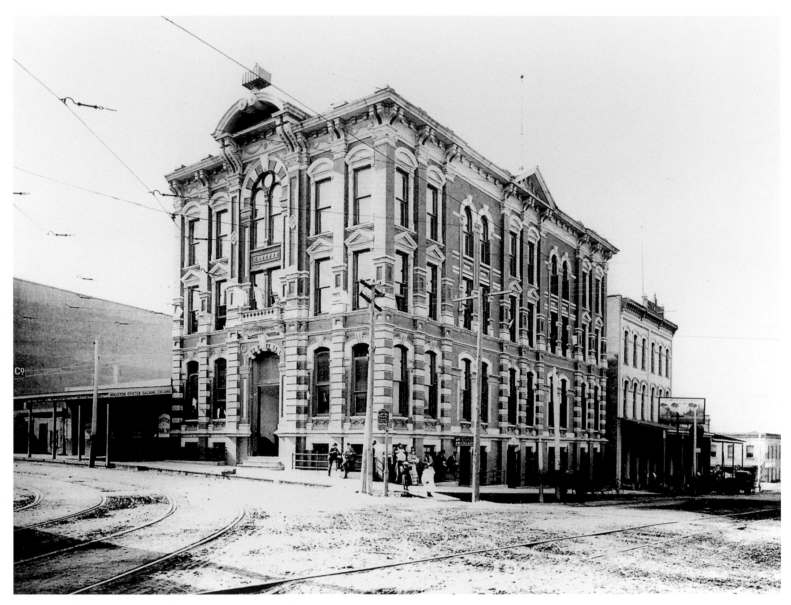

Cotton Exchange and Board of Trade, 202 Travis, 1884.
Note the zinc cotton bale, which served as a weather
vane on top of the building.

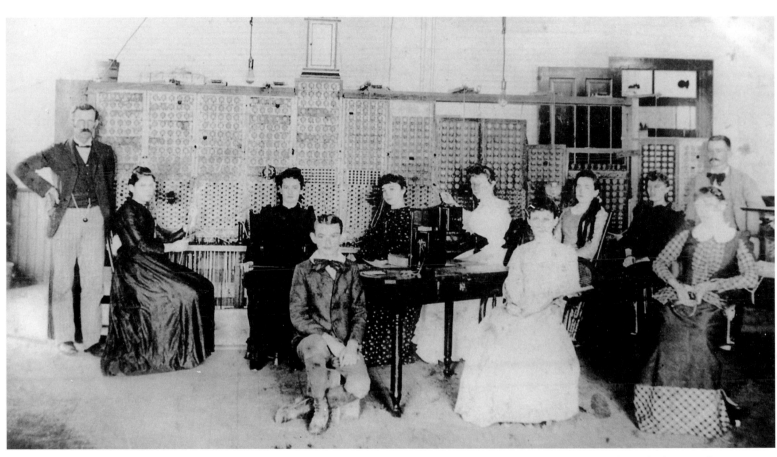

The city's first telephone exchange, 1887.

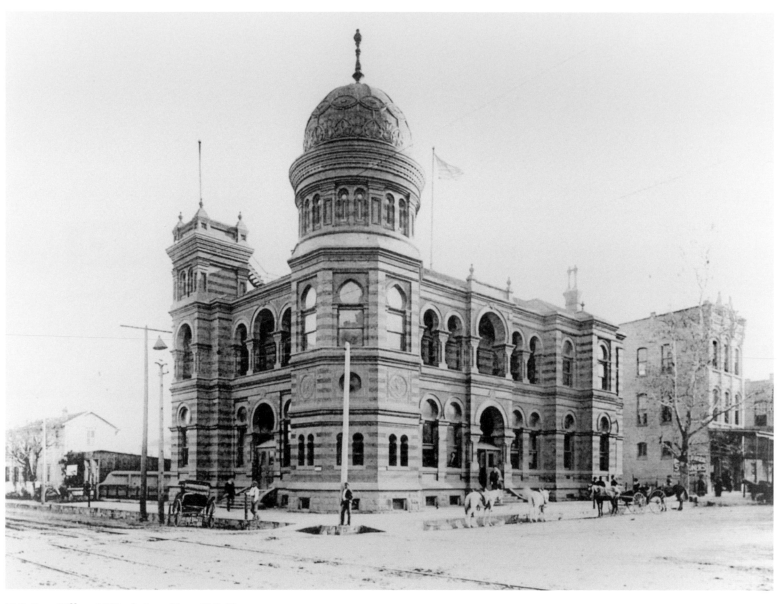

U.S. Post Office, 1888, designed by a U.S. Treasury
Department architect who thought this Moorish styling
was appropriate for Houston's warm climate.

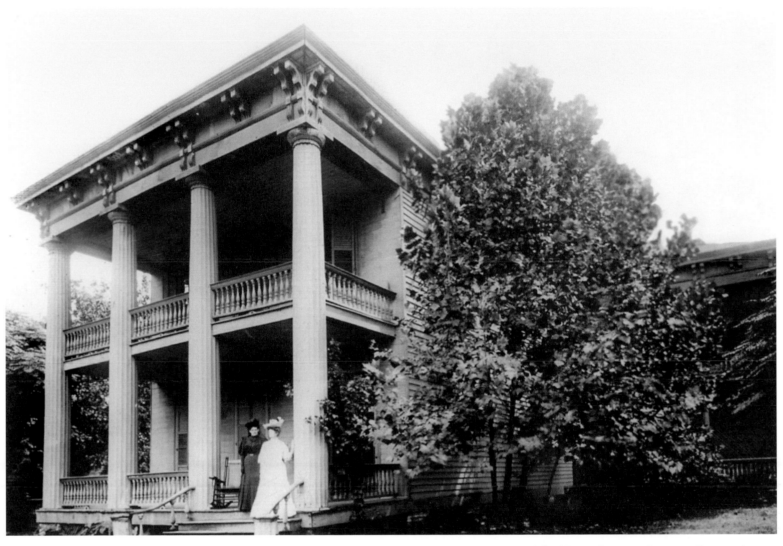

The Henry Sampson home on Preston Avenue
across from Courthouse Square.

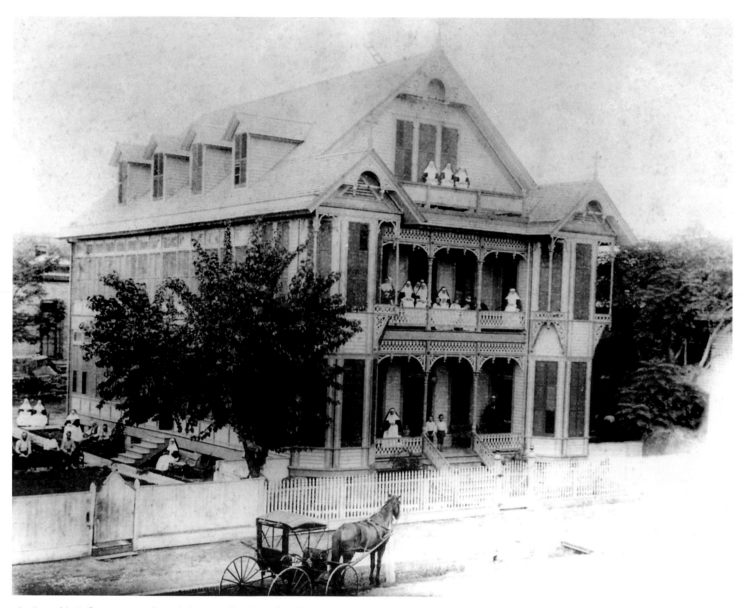

St. Joseph's Infirmary was founded in this building by the Sisters of Charity of the Incarnate Word in 1887. When it burned, the hospital (now St. Joseph Medical Center) was moved to the site it occupies today.

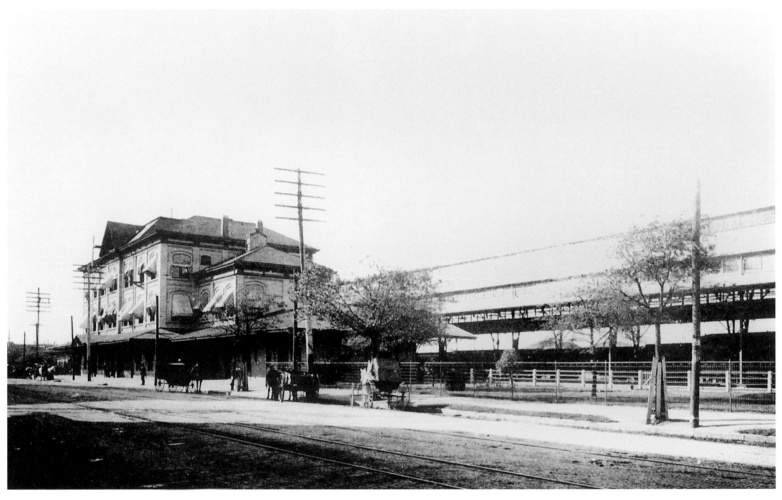

Grand Central Station, frequently called "the finest in the South," was built on Washington Avenue in 1887. The downtown post office occupies the site today.

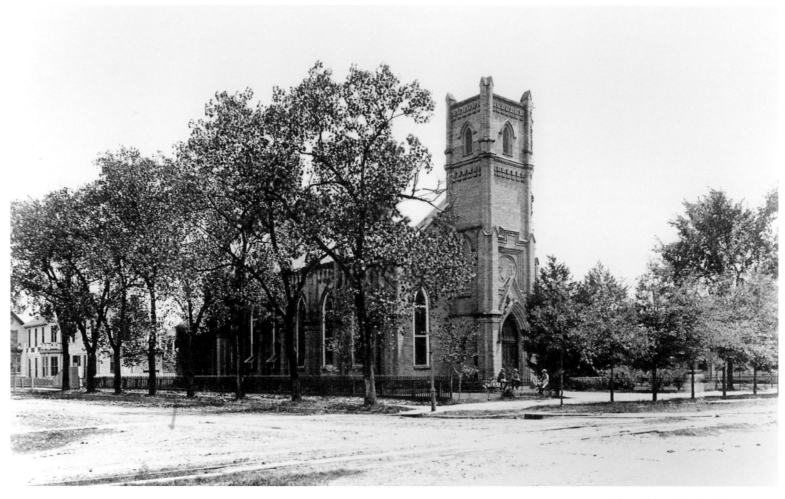

Christ Episcopal Church, ca. 1890.

Volunteer firemen with their horse-drawn service truck, ca. 1890.

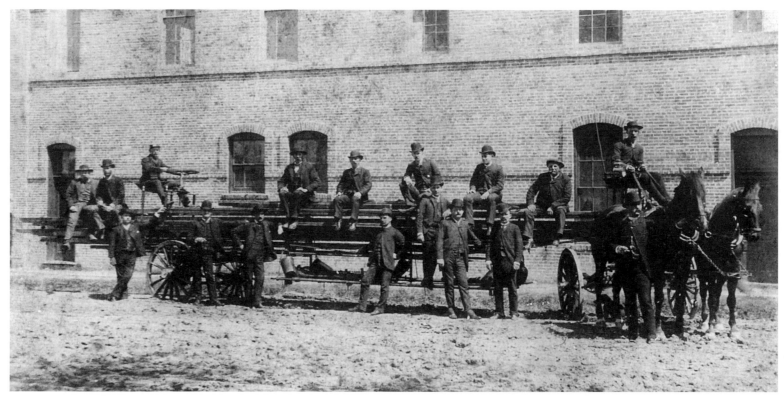

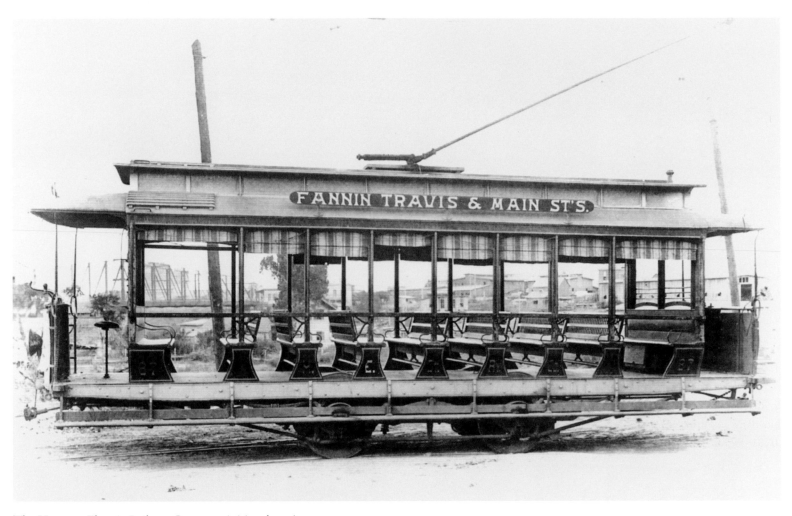

The Houston Electric Railway Company initiated service on tracks, which extended from downtown to the South End, June 12, 1891.

Heights Boulevard in Houston Heights, the first
suburban development, 1890s.

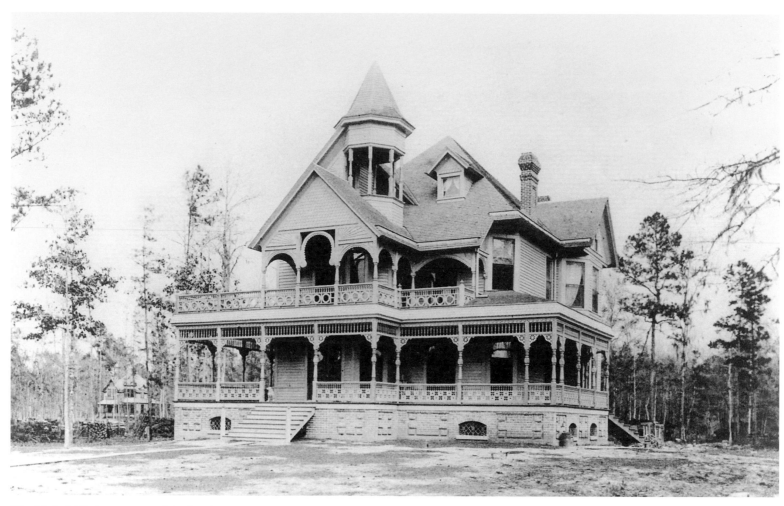

The N. L. Mills home, one of the first houses built
on Heights Boulevard.

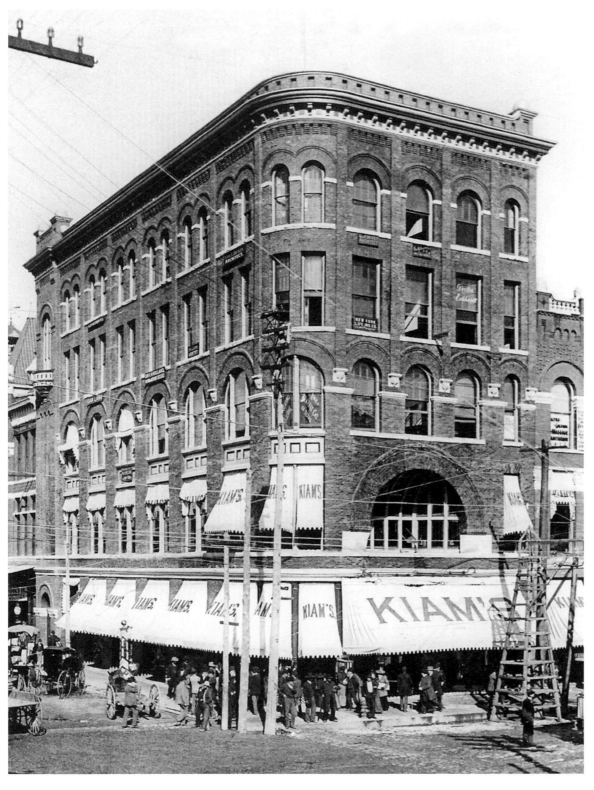

Kiam's clothing store, the first building in the city with an electric passenger elevator, 1893.

East side of Main Street looking north
from Prairie Avenue, 1894.

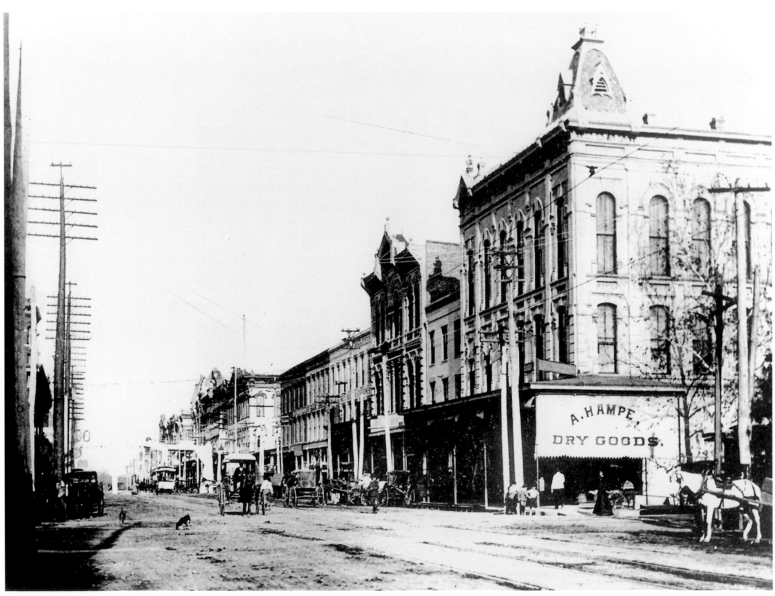

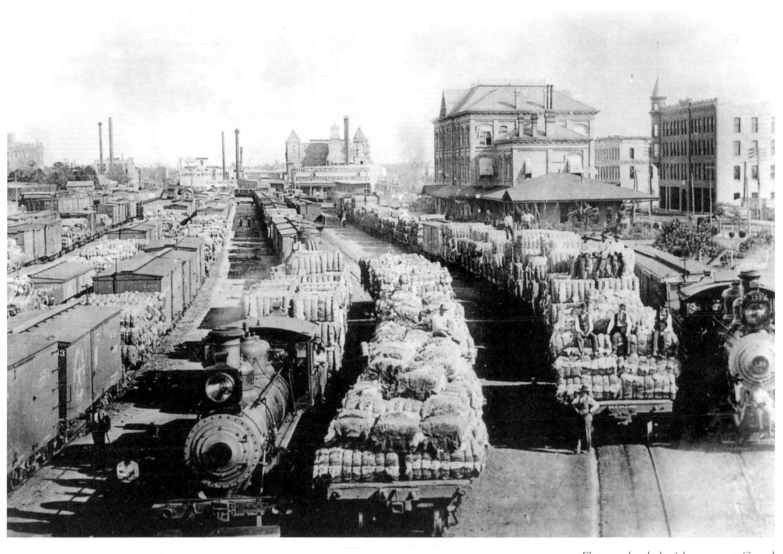

Flat cars loaded with cotton at Grand
Central Station, 1894.

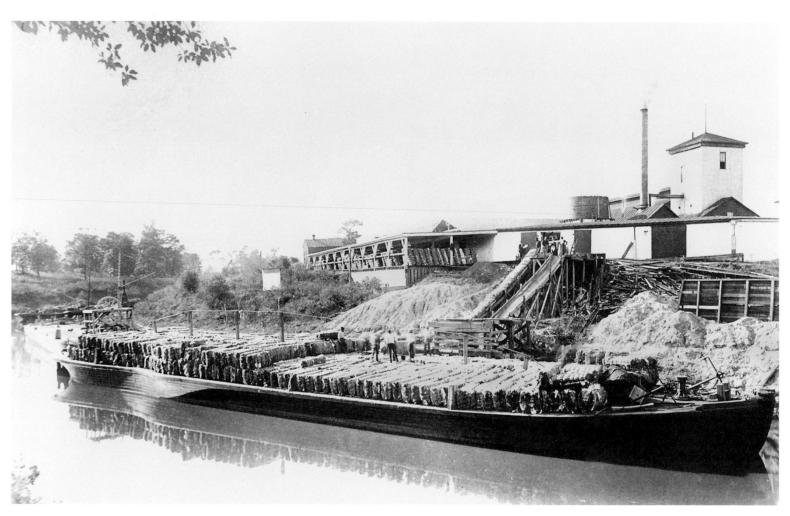

Bayou City Cotton Compress, 1890s. As cotton was received from
the interior, it was compressed, sent down chutes to barges on the
bayou, and then carried to ocean-bound vessels in Galveston.

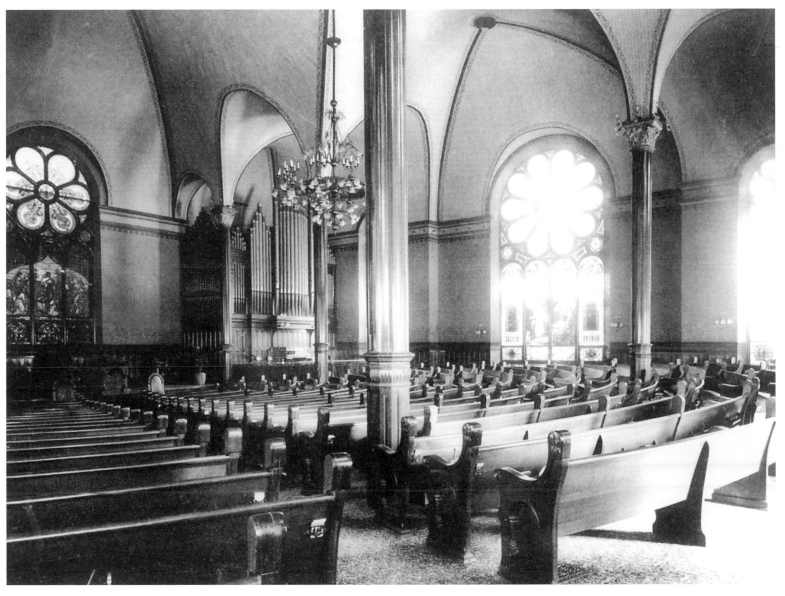

First Presbyterian Church, considered one of the most beautiful church interiors in the South when it was built in 1894.

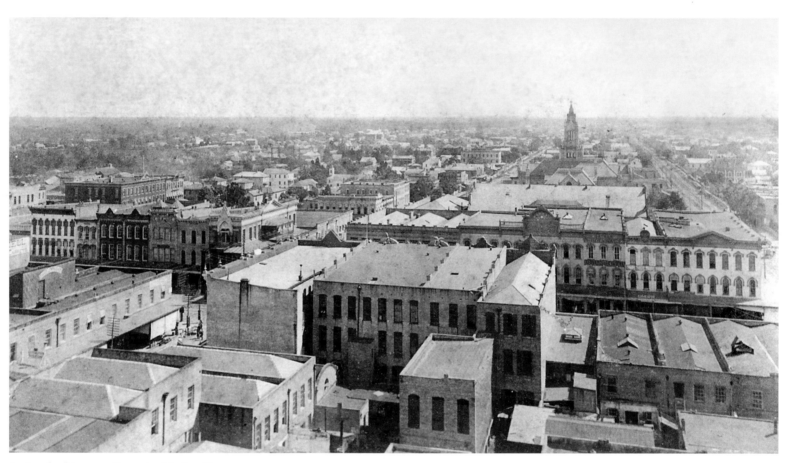

A view looking east from the Market House
tower, 1894. The tower of the Harris County
Courthouse is seen in the distance.

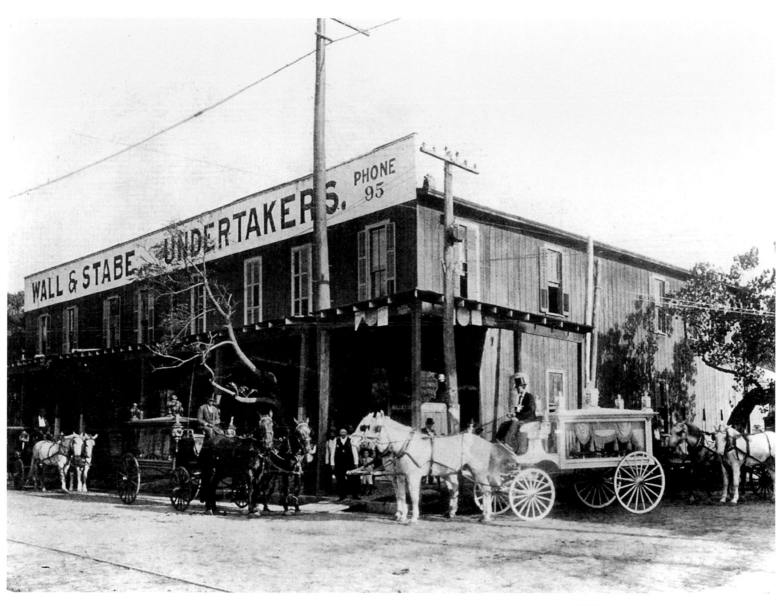

Wall and Stabe Undertakers, corner of
Prairie and San Jacinto, 1895.

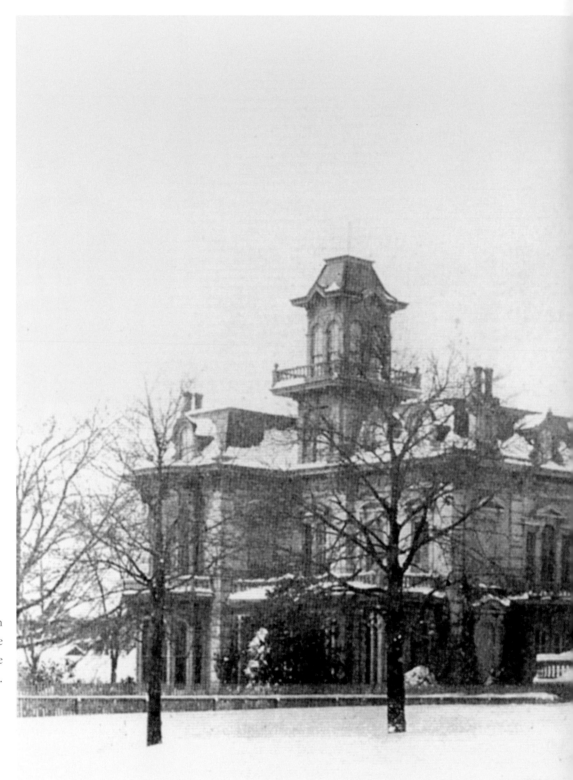

A record twenty-two inches of snow fell on February 14 and 15, 1895, as seen at the Main Street homes of Henry Fox and Judge James Masterson.

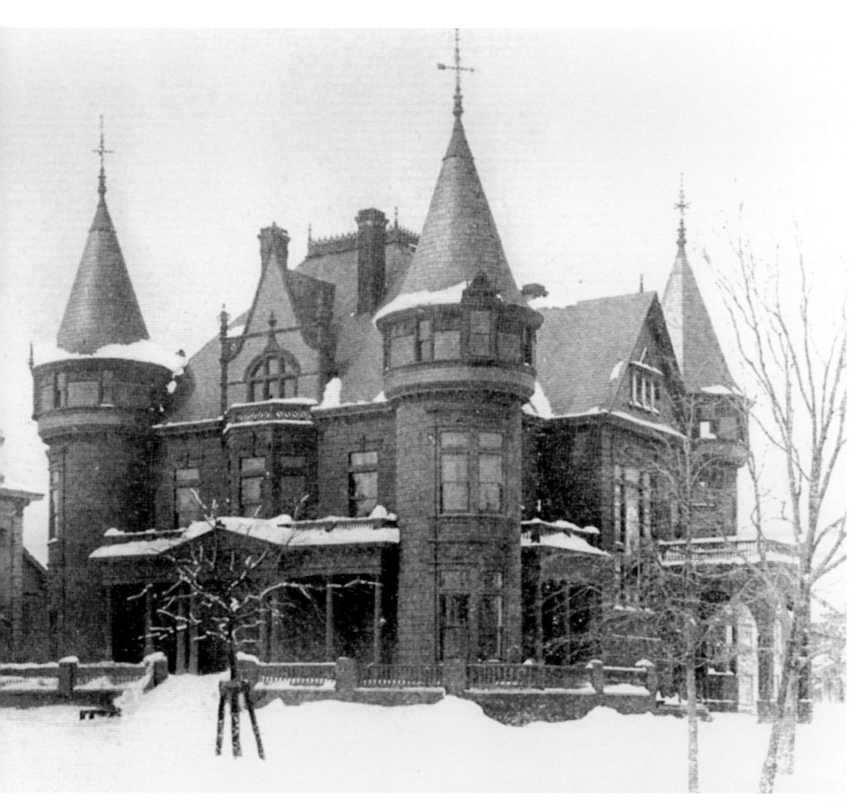

Winnie Davis Auditorium, built at Main and McGowen
to accommodate a national reunion of Confederate
veterans, 1895.

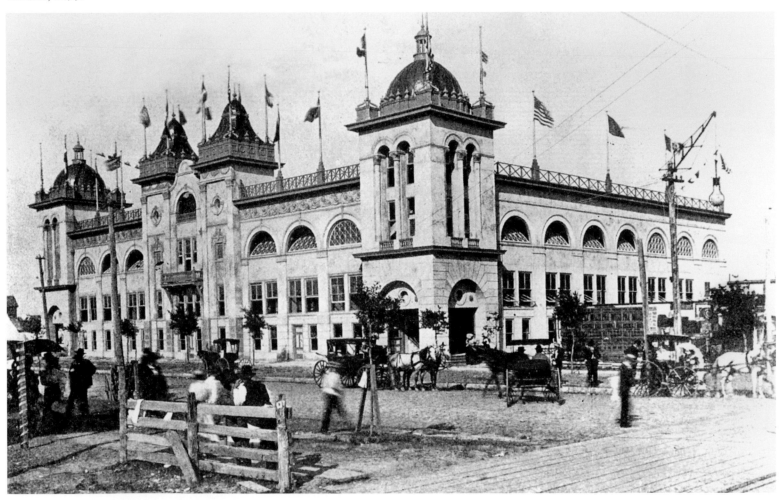

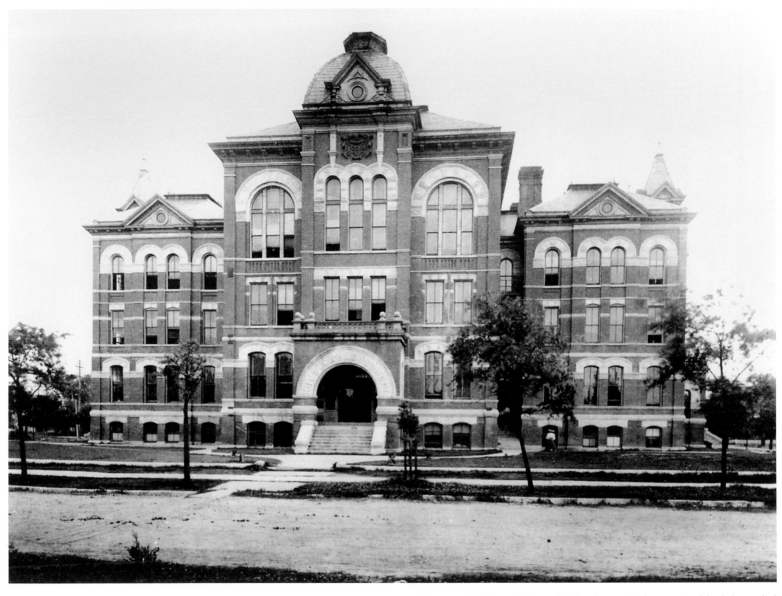

Houston High and Normal School occupied an entire block bounded by Capitol, Austin, Rusk, and Caroline, 1895. The building, later renamed Central High School, burned in 1919.

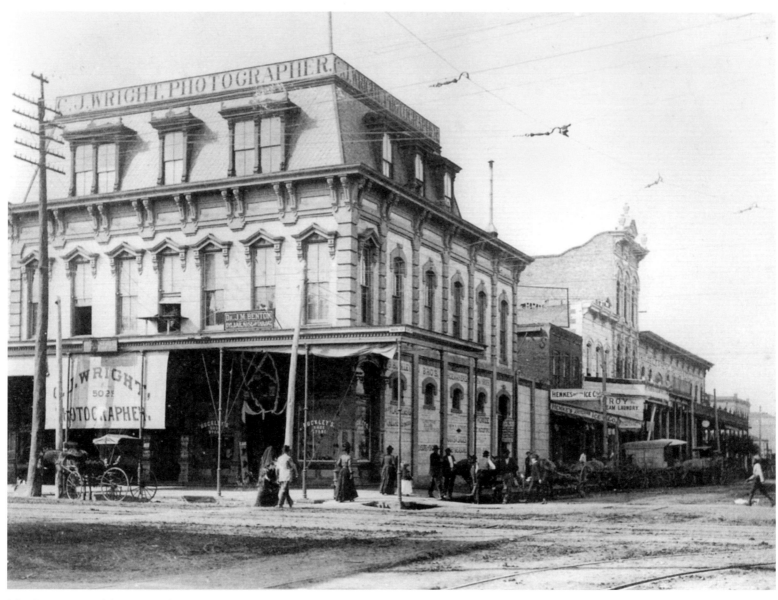

The Stegeman Building, erected in 1879 at
502 Main Street, is one of the oldest structures
remaining downtown.

A City Matures

1900–1920

As a new century dawned, Houston with 44,653 residents was seventy-fifth in population among American cities. It was the nation's largest railroad center south of St. Louis, the second largest manufacturing center in Texas, and the South's second largest city in bank clearings, exceeded only by New Orleans.

On January 10, 1901, an oil find of unparalleled magnitude created a new industry in Texas. As companies were organized to explore for oil, many of them moved their operations to Houston. Refineries were built along Buffalo Bayou, which by 1914 had attained a sufficient depth to accommodate ocean-borne vessels and was officially named the Houston Ship Channel.

Wagons and carriages gave way to automobiles, and by 1915 the city boasted 4,000 auto owners. Electric streetcars had appeared on the streets in the late nineteenth century and soon tracks crisscrossed the city in all directions. As a result, suburban neighborhoods began to appear. For the first time, residential subdivisions were platted with deed restrictions.

The advent of World War I actually brought economic benefits as the demand for oil and cotton increased. A tragic event occurred, however, when an incident between black soldiers stationed at a local Army camp and the city's police force erupted into a confrontation in which a number of lives were lost. The Riot of 1917 cast a somber tone over the city, reinforcing many of the Jim Crow segregation laws under which racial minorities were forced to live. At the same time, the population became more diverse as immigrants came from Mexico, Japan, Germany, Ireland, Greece, and various other countries, seeking economic advantages or political freedom.

Houston began to mature in other ways. The first public park was established in 1900. It was followed in 1914 by a more ambitious project, Hermann Park, which sparked a brief involvement with the City Beautiful movement that was sweeping the country. The roots were also planted for a public art museum, a symphony orchestra, a public library for both white and black residents, and an institution of higher education—Rice Institute.

Following the progressive movement in the country, Houston abolished the ward-based system of government and adopted the commission plan. Progress continued to be the key word as the community became known as the place with a "can do" spirit as it looked toward the future.

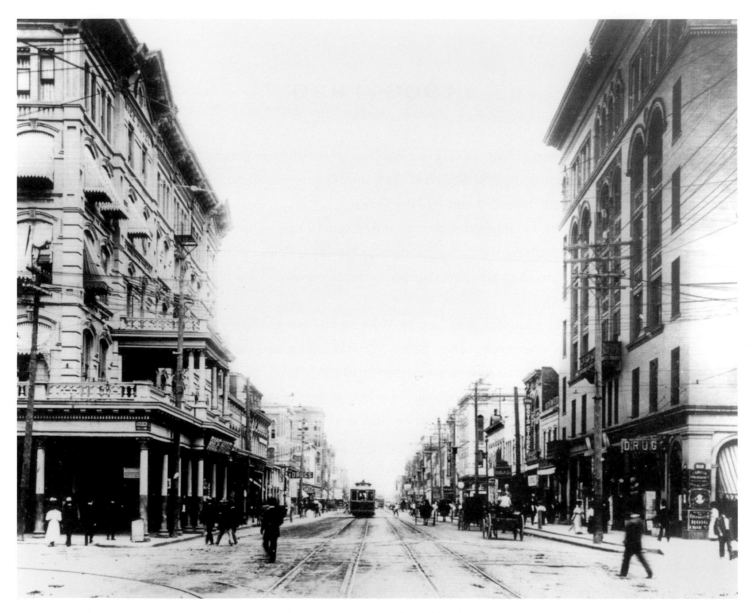

Main Street, looking north from Texas Avenue, 1904. The intersection is flanked by the Rice Hotel (left) and by the six-story Binz Building (right), considered Houston's first skyscraper when it was built in 1895.

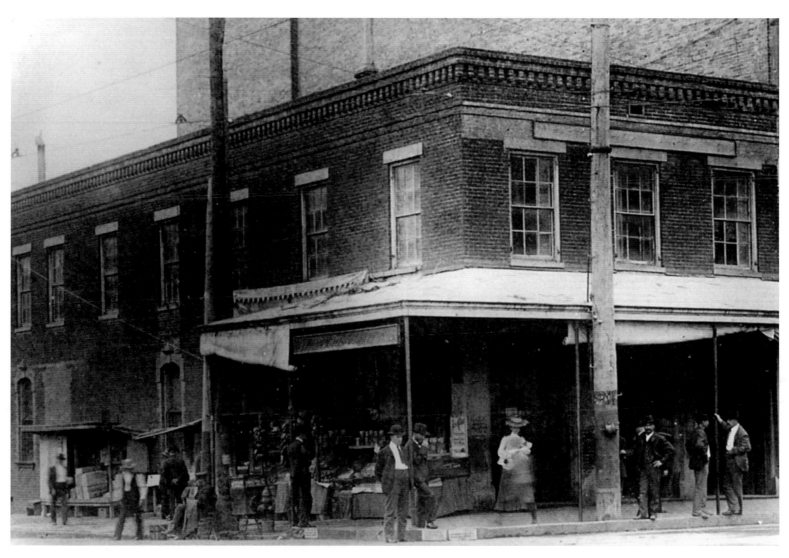

First National Bank at the corner of Main and Franklin, 1902. Fruit and cold lemonade were being sold from the sidewalk stand.

An unidentified bar on Washington
Avenue, ca. 1900.

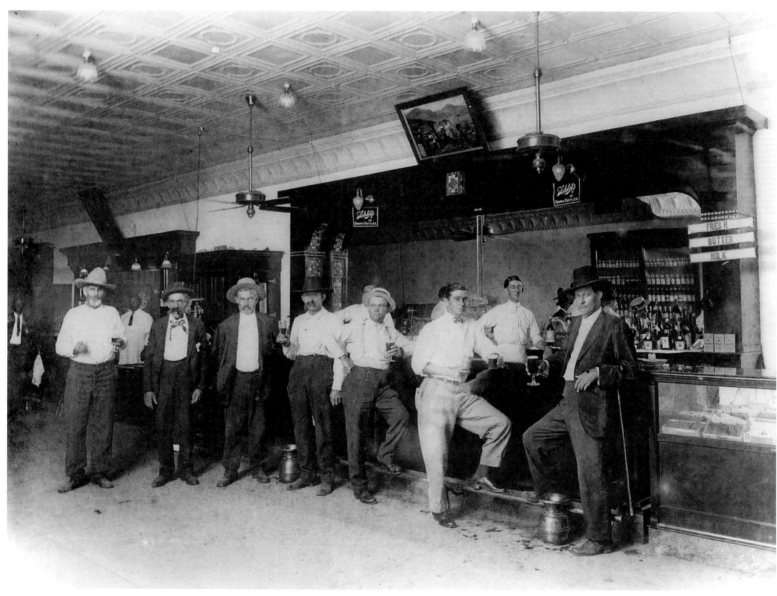

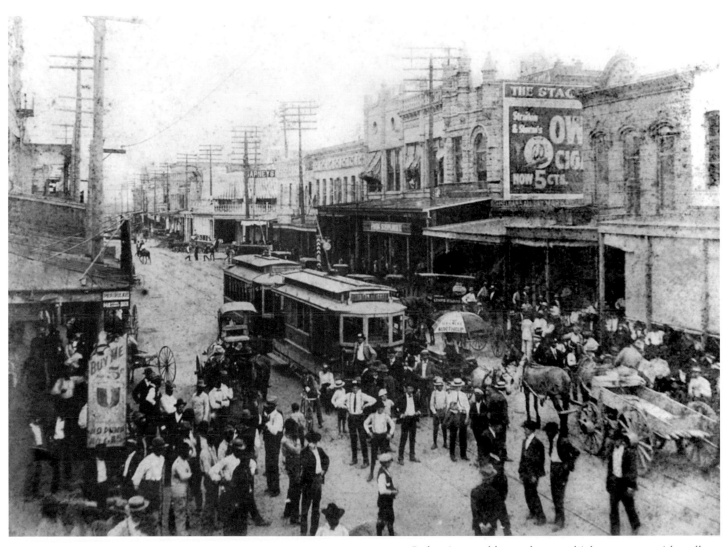

Pedestrians and horse-drawn vehicles compete with trolleys
for space on Travis Avenue, ca. 1900.

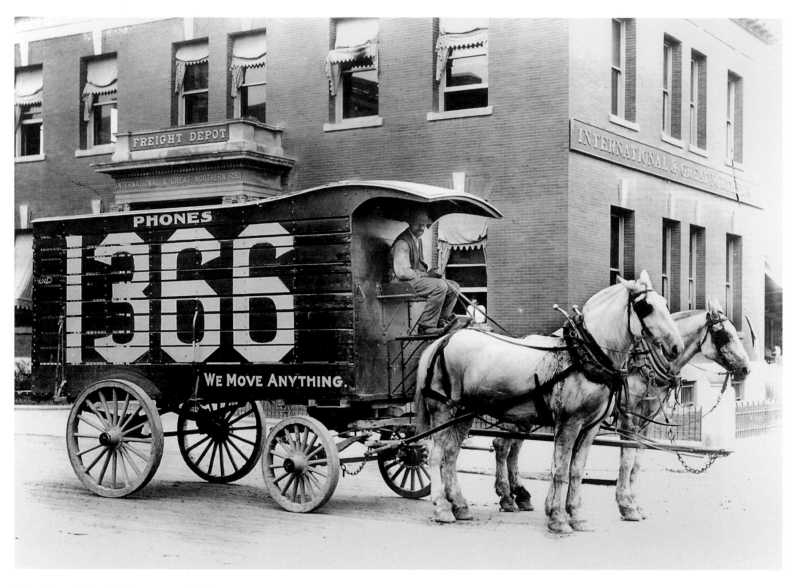

Westheimer Transfer Co. wagon, 1900.

Annunciation Catholic Church and Incarnate Word Academy, ca. 1900. The church structure dates to 1871 with later additions and remodeling by noted Galveston architect N. J. Clayton. Annunciation's steeple was the tallest point on the skyline until 1912.

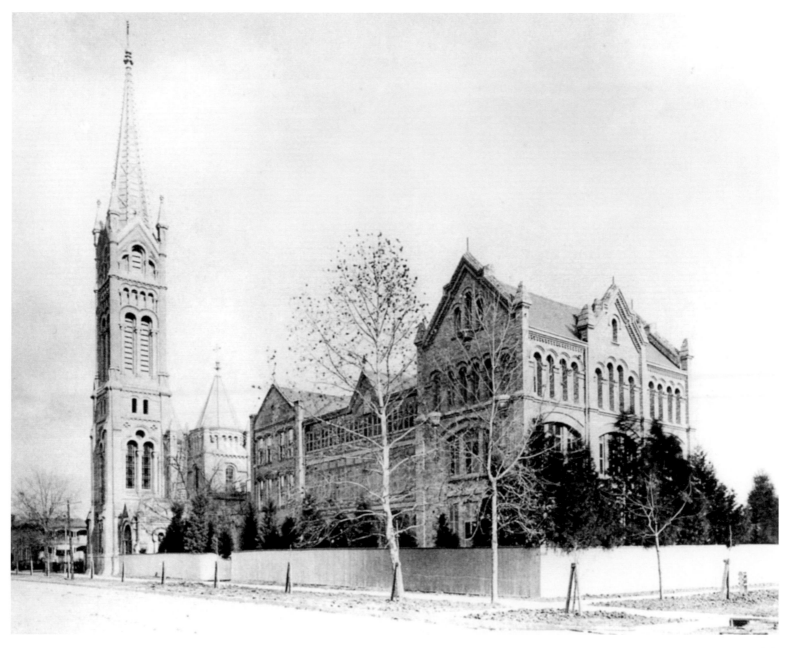

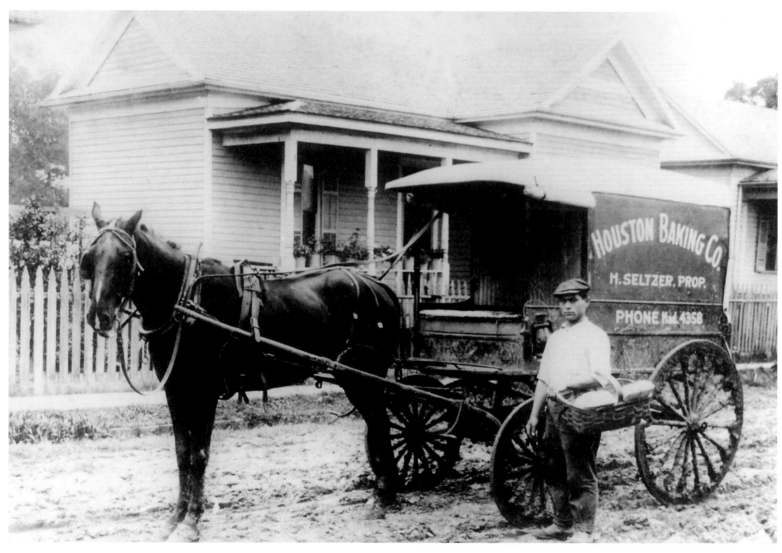

Houston Baking Co. delivering its products by wagon.

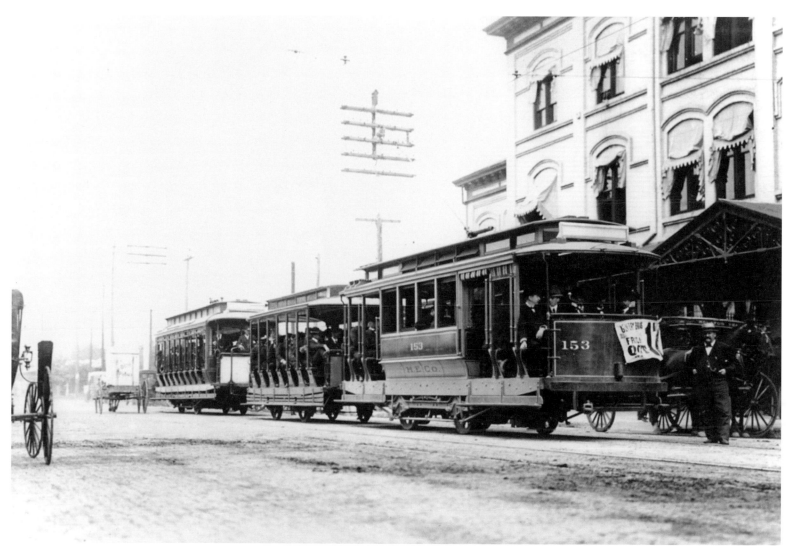

Streetcars leaving from Grand Central Station with a party of
Ohio businessmen visiting the city, 1902.

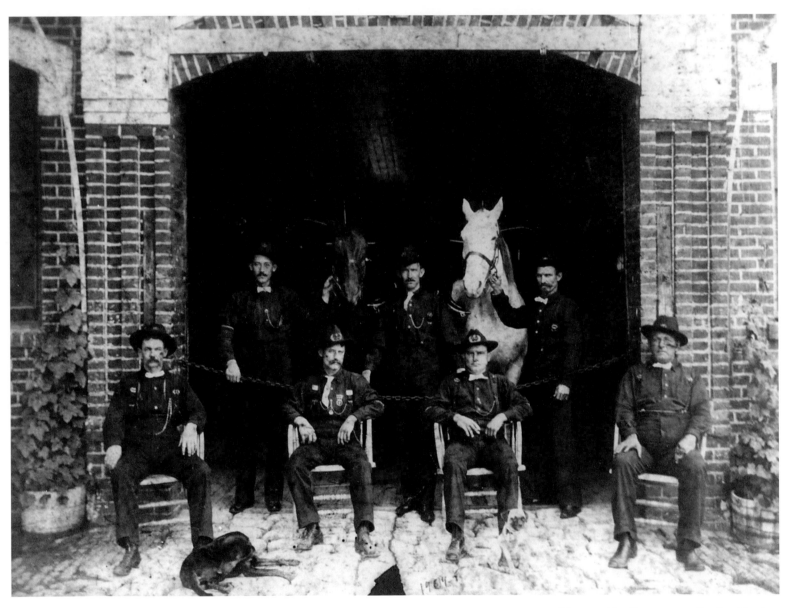

Houston Fire Department Station No. 5 at
910 Hardy Street, 1904.

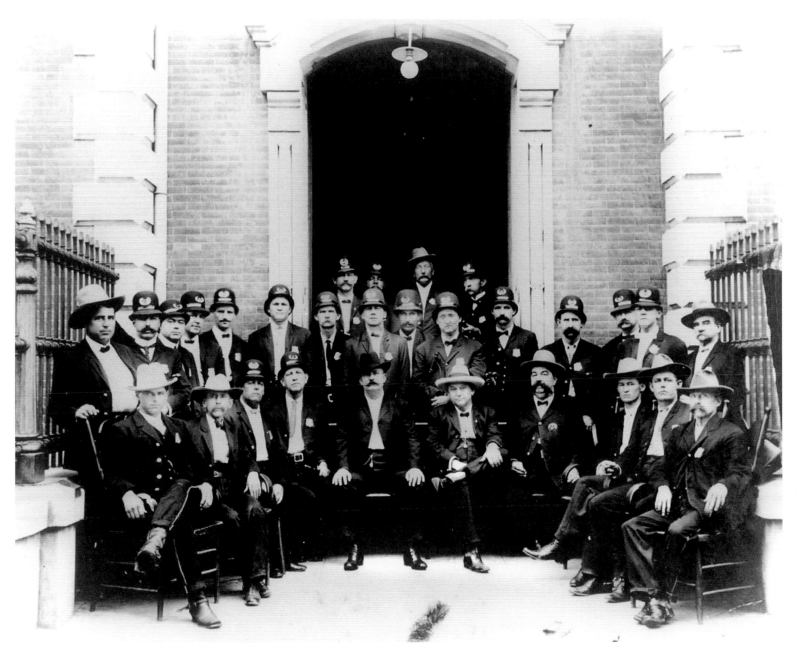

Houston Police Department in front of its headquarters on
Caroline Street, 1903.

Lavishly landscaped City Park around the time it was renamed
Sam Houston Park, ca. 1903.

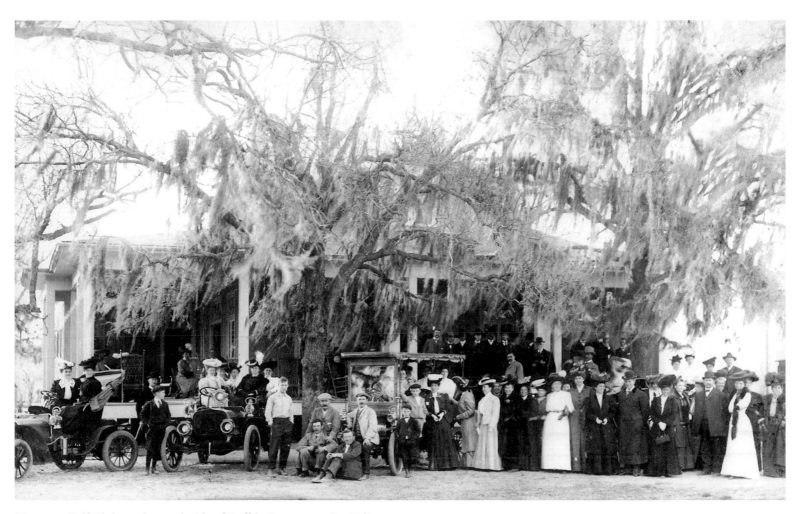

Houston Golf Club on the south side of Buffalo Bayou near San Felipe
Road, ca. 1904. The membership changed its name to Houston Country
Club in 1908 and relocated to a site near Brays Bayou southeast of
downtown.

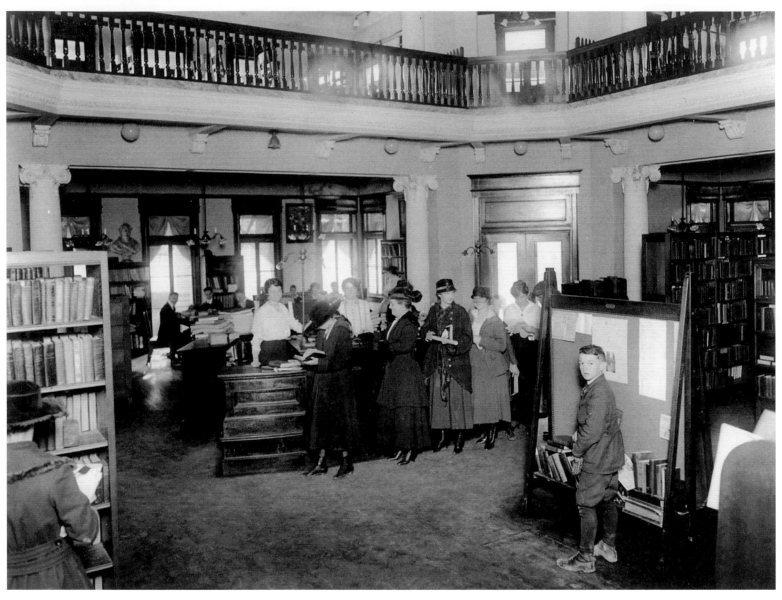

Check-out time at the newly opened Houston Lyceum and Carnegie Library, 1904.
Longtime librarian Julia Ideson is seen behind the circulation desk.

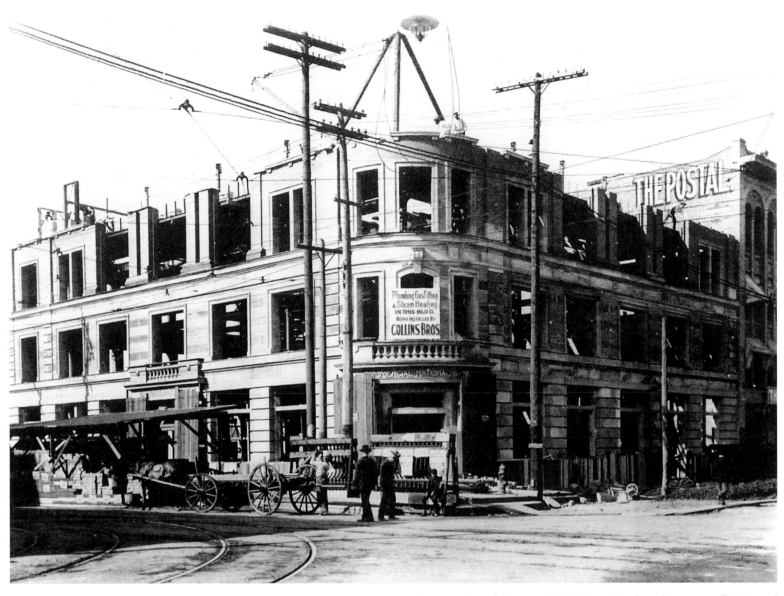

Construction of Commercial National Bank at the corner of Main and Franklin in the heart of the city's financial district, 1905.

Oil gushers were a common sight in the early 1900s.

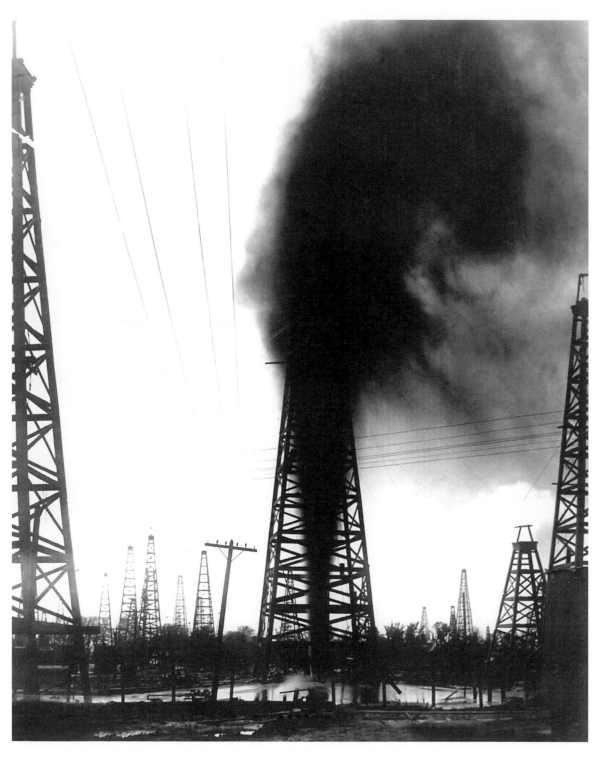

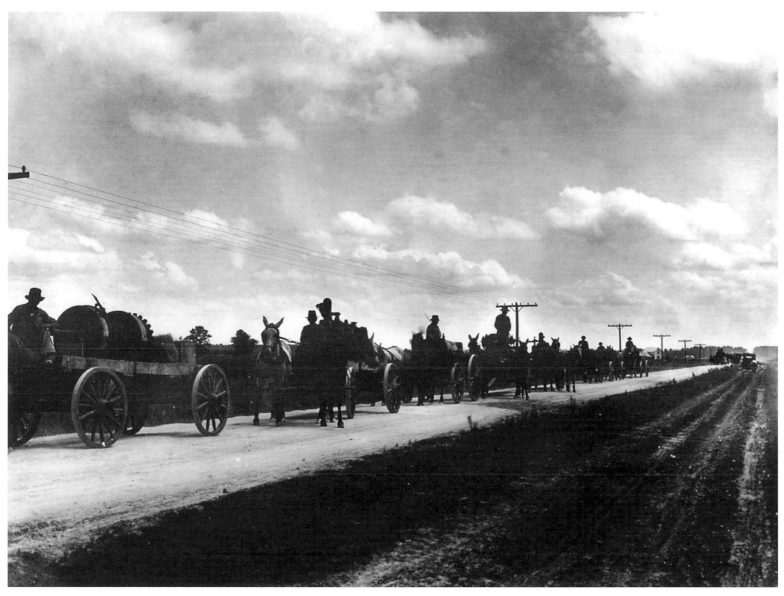

Mule train of men and equipment moving along a South Texas
road en route to the oil fields.

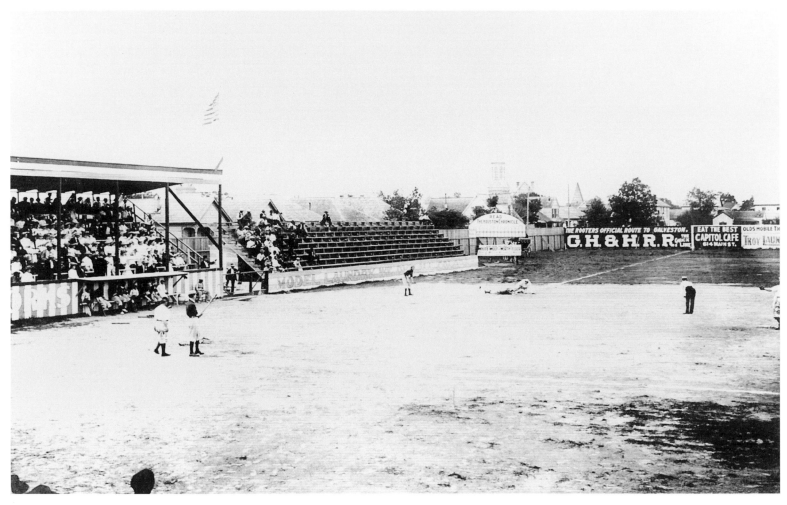

West End Park, Houston's first permanent home for professional baseball, was located at the end of Andrews Street on the San Felipe streetcar line. The steeple of Antioch Missionary Baptist Church can be seen in the background.

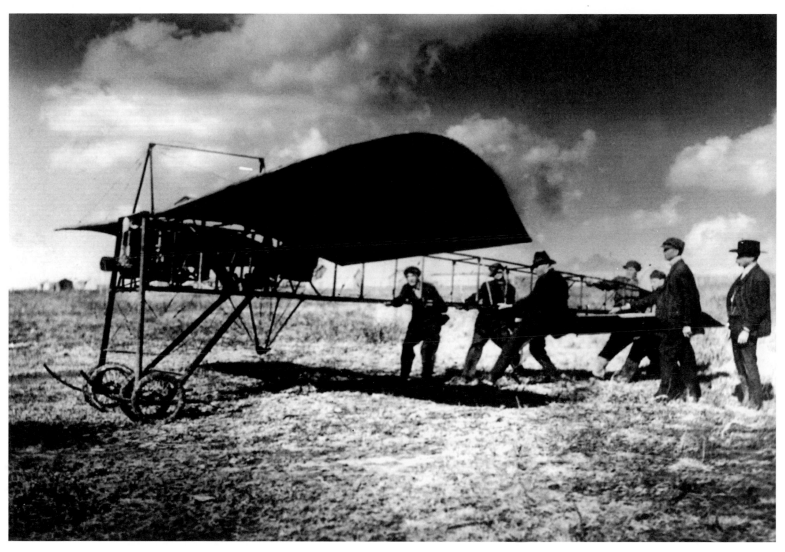

L. L. "Shorty" Walker, preparing to fly his homemade airplane on a field in South Houston, 1911. Walker built his plane on the top floor of the Auto and Motorworks Building, removed its wings to take it down on the freight elevator, and towed it to the field for the trial flight.

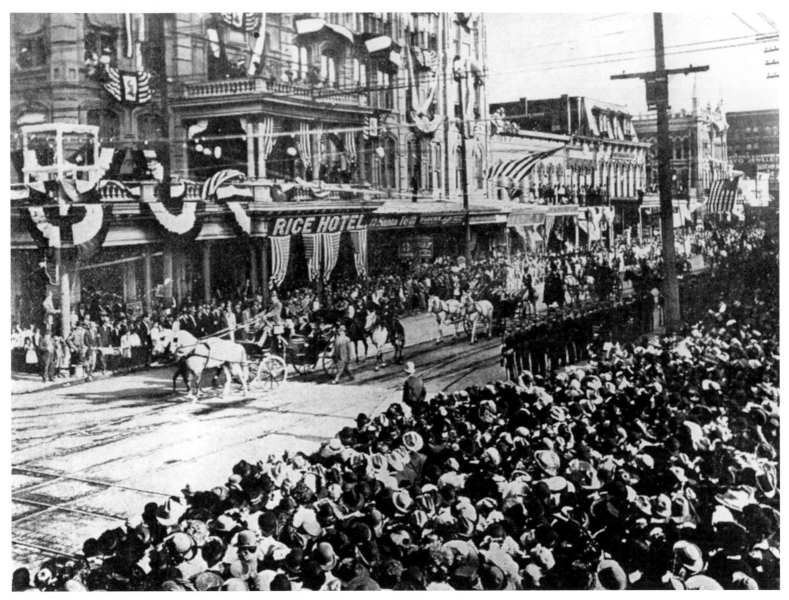

President William Howard Taft's procession down Main Street
when he visited the city in November 1909.

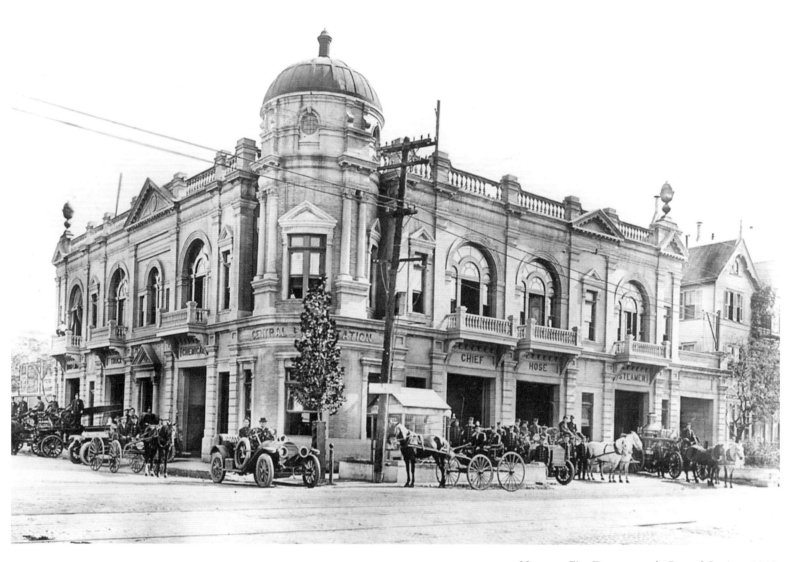

Houston Fire Department's Central Station, 1910.

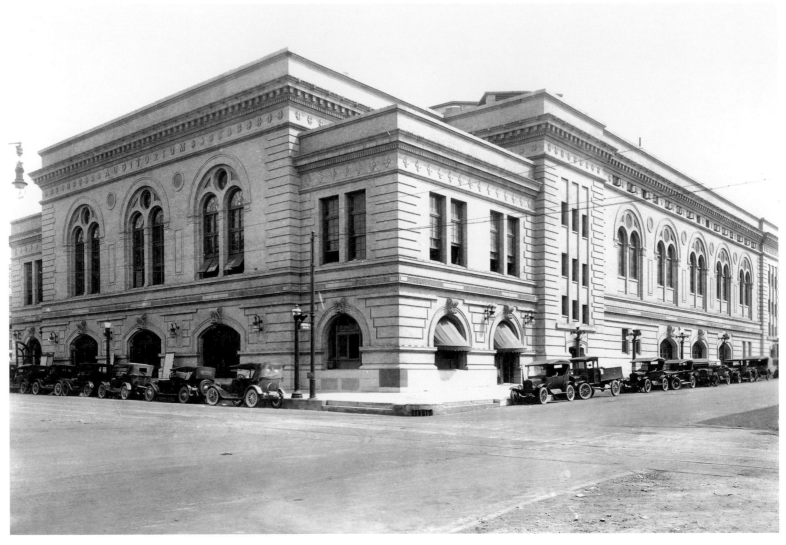

City Auditorium, built in 1910, was the site of concerts, trade shows, conventions, dramatic performances, and wrestling matches for fifty years. It was razed in 1963 for the construction of the Jesse H. Jones Hall for the Performing Arts.

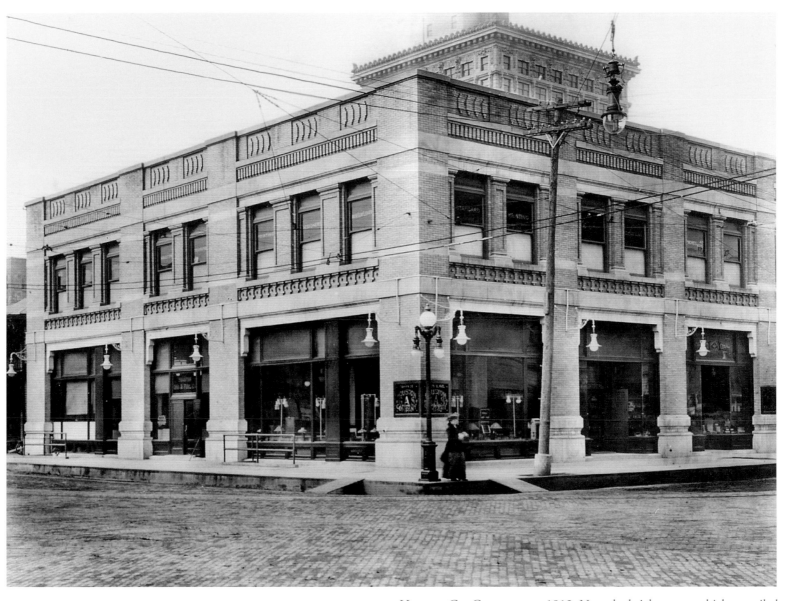

Houston Gas Company, ca. 1912. Note the brick streets, which prevailed well into the twentieth century in the downtown area.

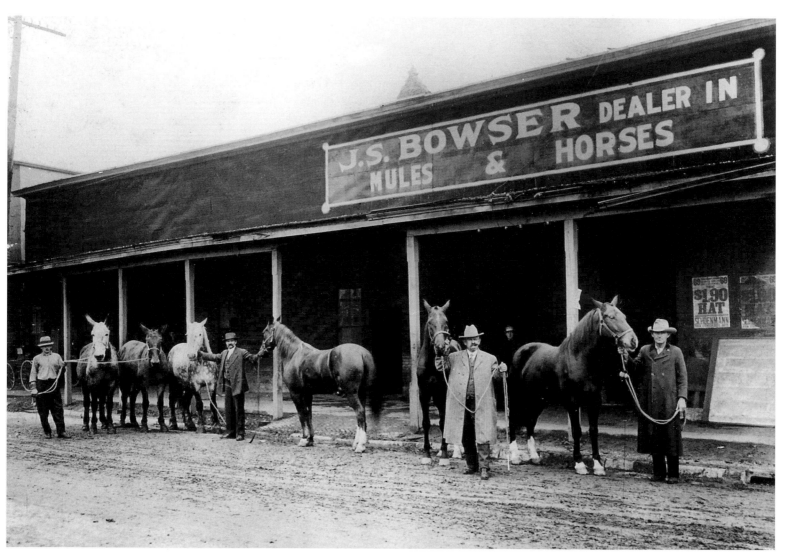

J. S. Bowser Livery, 611 Preston, 1911.

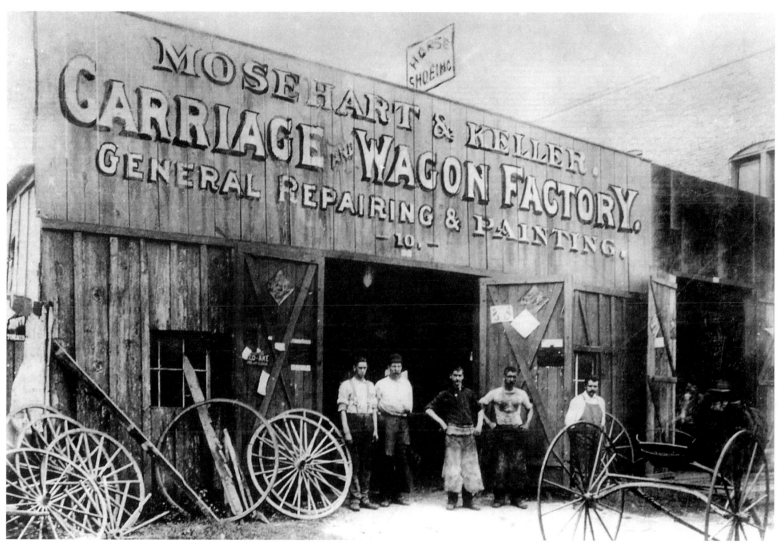

Mosehart and Keller Carriage and Wagon Factory, 1910. The business soon made the transition to selling automobiles.

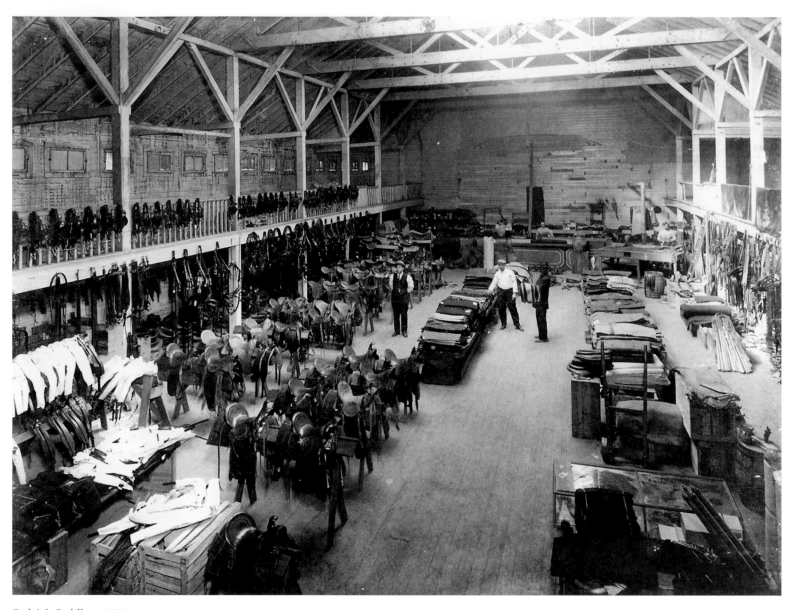

Stelzig's Saddlery, 1911.

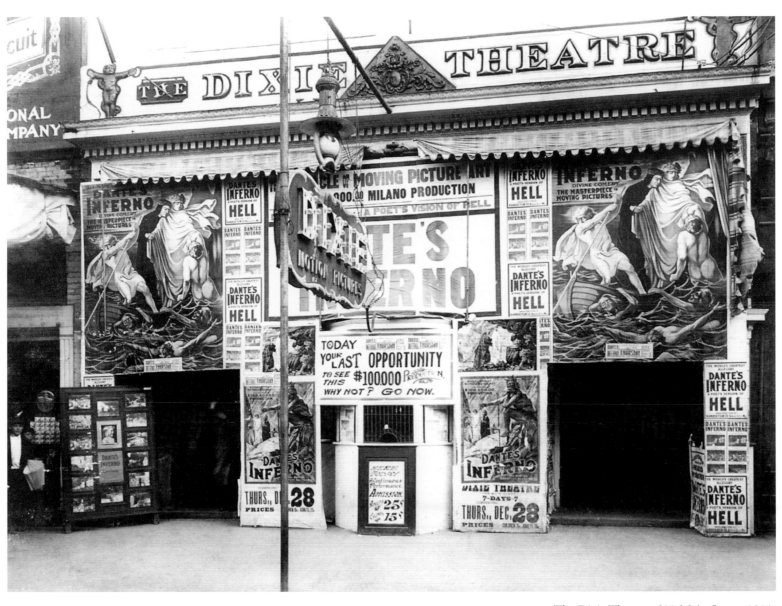

The Dixie Theatre, 603 Main Street, 1911.

American Laundry, 1304 Washington Avenue, 1910.

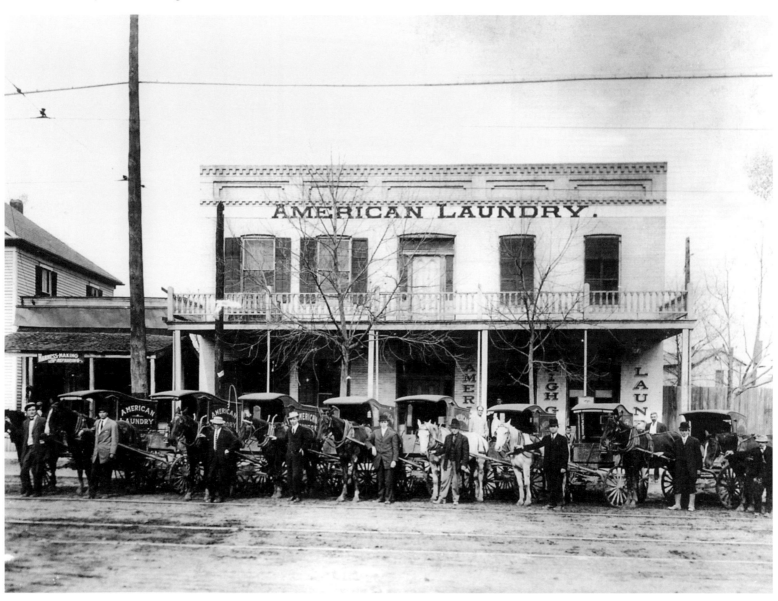

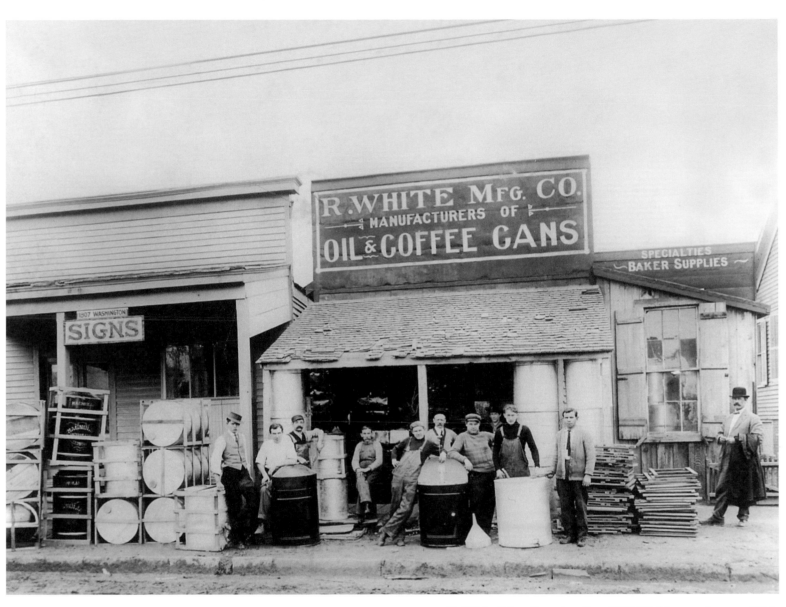

R. White Manufacturing Co., 1809 Washington Avenue, 1910.

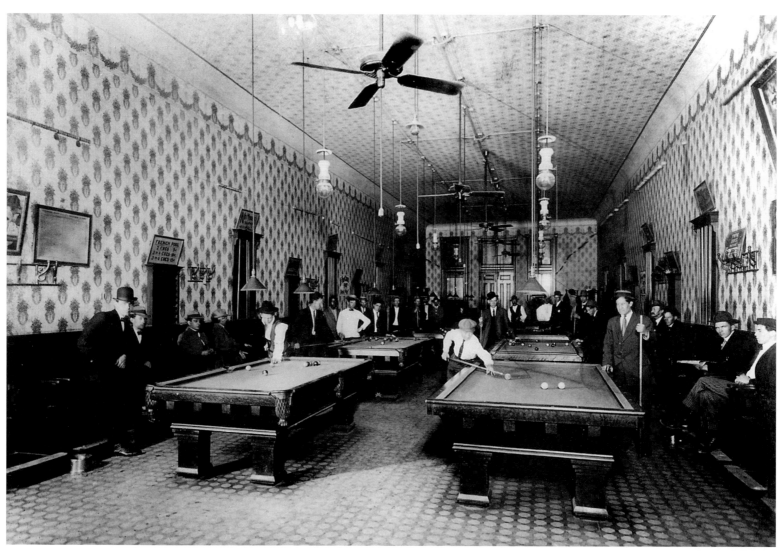

W. Keating Crystal Pool Parlor, 414 Travis Street, 1910. Signs on the wall caution, "If you can't pay, don't play."

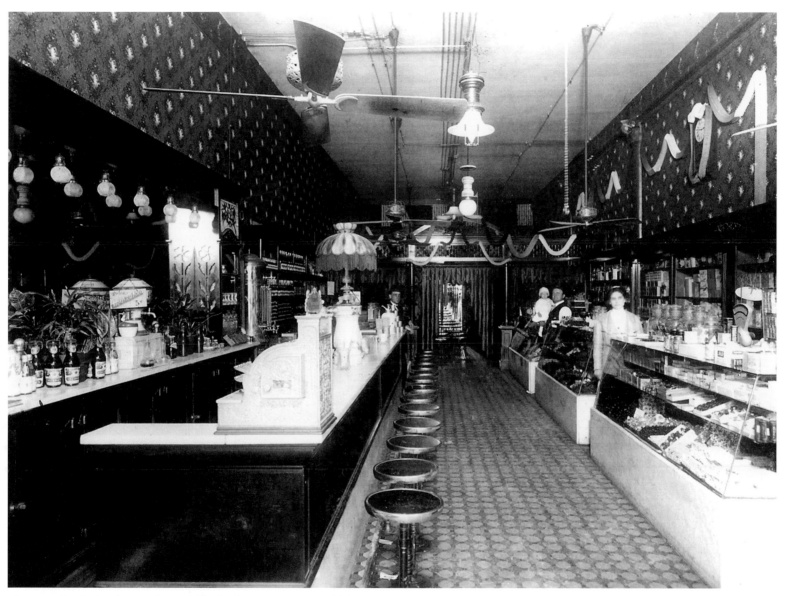

Houston Candy Kitchen in the 700 block of Main, 1911. It sold fine
French candies and advertised that it was one of the most up-to-date ice
cream parlors in Texas.

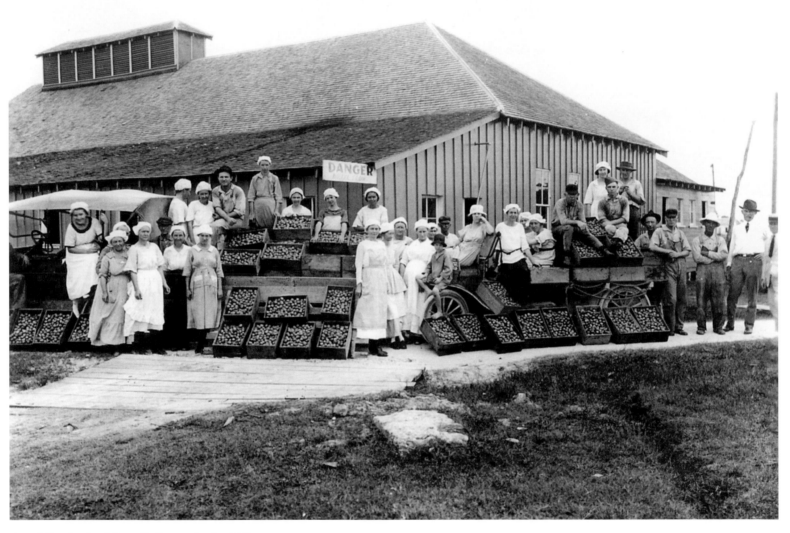

Boxed figs destined for a fig factory in the Aldine area.

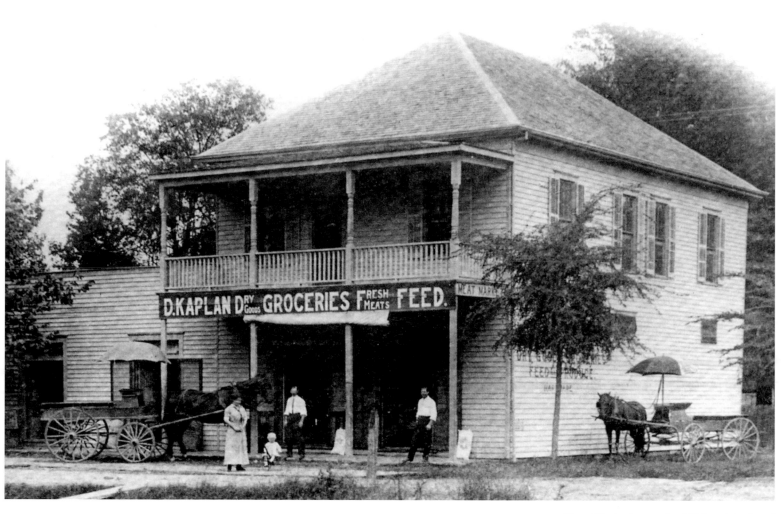

Dave Kaplan's store in 1912 at 22nd and
Yale, where its successor, Kaplan's-Ben Hur, operated
until 2005.

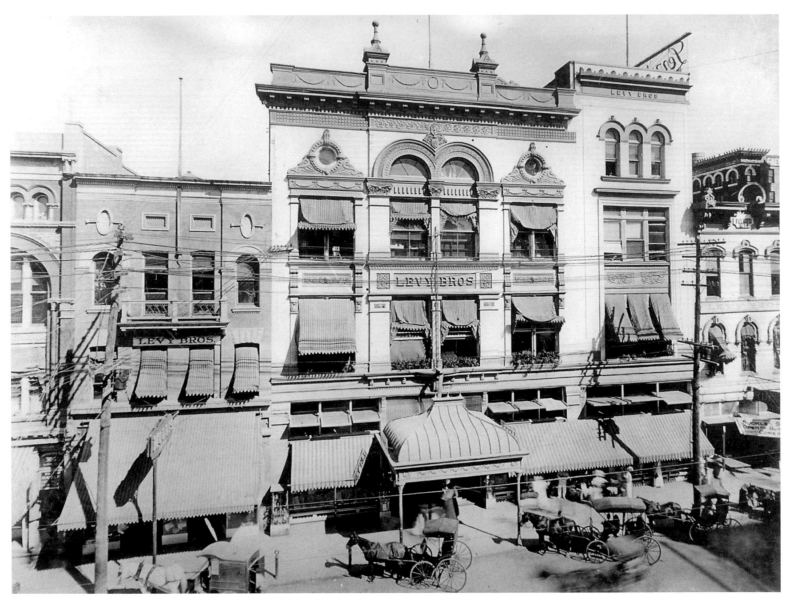

Levy Bros. Dry Goods, founded in 1887 and pictured here in 1911.

Office and hospital of Drs. Burkey and Burkey, veterinary surgeons, 1910.

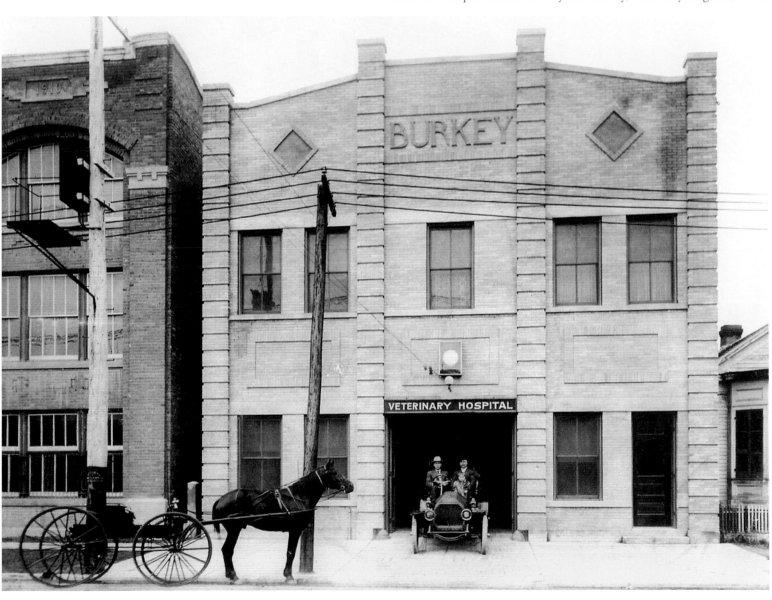

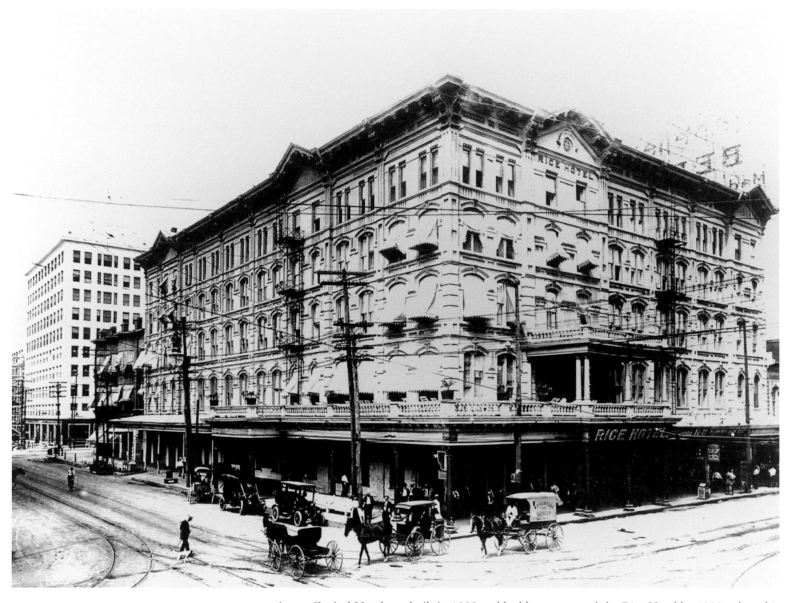

A new Capitol Hotel was built in 1882 and had been renamed the Rice Hotel by 1909, when this photo was made. The hotel bar had some of the first electric lights in the city.

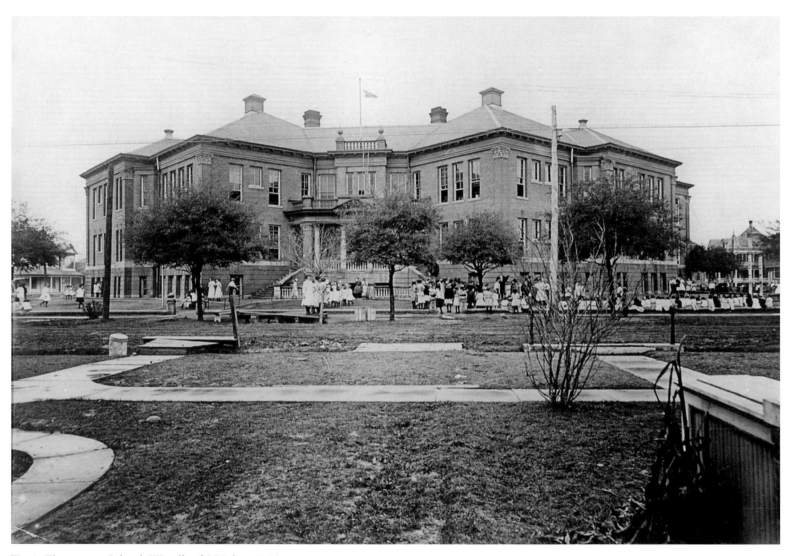

Travis Elementary School, Woodland Heights, 1909.

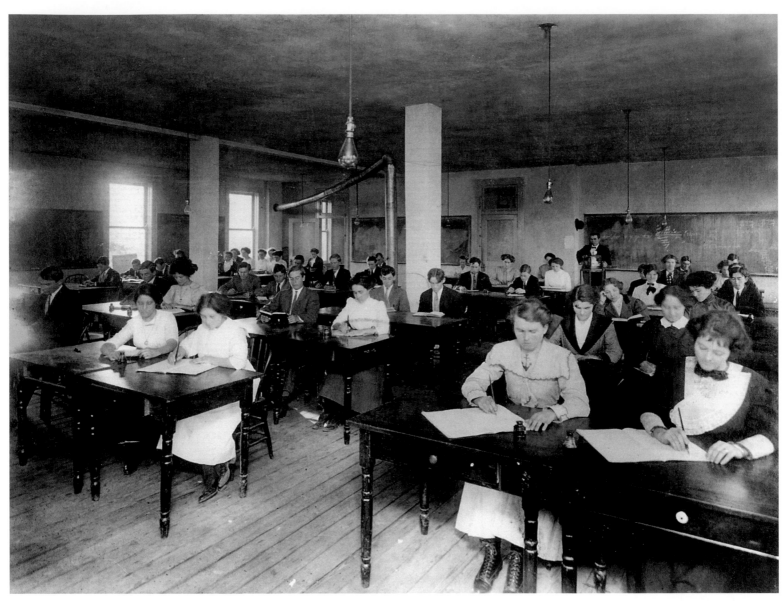

Students in the Commercial Department of Draughon's Practical
Business College, 1910.

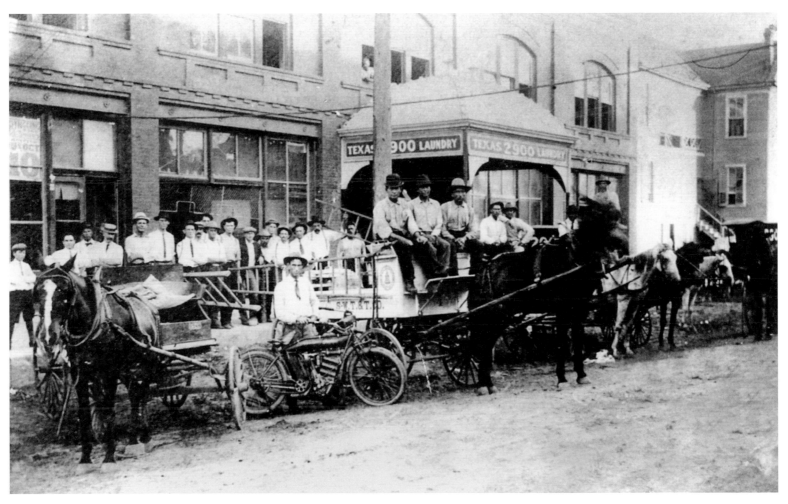

Telephone company employees showing off their new motorcycle, ca. 1910.

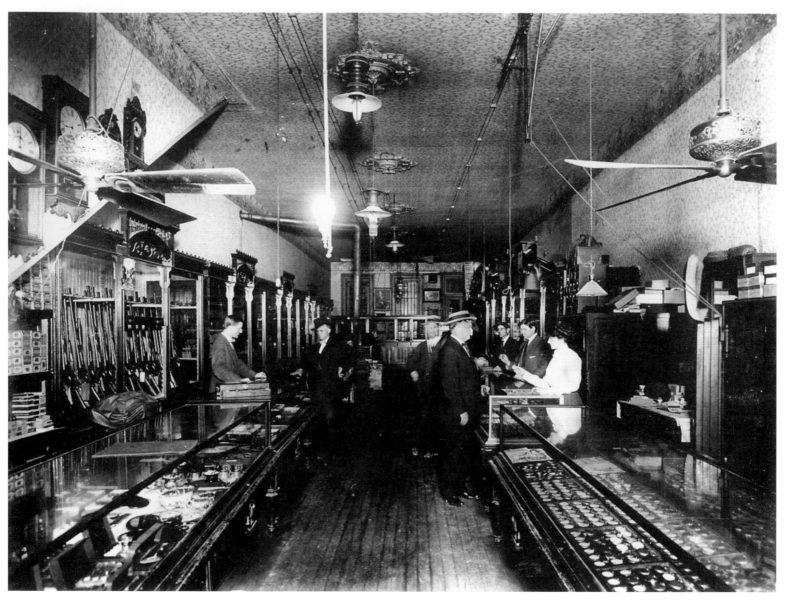

Sweeney Loan Company, 310 Main Street, 1910. The business sold fine watches and diamonds, but also advertised as a pawnbroker.

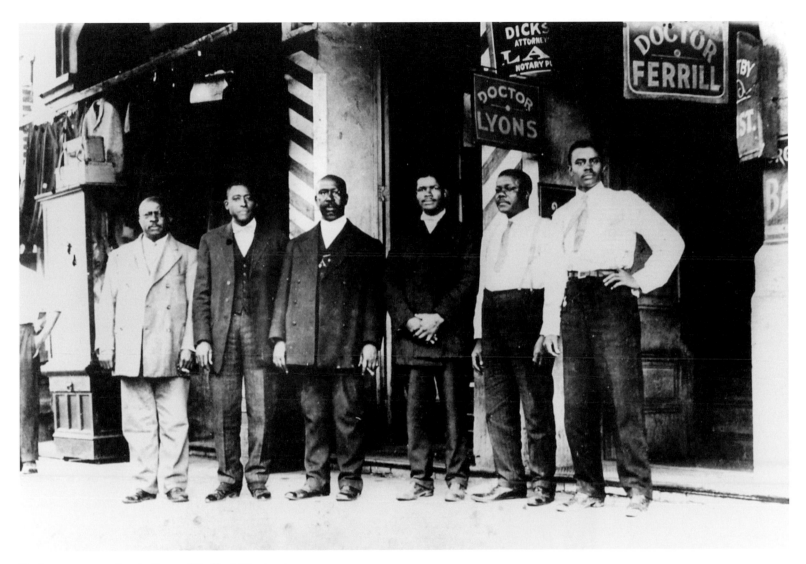

Businessmen standing in front of Stafford Harrison's
barbershop, 409 Milam, 1910.

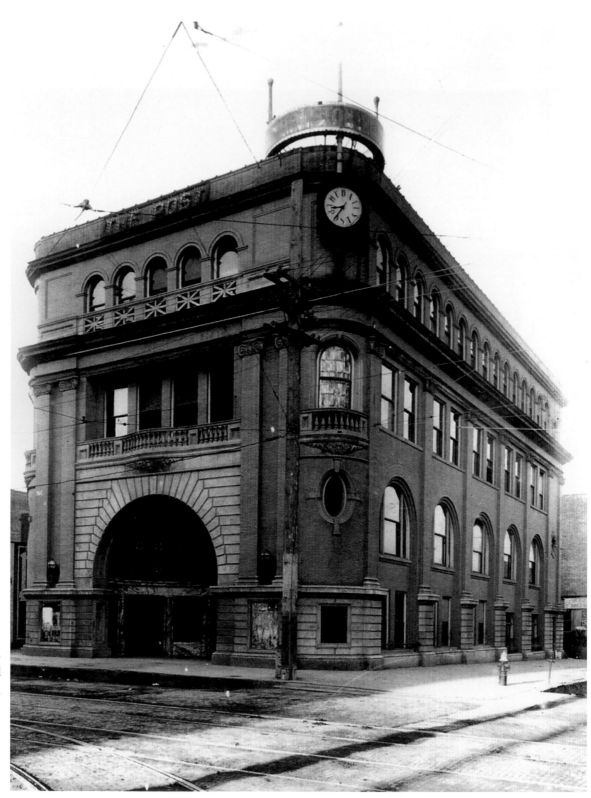

The Houston Post Building, 1910.
The newspaper was published
from 1885 until 1995.

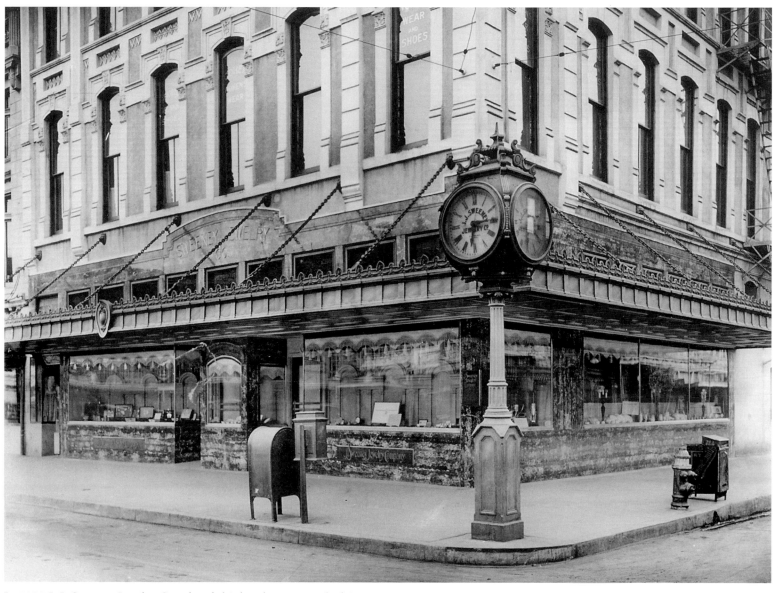

In 1908 J. J. Sweeney Jewelry Co. placed this handsome post clock in
front of its store at 409 Main Street. It resides today on a special plaza at
the intersection of Capitol and Bagby.

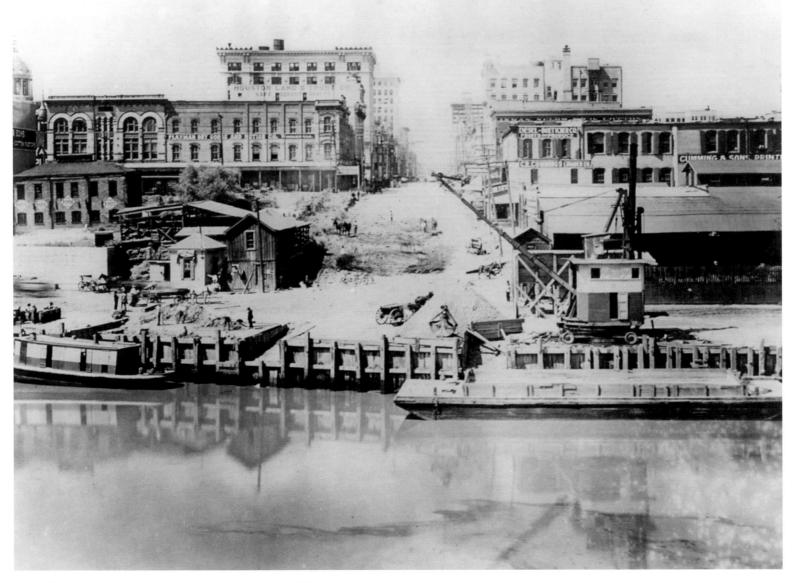

Foot of Main Street, shown here in 1910, was the site of the
Port of Houston docks from 1841 until the present Turning
Basin opened in 1908.

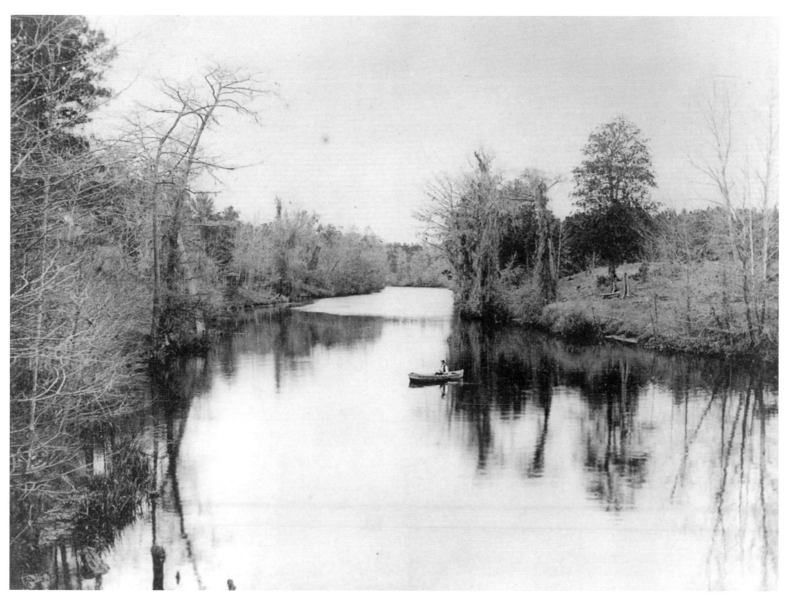

A lone boater floating downstream on Buffalo Bayou near the location of the Turning Basin, ca. 1912.

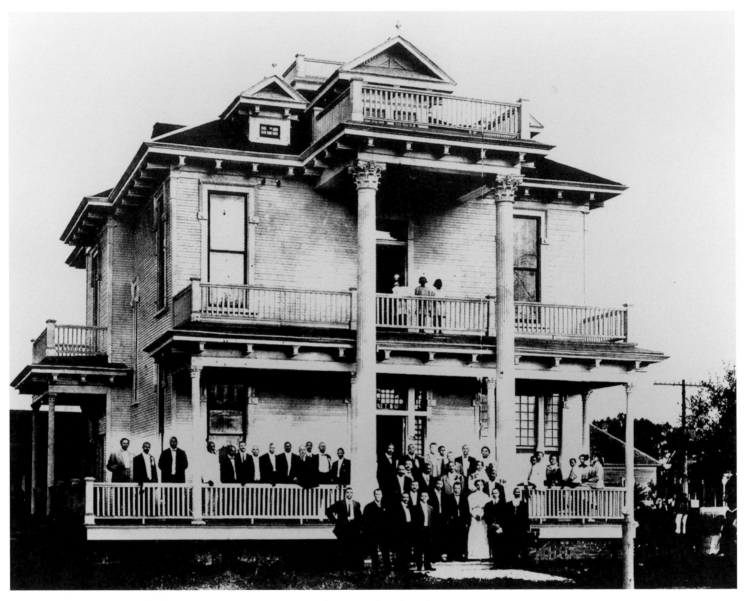

Guests attending a dinner held at the Benjamin J. Covington home on Dowling Street to honor Booker T. Washington, who visited Houston to encourage organizing a library in the African American community, 1911.

Harris County Courthouse, the fifth building to occupy Courthouse Square, was dedicated on March 2, 1911.

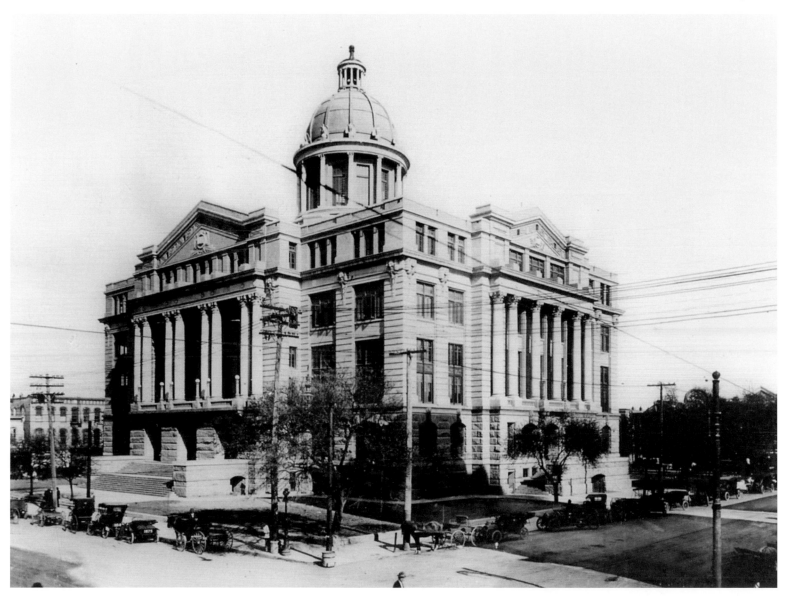

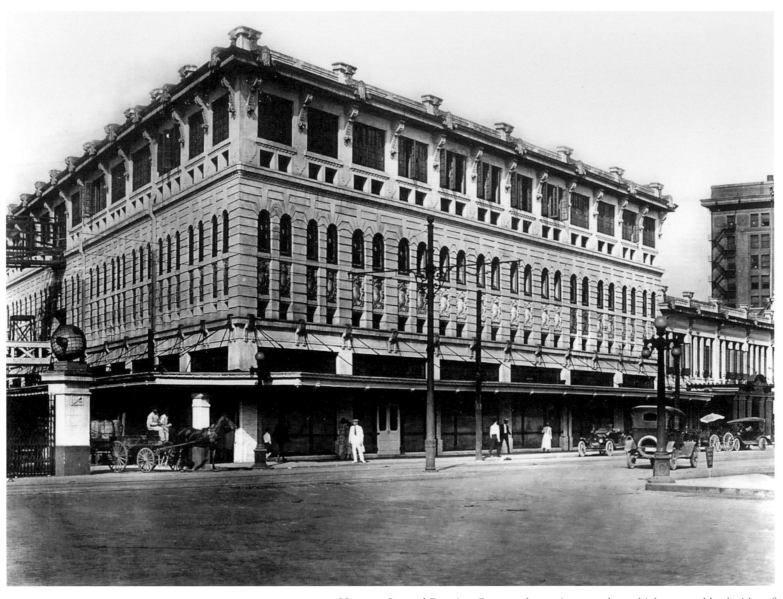

Houston Ice and Brewing Company's massive complex, which spanned both sides of Buffalo Bayou, 1912. The small building on the right, its only surviving structure, has been designated a Protected Landmark by the City of Houston.

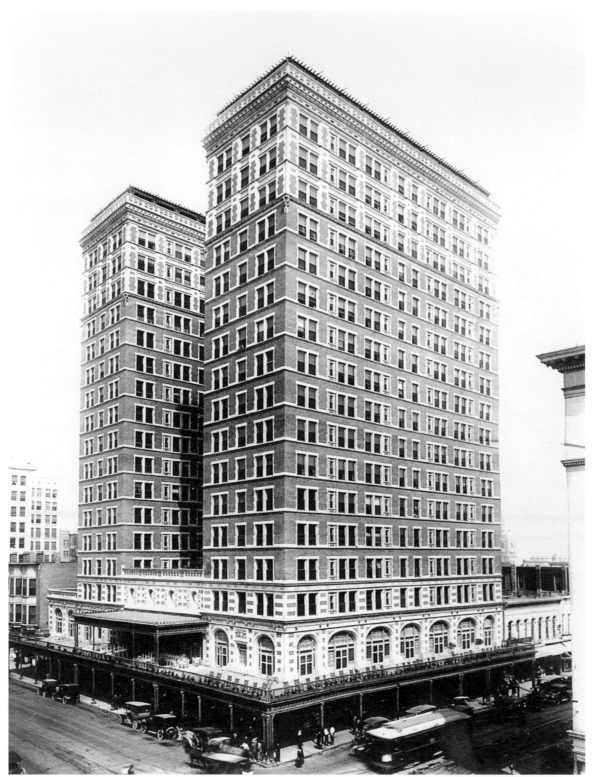

Jesse H. Jones built a new seventeen-story Rice Hotel, which opened on May 17, 1913. The building now houses residential lofts.

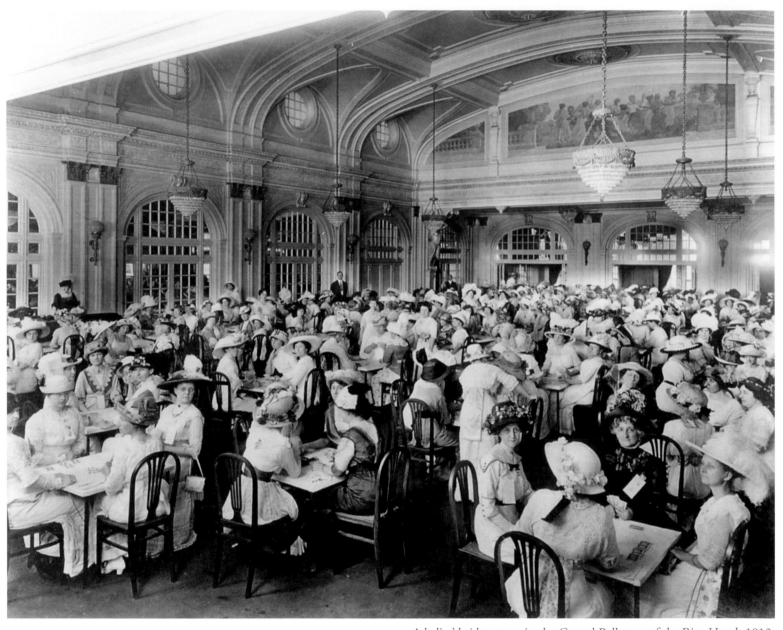

A ladies' bridge party in the Crystal Ballroom of the Rice Hotel, 1913.

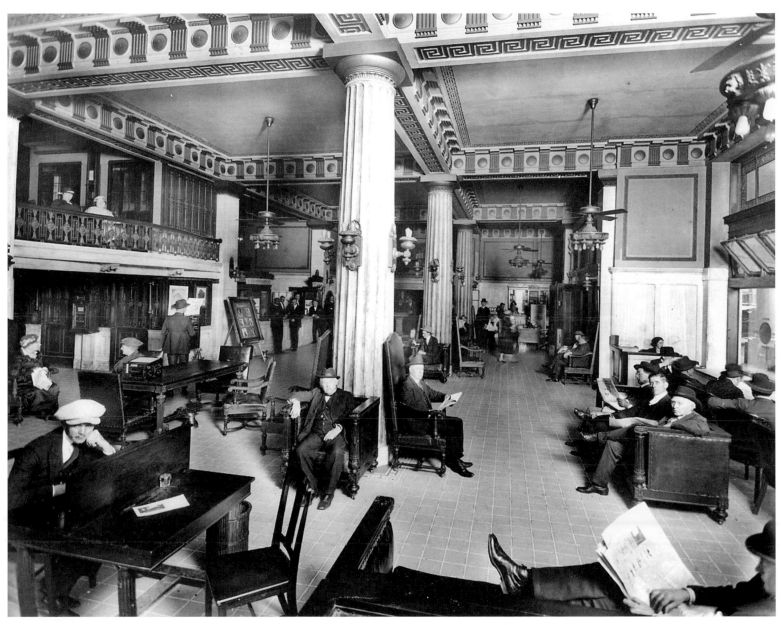

Men relaxing in the Bender Hotel lobby, 1914.

A disastrous fire, fanned by a 38-mile-per-hour wind, destroyed
forty blocks of the Fifth Ward, February 21, 1912.

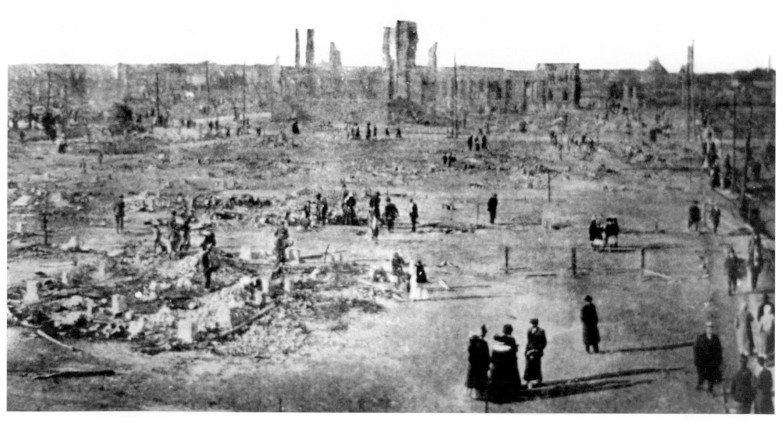

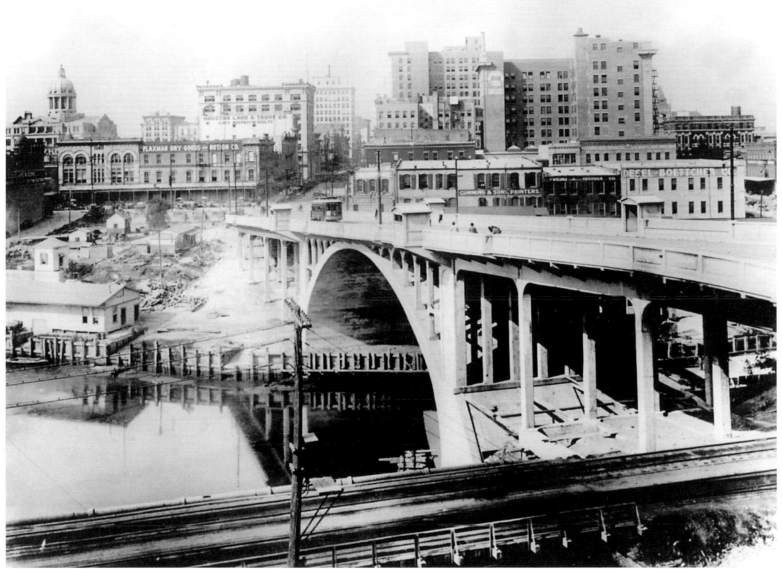

Main Street Viaduct, completed in 1913 to link Main Street
with the north side of Buffalo Bayou, was the longest concrete
span in Texas at the time.

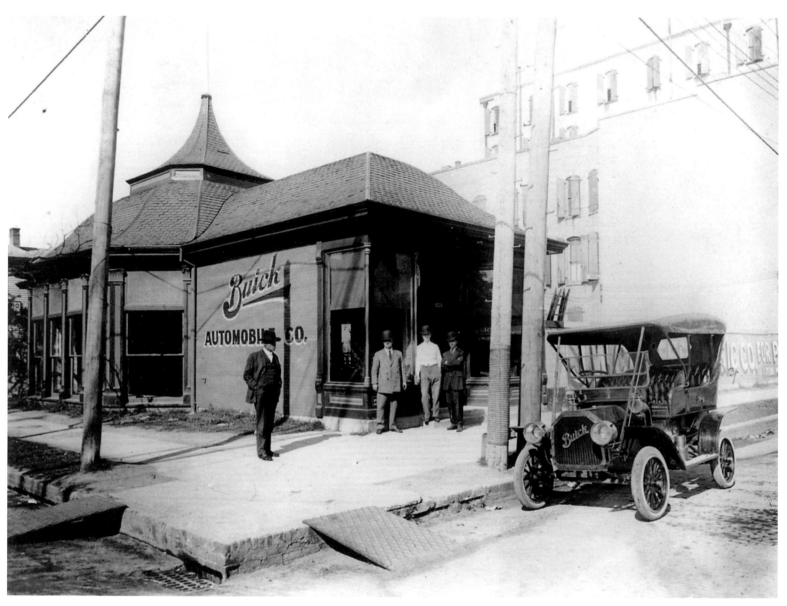

This early automobile dealership was located at 1403 Main Street in 1913
when there were twenty-seven auto companies in the city.

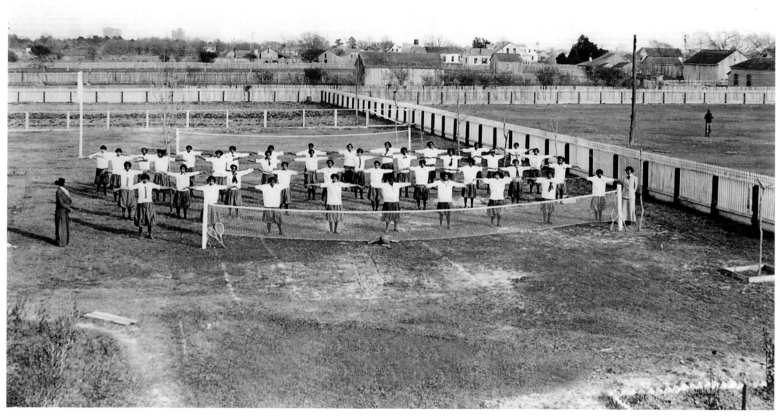

Women's physical education class at Houston College, 1914.

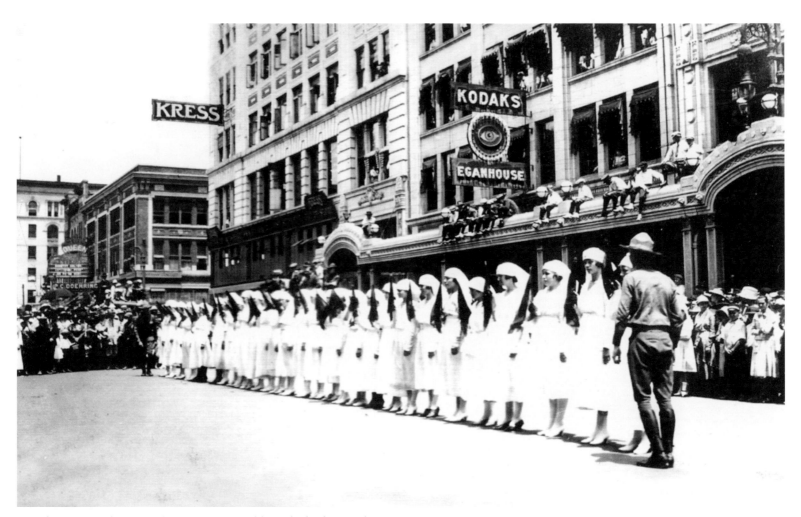

A Red Cross parade, December 16, 1918. Visible in the background are storefronts, among them Kress, a five-and-dime discount chain well known and popular for decades.

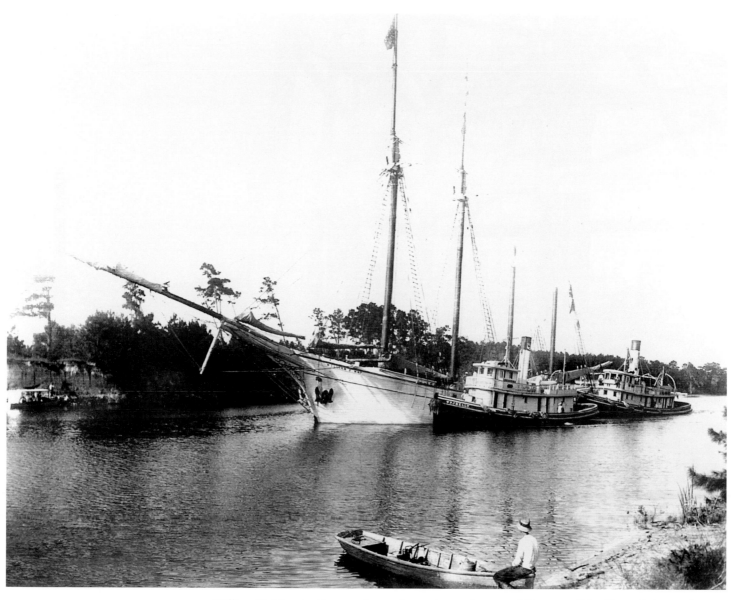

William C. May, the first vessel to arrive at the newly opened Houston Ship Channel, September 26, 1914. The assisting tugboats are the *William J. Kelly* and the *Ima Hogg.*

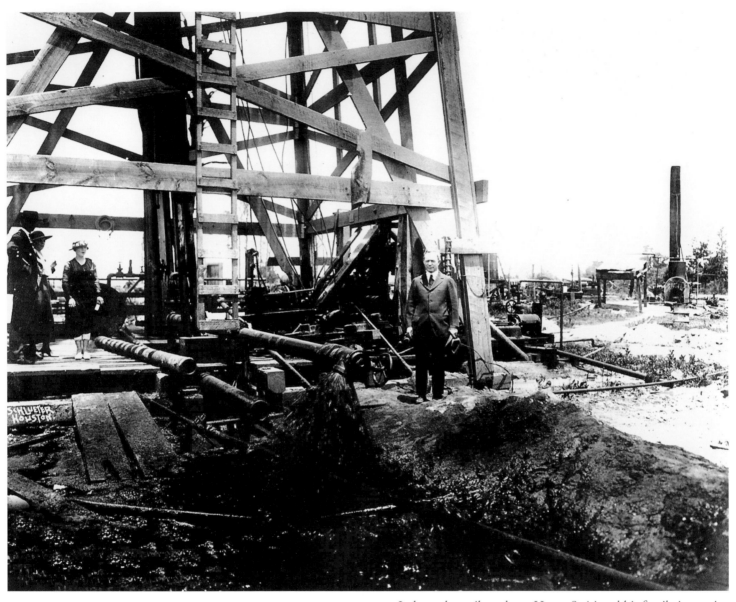

Independent oil producer Henry Staiti and his family inspecting
his latest find in the Humble field, ca. 1915.

Main Street, looking north from Preston
Avenue, 1915.

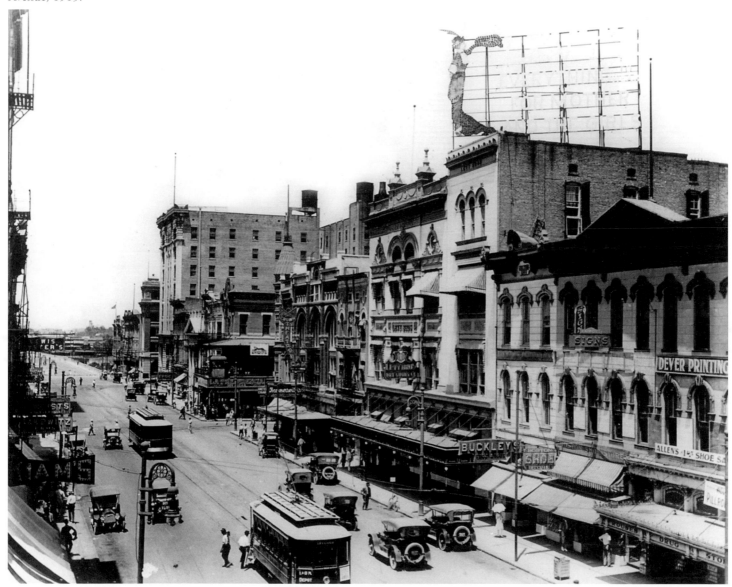

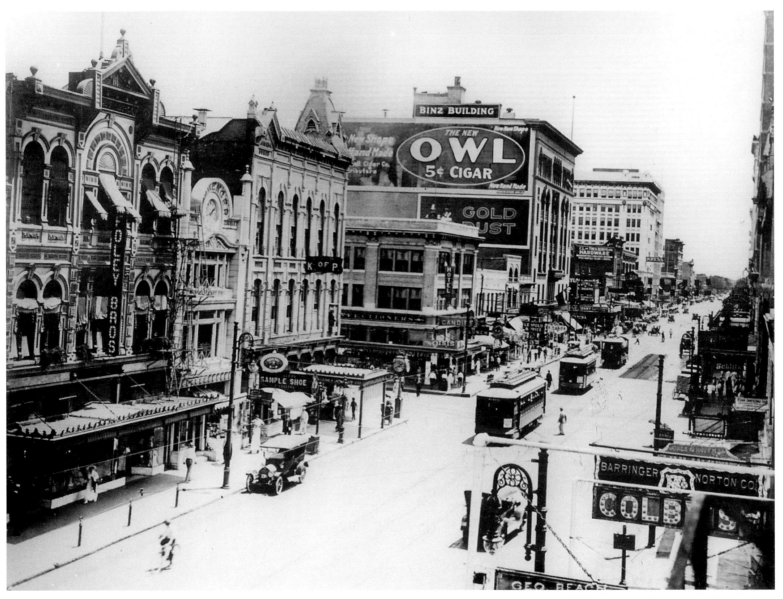

Main Street, looking south from Preston
Avenue, 1915.

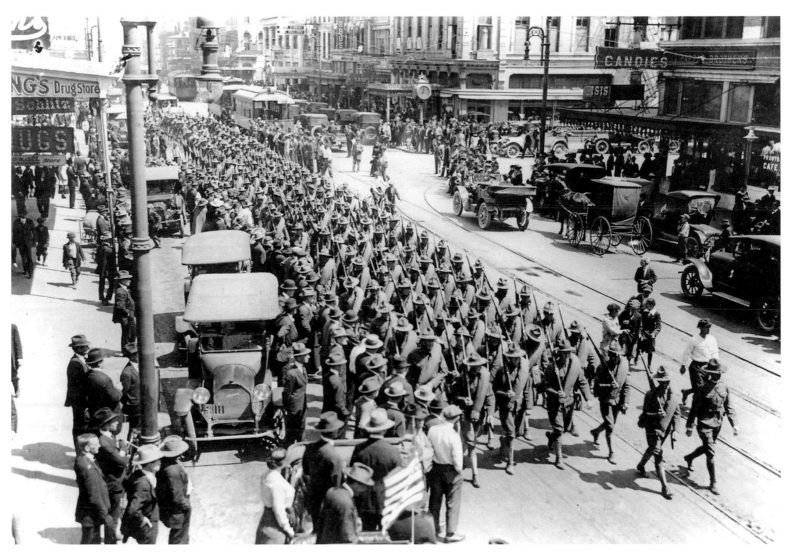

National Guard unit marching down Main Street in a
preparedness parade, 1915.

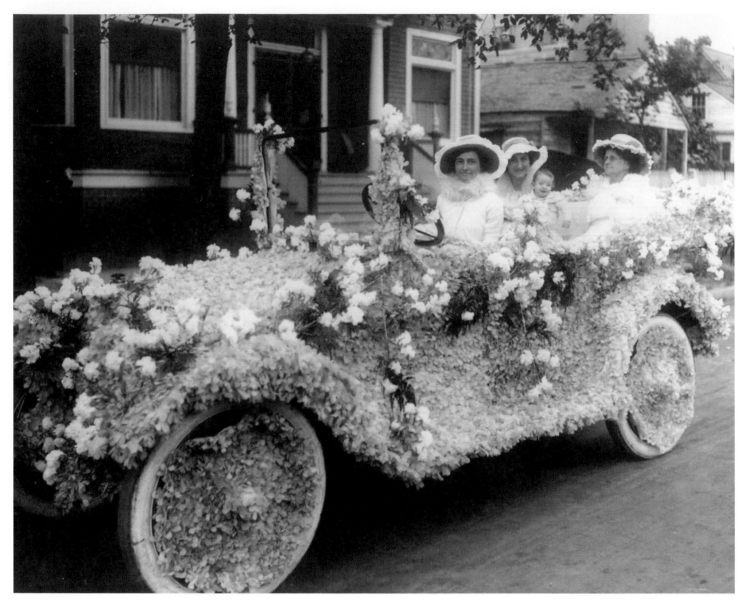

Ferdie Trichelle in her flower-bedecked auto for a Notsuoh Festival parade, ca. 1915. Notsuoh ("Houston" spelled backward) was held annually for almost twenty years to promote the city's commercial advantages.

Photographer Frank Schlueter posing beside his shiny, eight-cylinder automobile in 1916 as he advertised his 25th year in business.

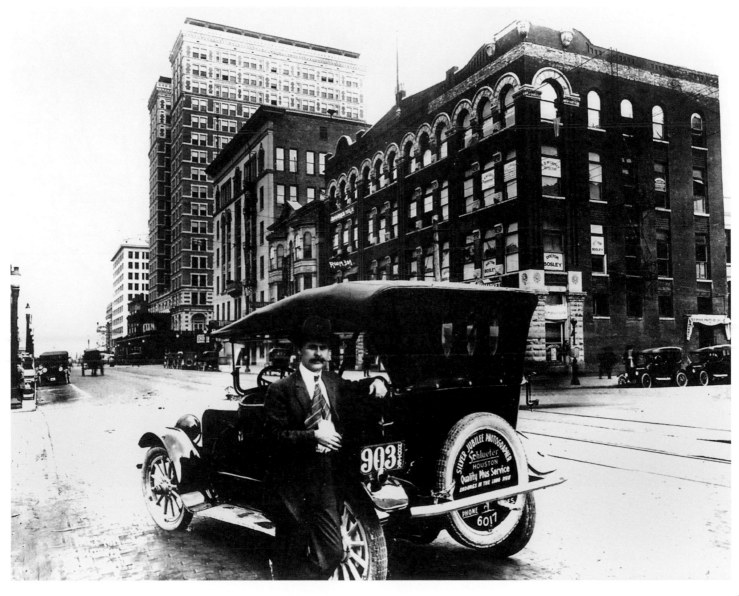

Camp Logan, built on 2,000 acres of land just west of the city limits, served as a training camp for U.S. soldiers during World War I. The property later became Memorial Park, named in honor of those soldiers.

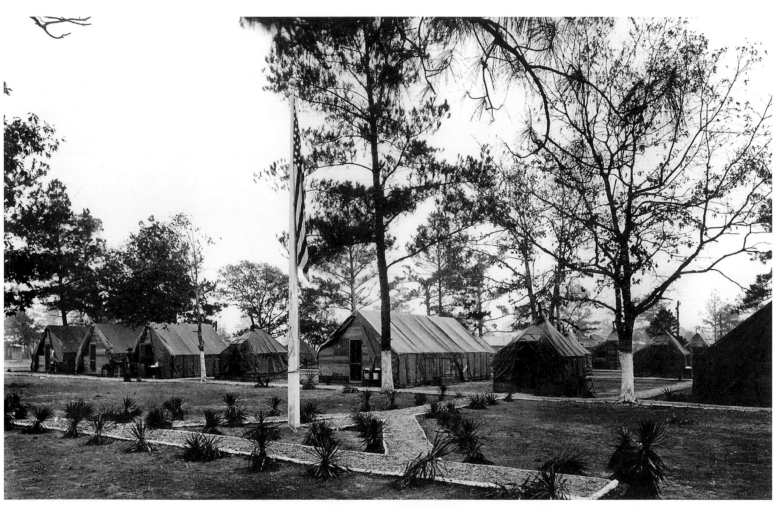

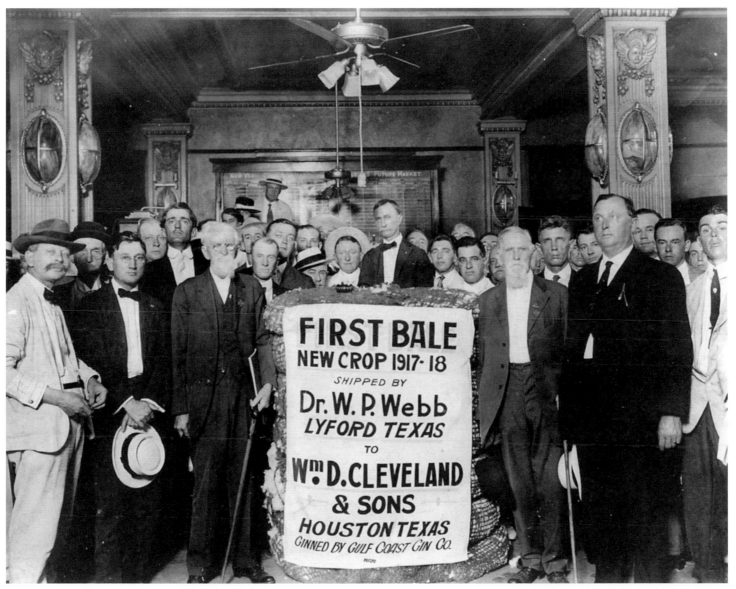

Awards were given to Texas cotton farmers who shipped
the first bale of cotton to Houston each year.

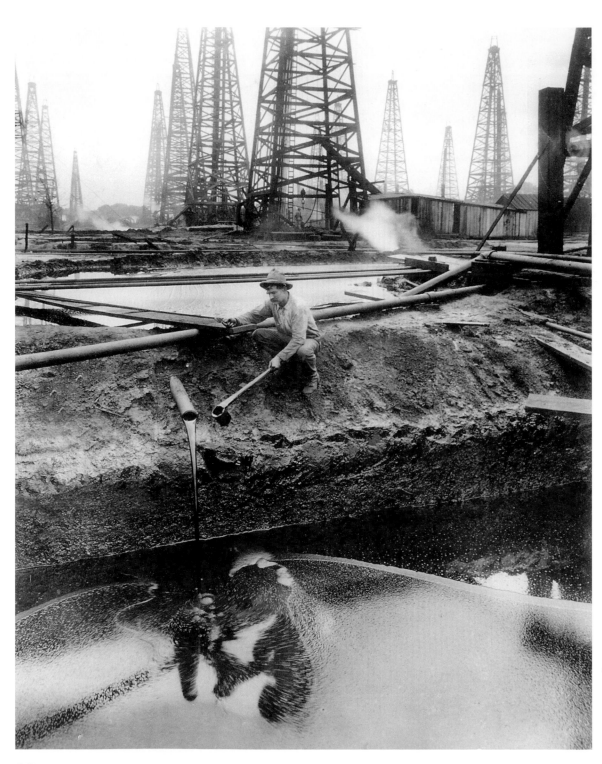

West Columbia oil field, 1919.

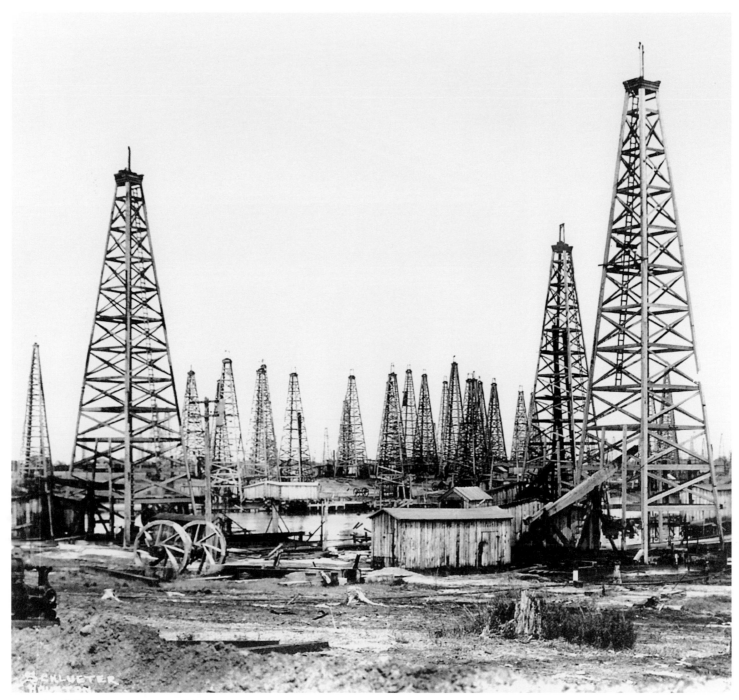

Derricks of the Pierce Junction oil field as seen
from downtown Houston, 1918.

The largest single blocks of marble in Texas were used when South Texas Commercial National Bank was built at 215 Main Street.

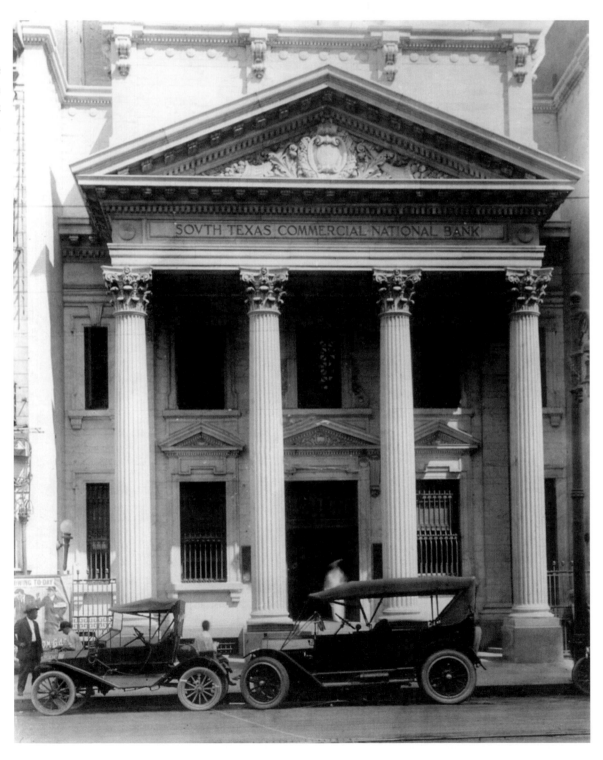

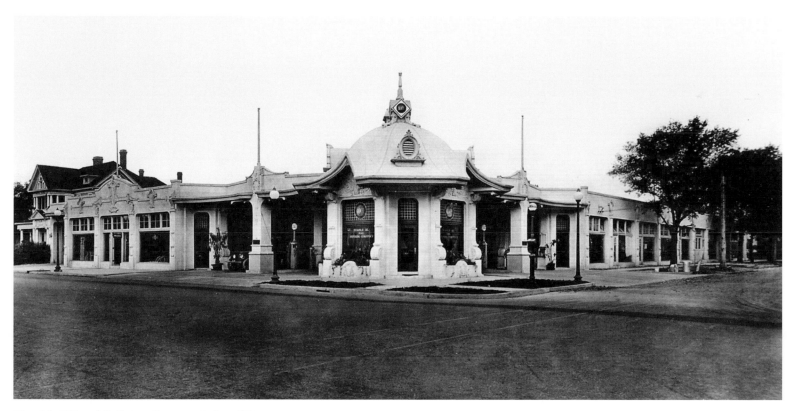

Humble Oil and Refining Company's first filling
station at Main and Jefferson, 1919. Designed by
Alfred Finn, it boasted elegant features such as mosaic
tiles and art glass.

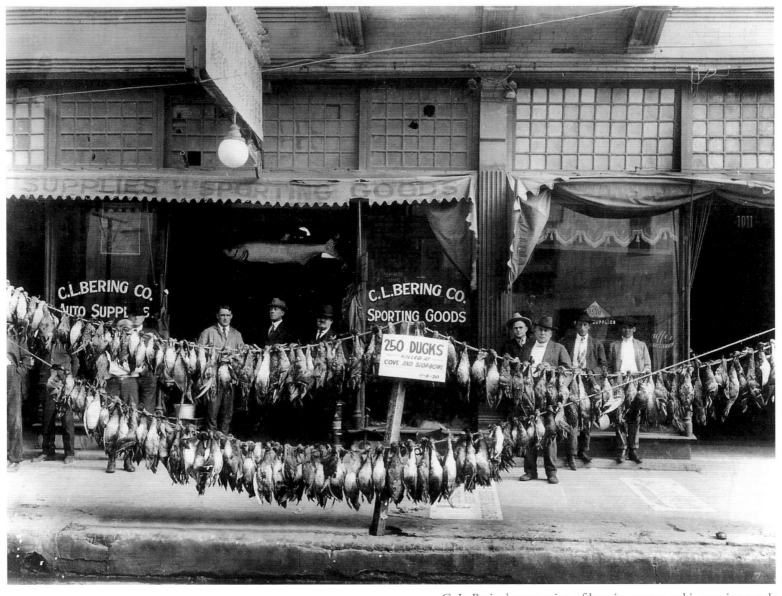

C. L. Bering's promotion of hunting season at his sporting goods store, November 6, 1920.

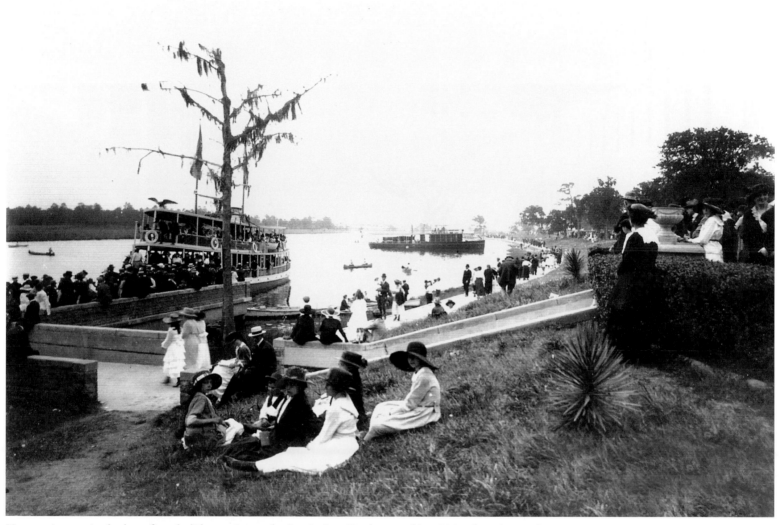

Houstonians arrive by boat for a holiday outing at the San Jacinto Battleground in 1920, where in 1836
General Sam Houston defeated Santa Anna's Mexican forces to pave the way for the Republic of Texas and later
entry of Texas into the union as the 28th state.

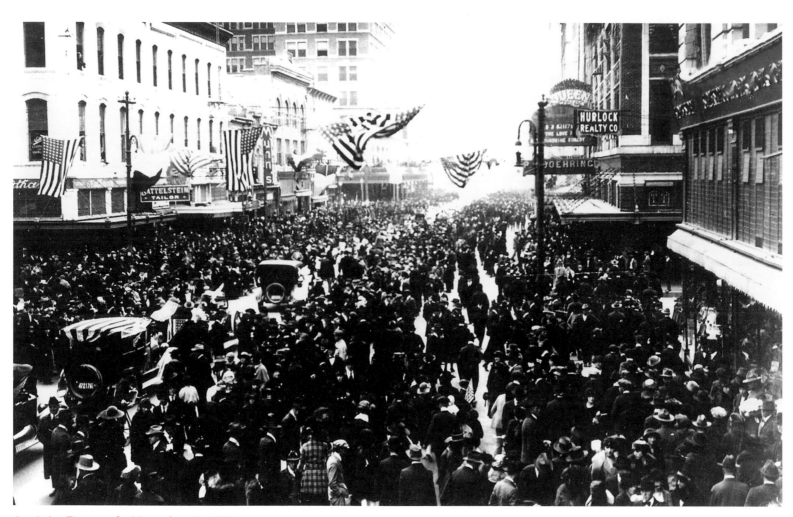

Armistice Day parade, November 11, 1920.

A City on the Move

1921–1939

The 1920s were years of explosive growth for Houston. By the end of the decade, Houston was the largest city in Texas with a population approaching 300,000. It also doubled in area, covering 68 square miles.

This growth was expressed in many ways. Construction was at an all-time high. New residential pockets sprang up on the prairie encircling the city while the central business district, too, acquired a new face. Banks built impressive structures to house their operations. Modern hotels appeared on the scene to accommodate permanent residents as well as travelers. Elaborate movie palaces were created for fans of the silver screen.

As the city expanded, traffic became a serious problem. By 1922 the city claimed 35,000 gasoline-powered vehicles and 90 miles of streetcar track. Houstonians could even make a speedy trip to Galveston and back on the Interurban streetcar. The installation of electric signals improved the situation, but traffic jams were everyday occurrences.

Houston received its first widespread publicity in 1928 when it hosted the national Democratic convention. Delegates endured the hot, humid weather—many in wool suits—as they discovered an interesting city that offered many recreational diversions: a race track, an amusement park with a roller coaster, performances at an outdoor theater, semi-professional baseball games, and numerous musical attractions.

Work continued on expanding the Houston Ship Channel. After its depth was increased to 32 feet, the volume of goods passing through the city greatly increased. The greatest advancement in the eyes of most residents, however, was the advent of air conditioning. This invention made life more bearable in Houston's climate even though years would pass before the convenience was widespread.

Considerable progress was made, too, in educational circles. Two junior colleges offered classes at night for working people. They soon expanded their efforts, resulting in the establishment of the University of Houston and Texas Southern University as four-year colleges.

Although times were hard during the Depression, the city survived without any bank failures. Funds dispensed through the federal government assisted in building a new City Hall, a county hospital, the Coliseum and Music Hall, and several schools. To commemorate the Texas Centennial in 1936, a monument was built at the San Jacinto Battleground. This created a historic landmark and recognized the year that gave birth to both Texas and Houston.

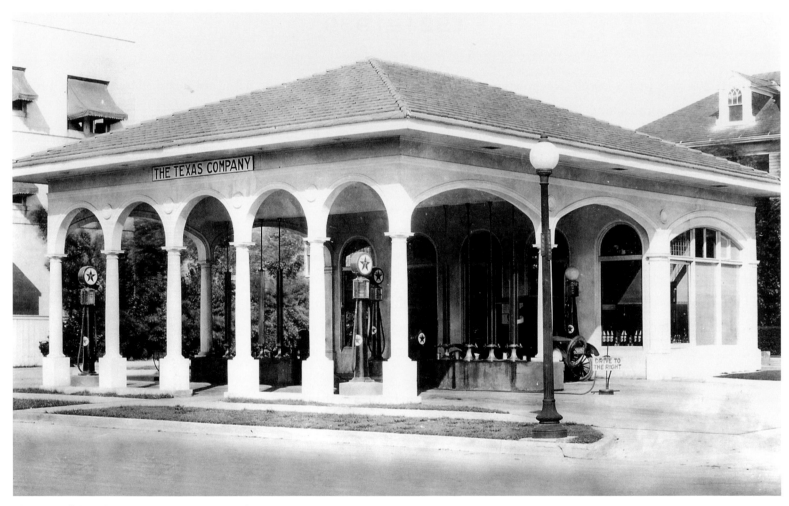

Texas Co. (Texaco) station, Main at Bremond, 1922.

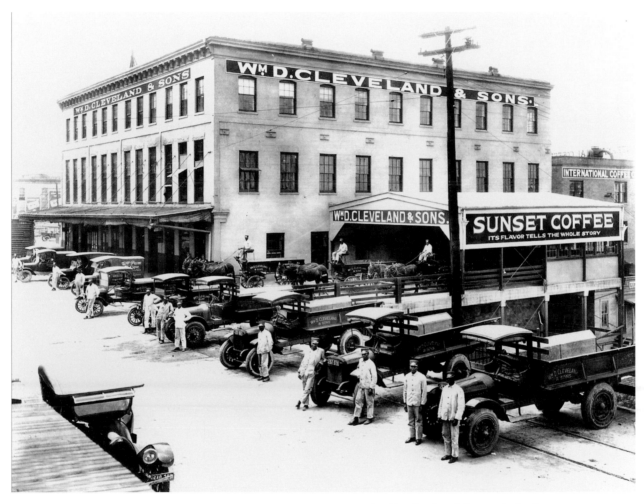

W. D. Cleveland and Sons, wholesale grocery company
on Commerce near Buffalo Bayou.

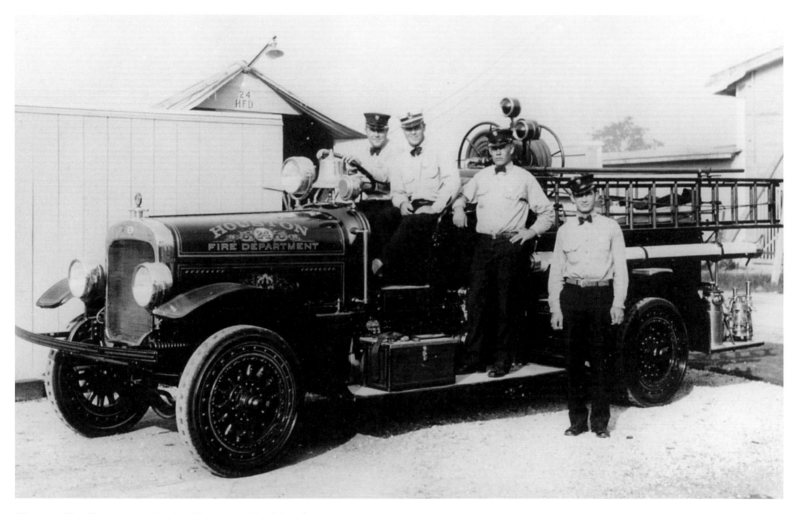

Houston Fire Department Engine Company No. 24 and
its tent station, 1924.

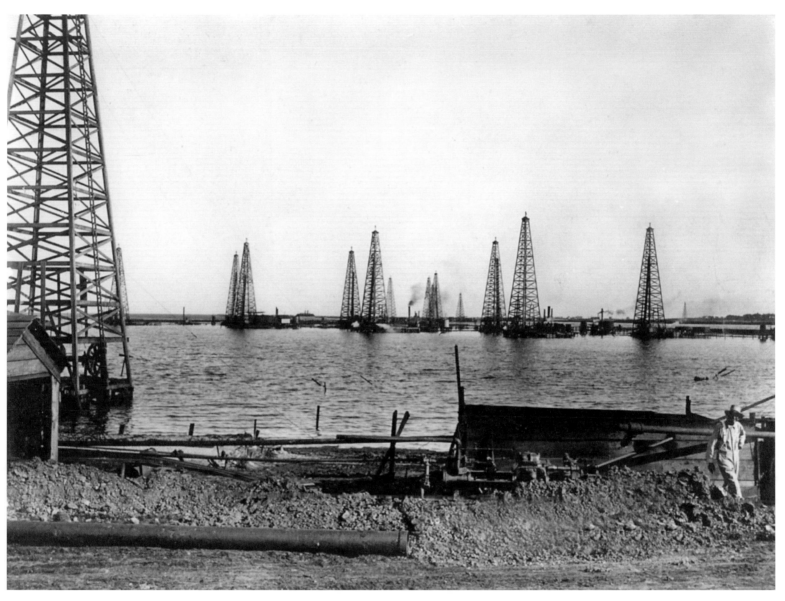

Goose Creek oil field, site of the first offshore drilling along the
Gulf Coast, 1923.

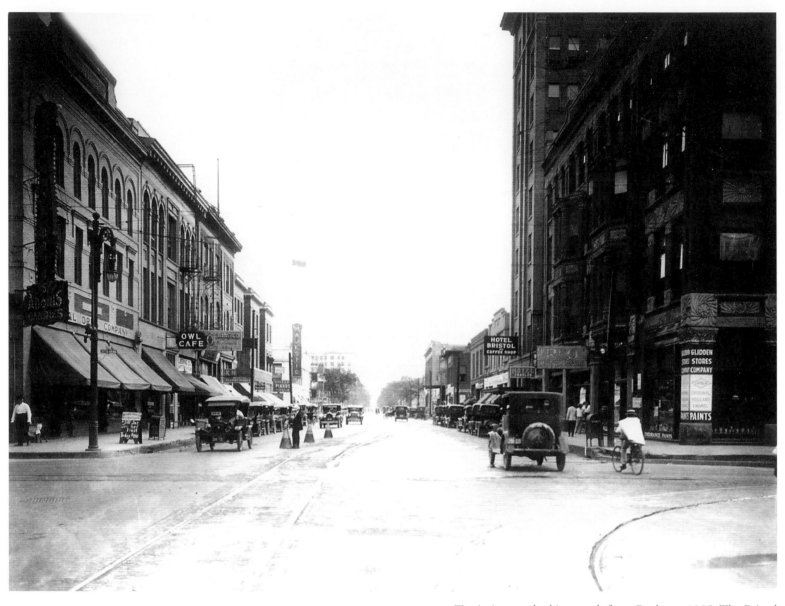

Travis Avenue, looking north from Rusk, ca. 1925. The Bristol Hotel, built in 1908 as Houston's first deluxe hotel, had the first roof garden in Texas.

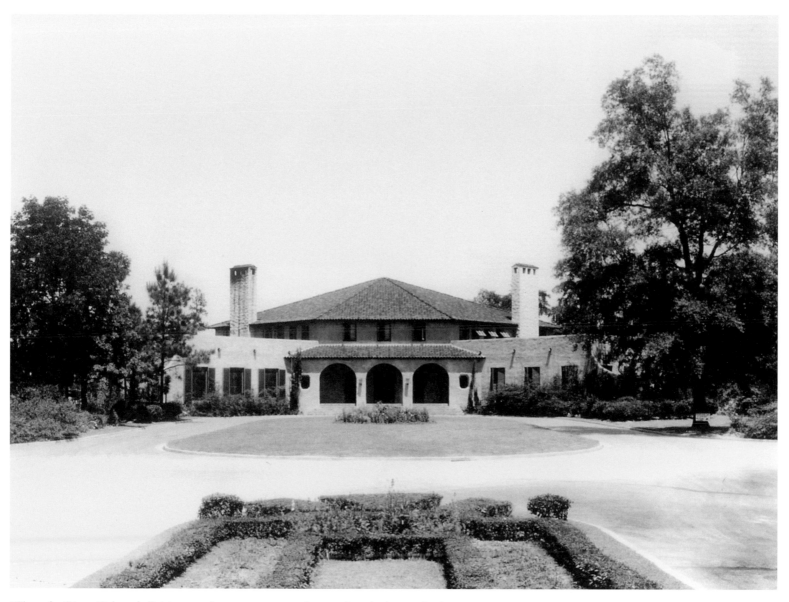

When the River Oaks subdivision was begun, everyone who purchased a lot received membership in the River Oaks Country Club. This 1924 building, designed by John Staub, was replaced with the present one in 1969.

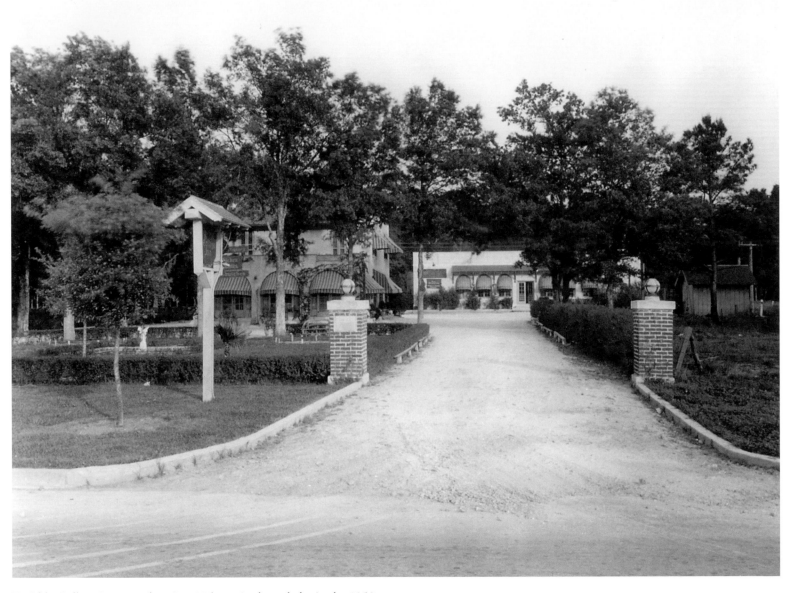

Ye Olde College Inn, seen here in 1924, received accolades in the 1950s as "one of the 20 greatest restaurants of the world."

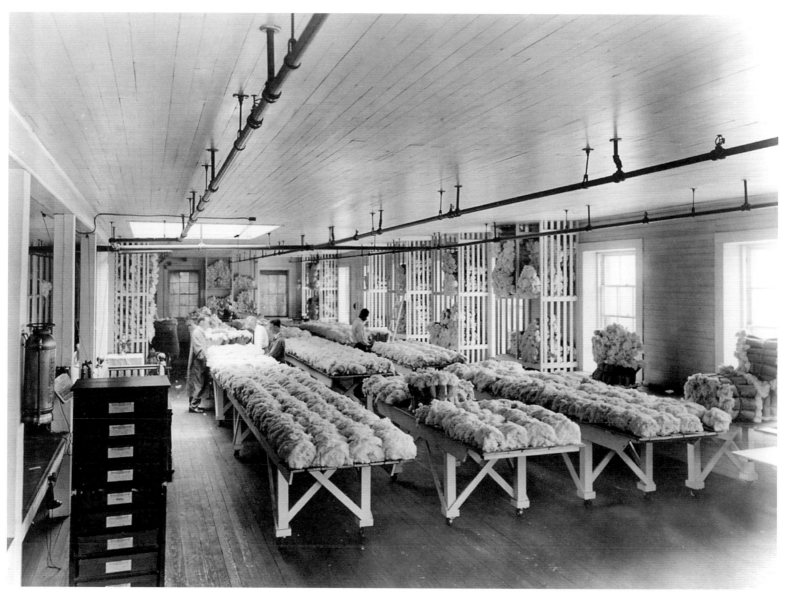

Cotton examiners determining the grade of cotton in the new
Cotton Exchange Building on Prairie Avenue, 1924.

The Houston Electric Company promoting its services by inviting Houstonians to
step on board and inspect a new streetcar, September 4-5, 1924.

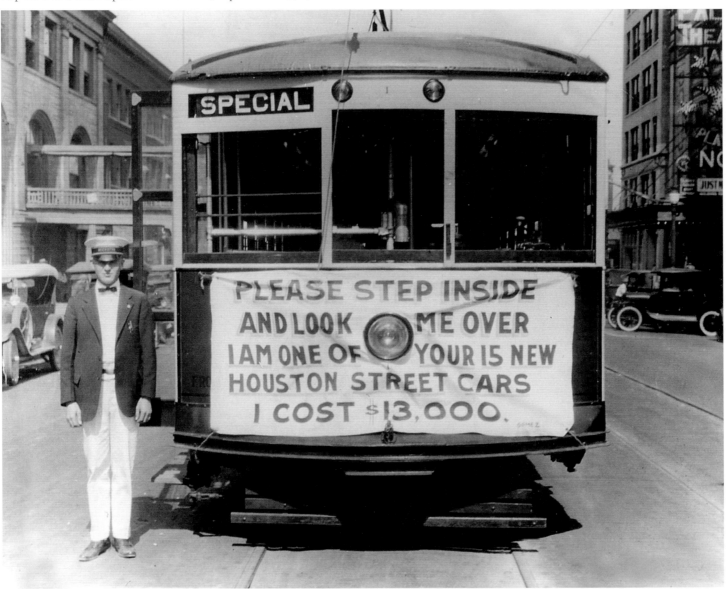

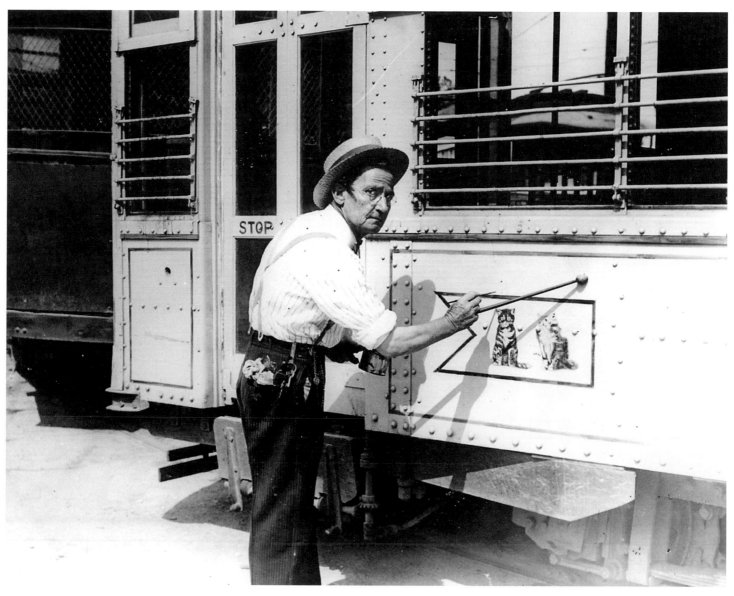

A sign painter personalizing a streetcar, possibly with a
local high school mascot.

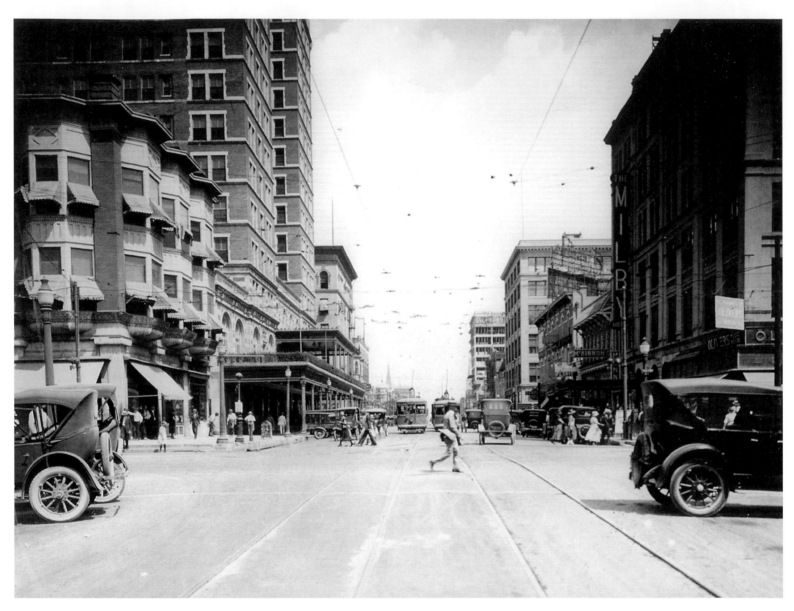

Texas Avenue, looking east from Travis, early 1920s. Texas Avenue was lined with hotels, including the Rice and the Milby seen here.

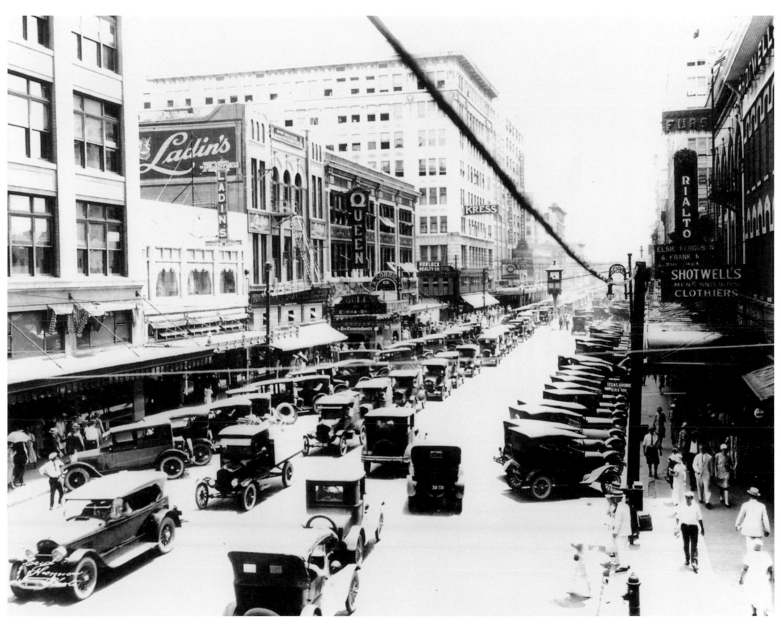

Main Street, ca. 1925. Note the traffic control tower in the distance where a policeman sat and flipped switches to control the lights at several intersections.

Travis Street, looking north from Texas Avenue, mid 1920s. The building on the right is the Rice Hotel Annex, which was demolished soon thereafter to build the hotel's third wing.

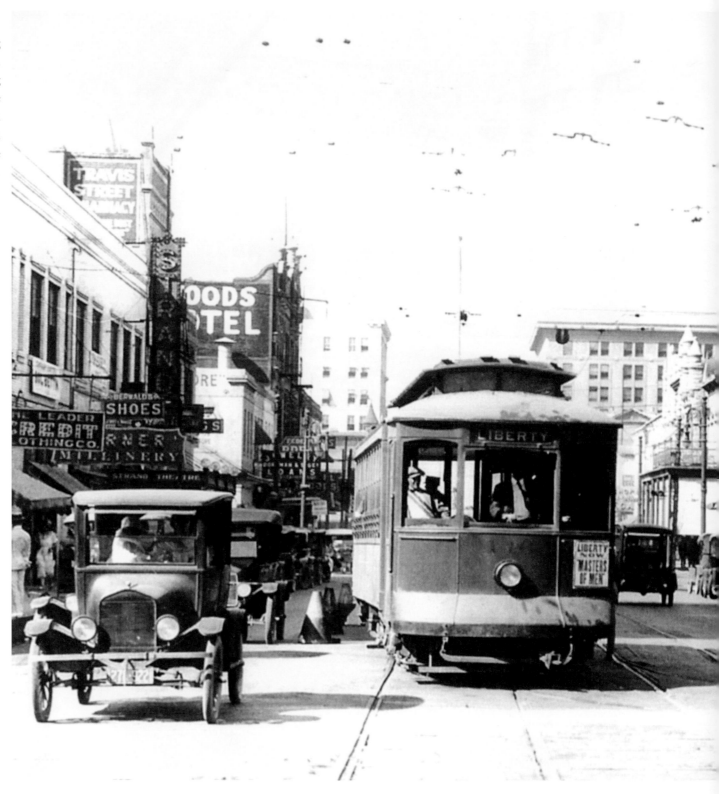

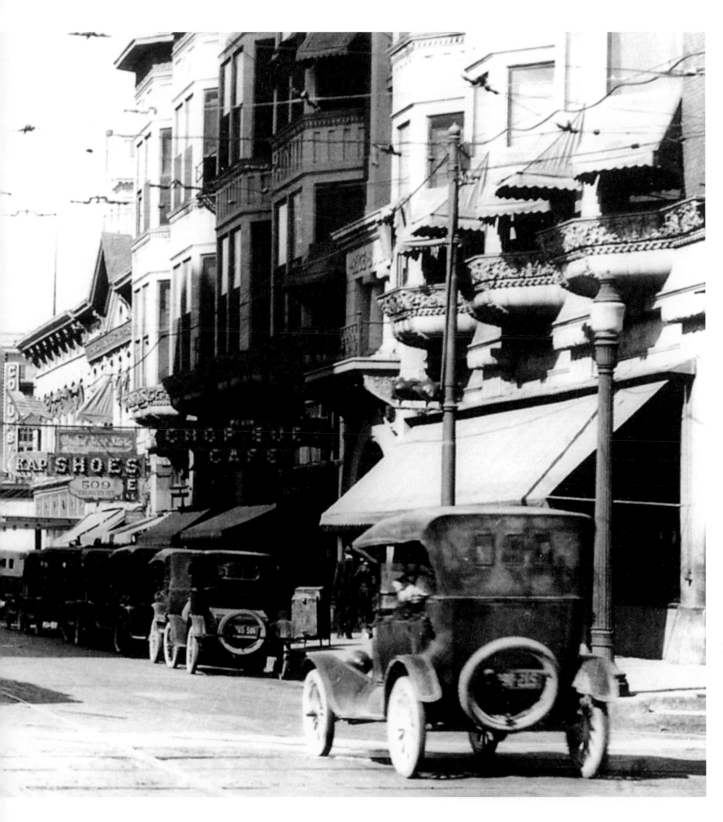

Following Spread:
Automotive event
promoting the Ruckstell
Axle, January 14,
1925. The Houston
Public Library and First
Presbyterian Church
can be seen in the
background.

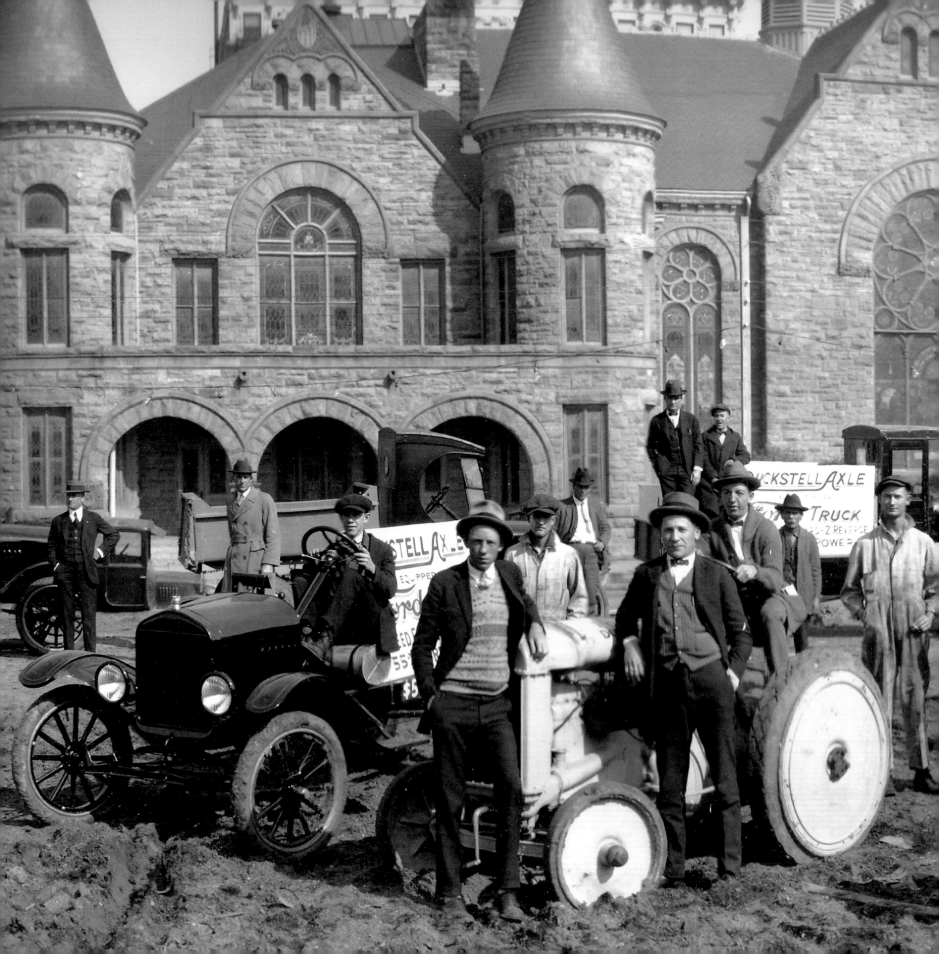

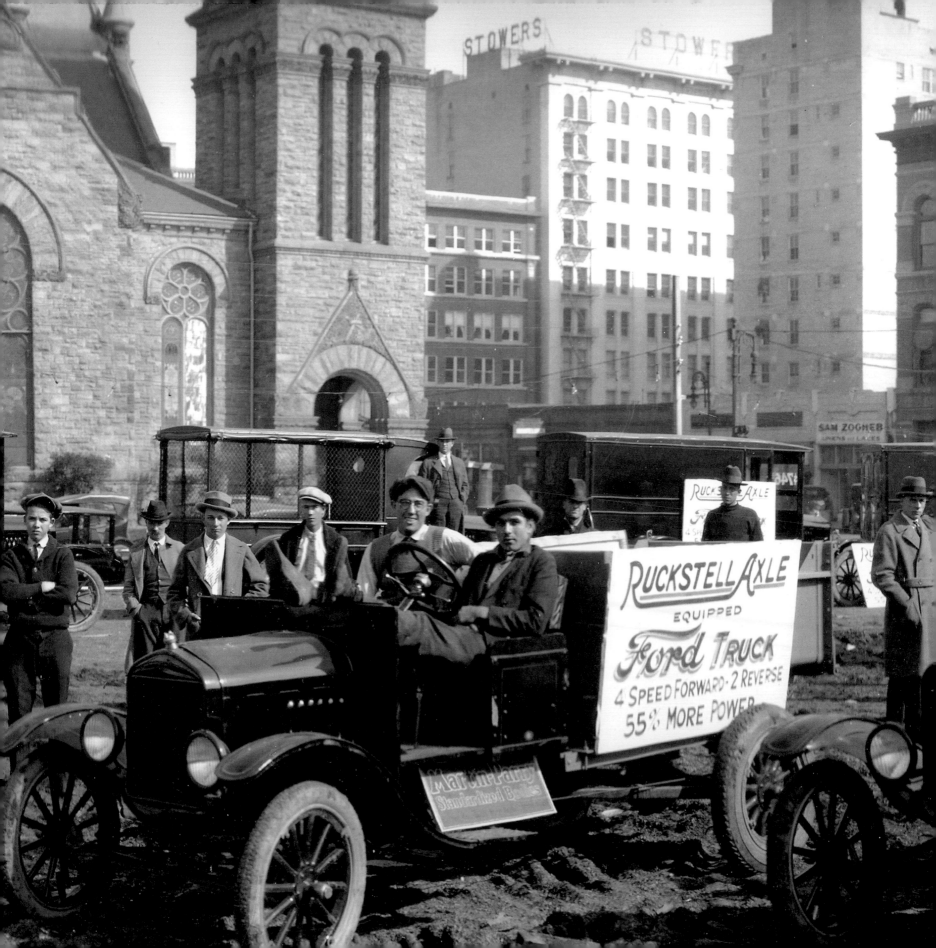

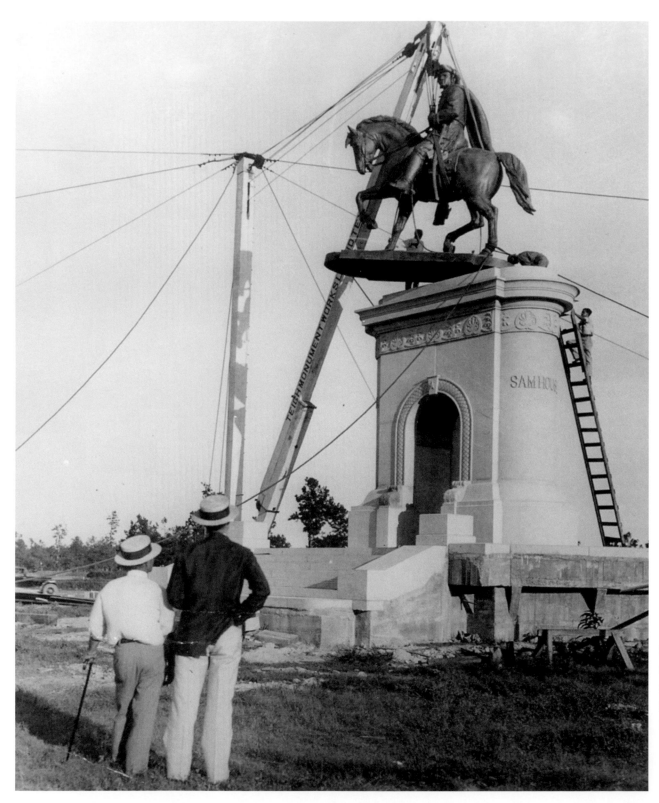

Sculptor Enrico
Cerrachio's statue of
Sam Houston being
installed in Hermann
Park, 1925.

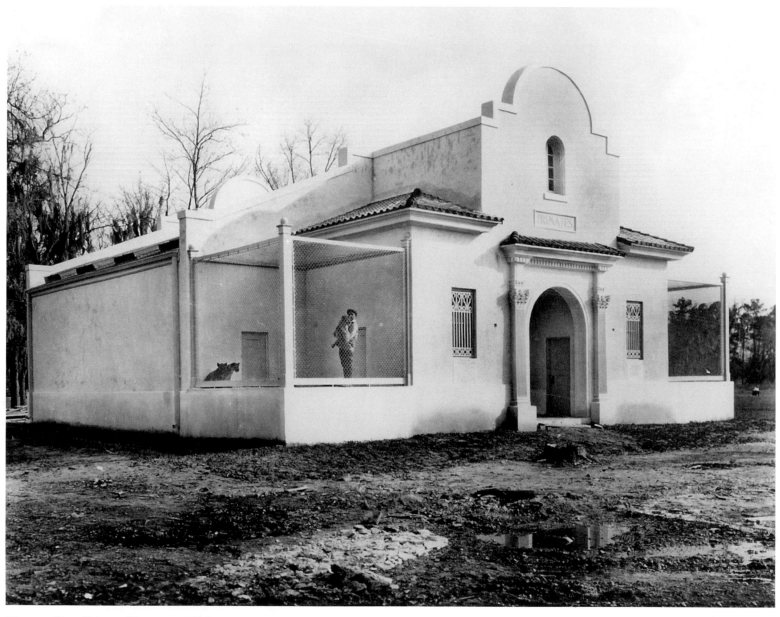

Houston Zoo, Primate House, ca. 1925.

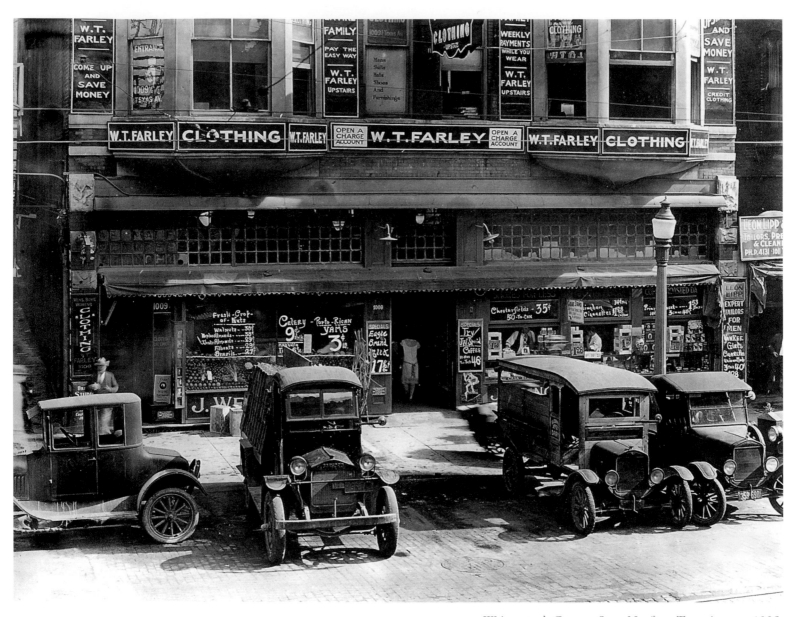

Weingarten's Grocery Store No. 2 on Texas Avenue, 1925.

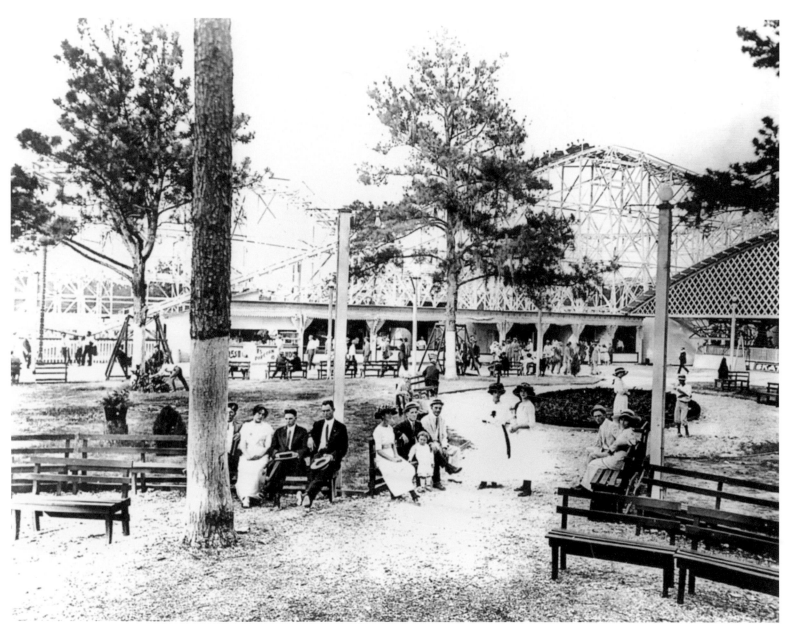

Luna Park, located near Woodland Heights, was home to the city's first
roller coaster, 1925.

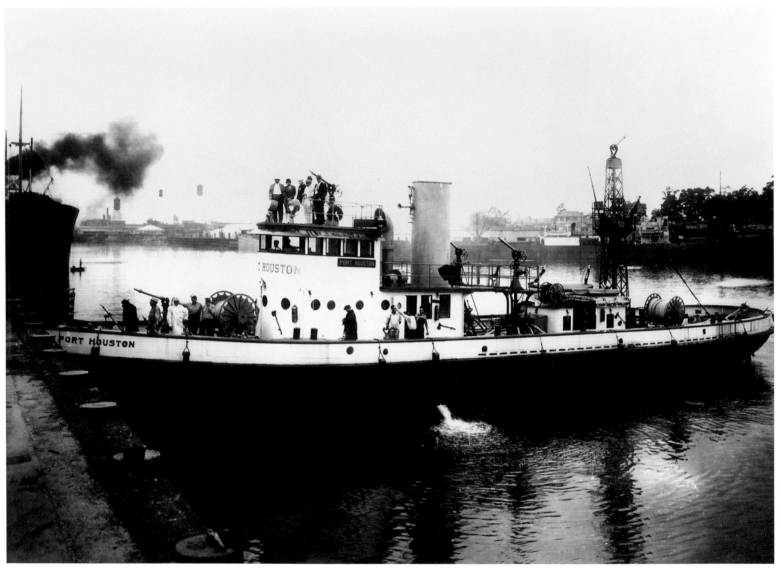

Port Houston, the first boat used on the Houston Ship Channel to fight fires, 1926.

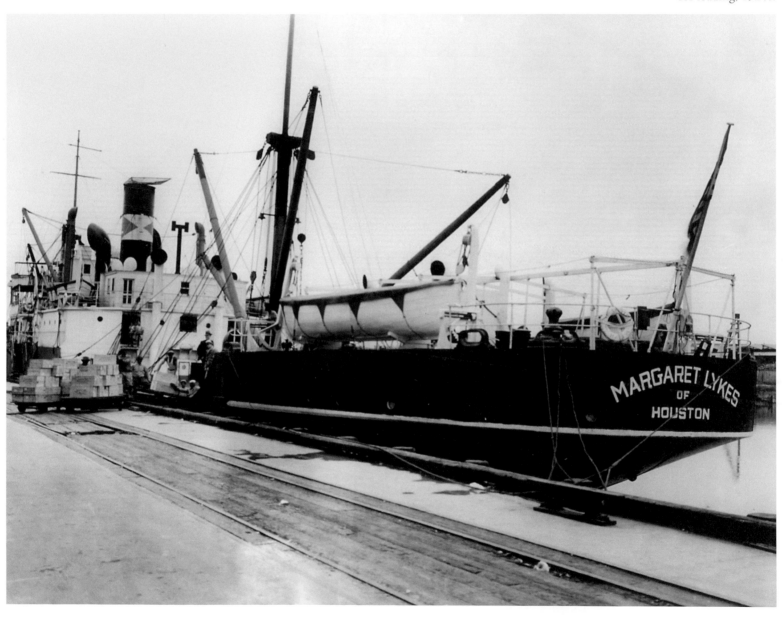

The *Margaret Lykes* docked at the Port of Houston for loading, 1920s.

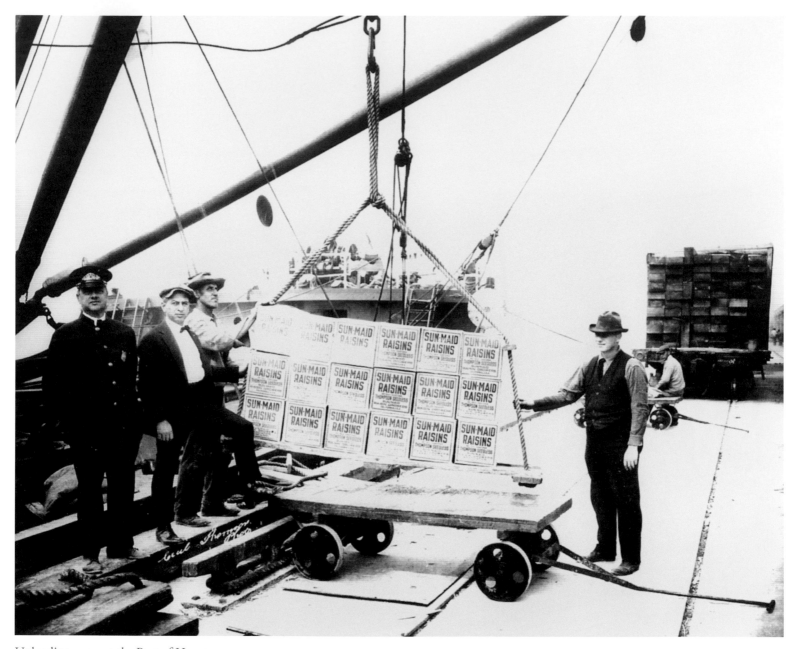

Unloading cargo at the Port of Houston.

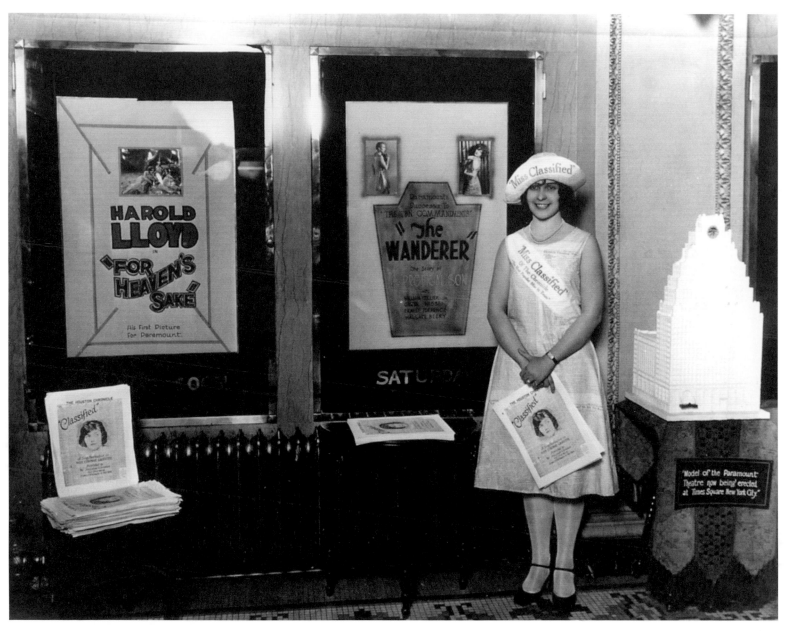

The *Houston Chronicle*'s Miss Classified, dubbed the Most Popular Miss in Texas, at a promotional event held in the Isis Theatre, 1927.

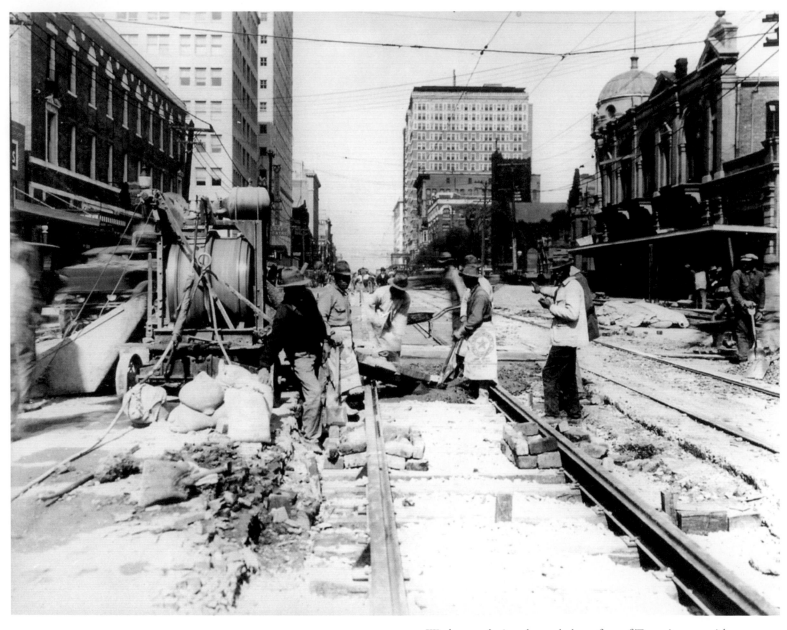

Workers replacing the asphalt surface of Texas Avenue with concrete.

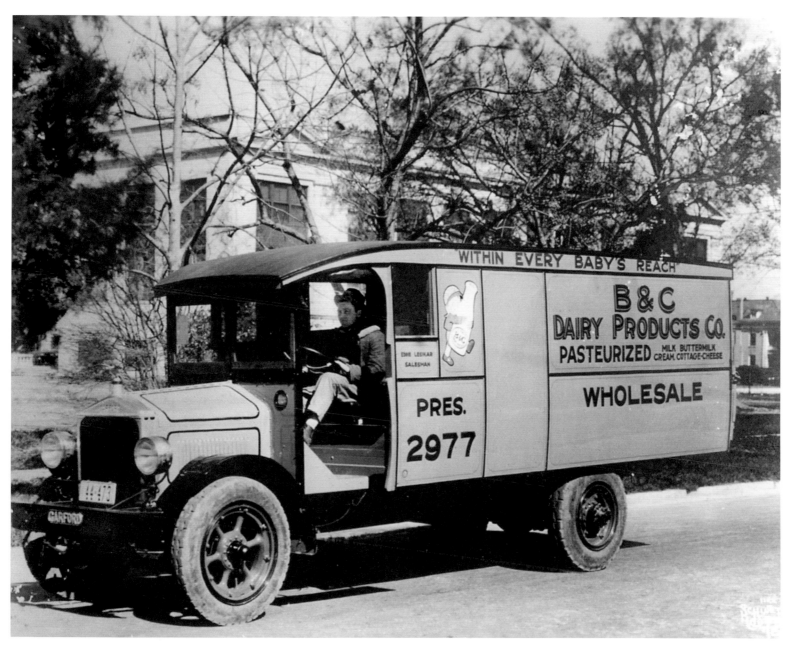

Convenient delivery of dairy products, 1926.

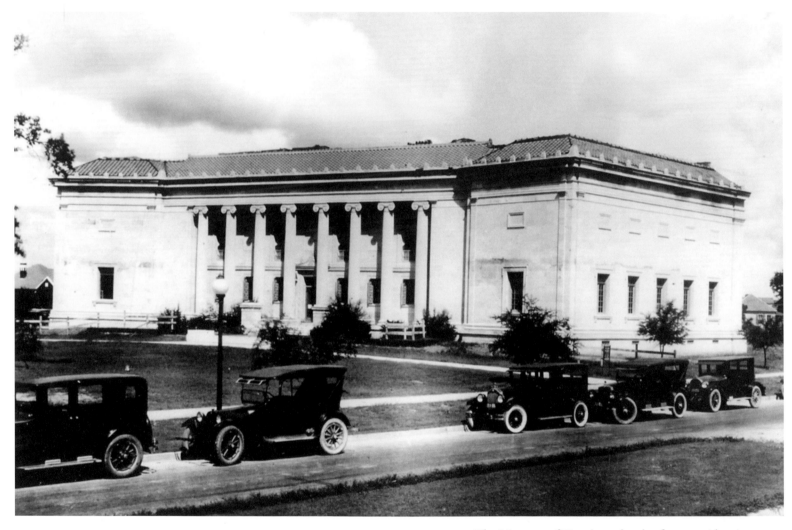

The Museum of Fine Arts, shortly after two side wings were
added to the main structure, 1926.

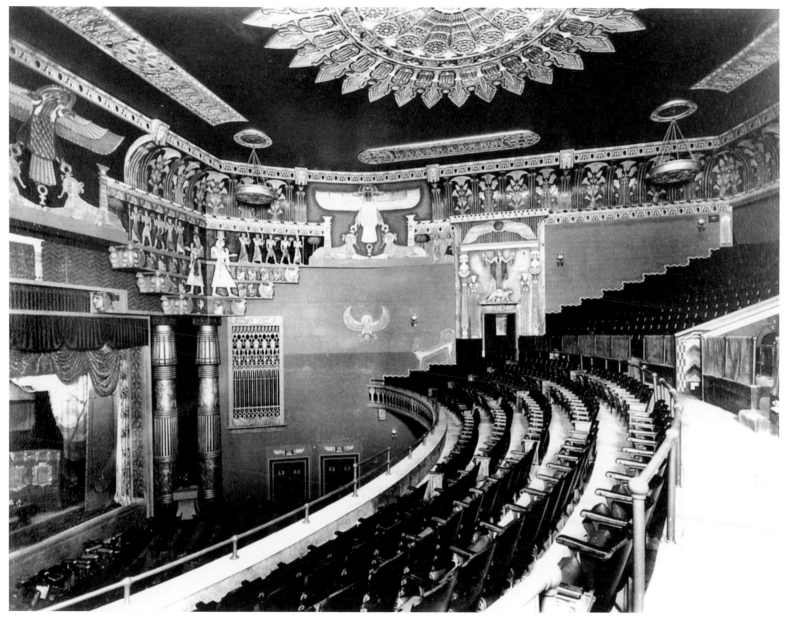

The Metropolitan Theatre transported moviegoers to Egypt in this
elaborate setting, 1927.

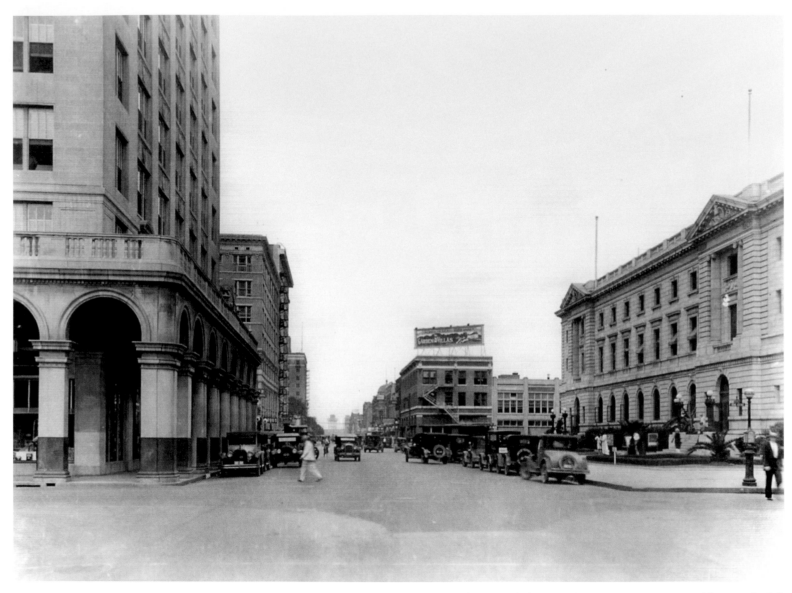

San Jacinto Street, looking north from Rusk with the Texas Co. Building on the left and the U.S. Post Office on the right, 1927. The billboard in the distance advertises Garden Villas, a new residential area.

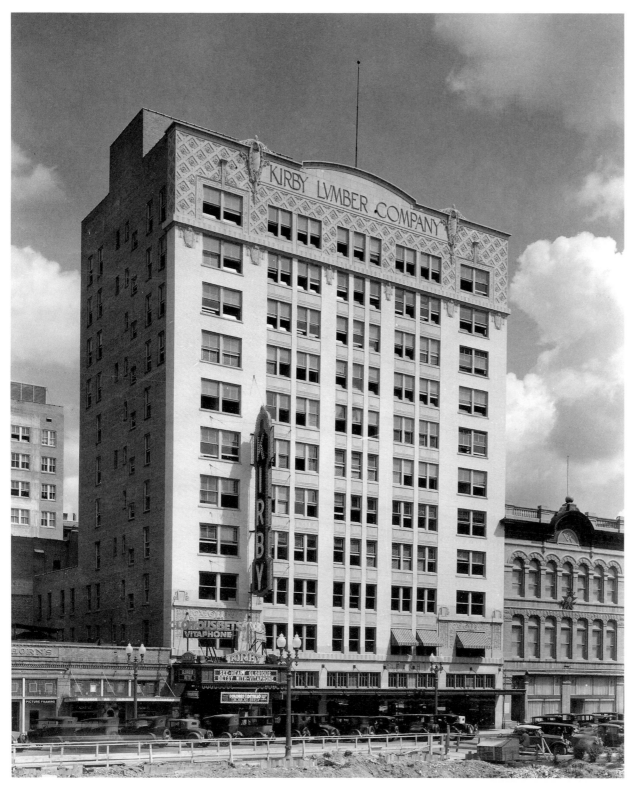

Jesse Jones erected this office building in 1927 as offices for the Kirby Lumber Company. The Kirby Theatre occupied the ground floor for many years.

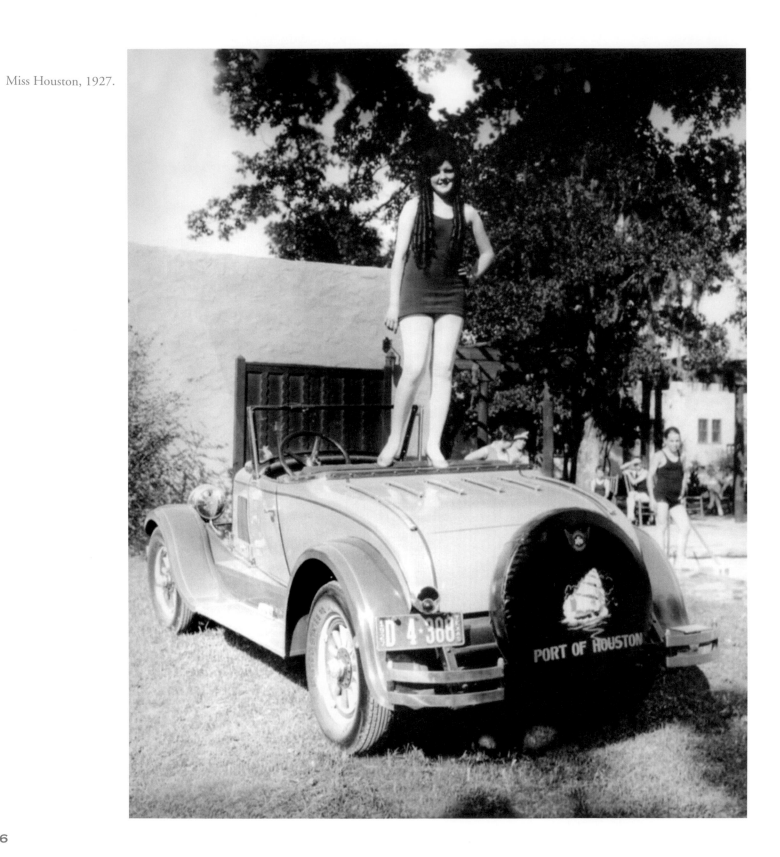

Miss Houston, 1927.

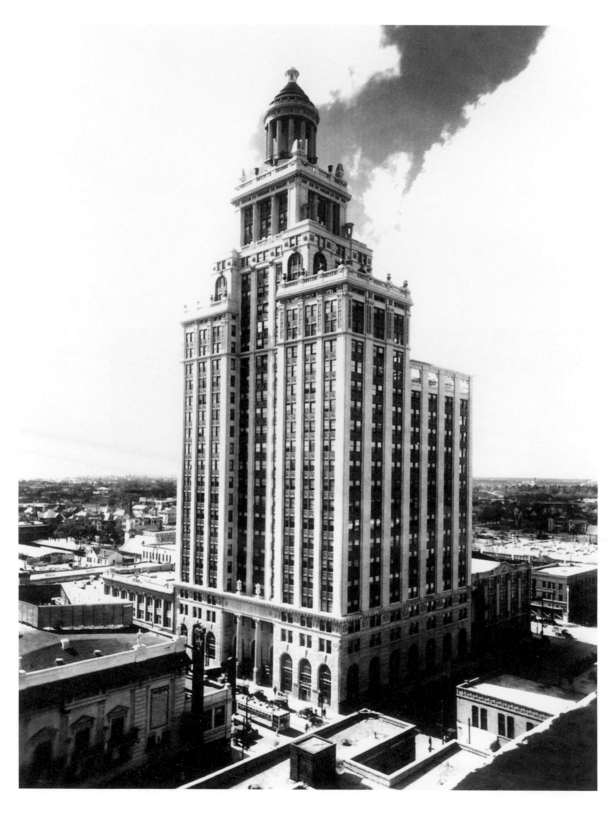

Mellie Esperson built the Neils Esperson Building in honor of her husband and the oil industry. When it was completed in 1927, it was the tallest building in Texas.

James Bute Paint Co. warehouse, 1926. The building now houses Dakota
Lofts, a downtown residential property.

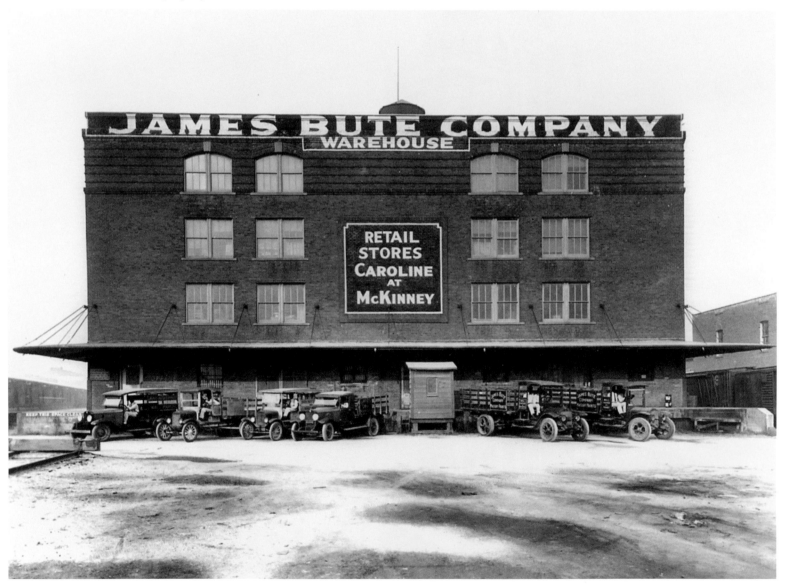

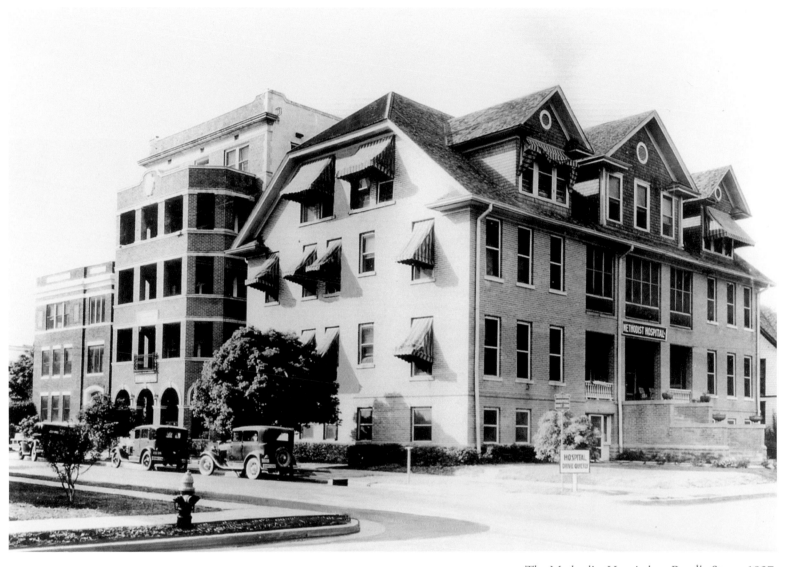

The Methodist Hospital on Rosalie Street, 1927.

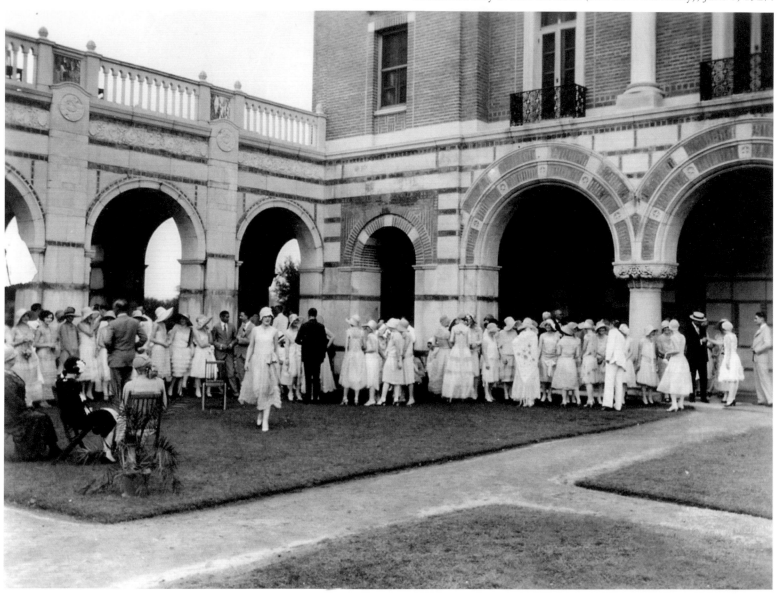

Graduation Day at Rice Institute (now Rice University), June 6, 1927.

Ice houses were a necessity before ice-making refrigeration was available in homes. Texas Ice and Fuel Co. was located at 6301 Harrisburg Boulevard.

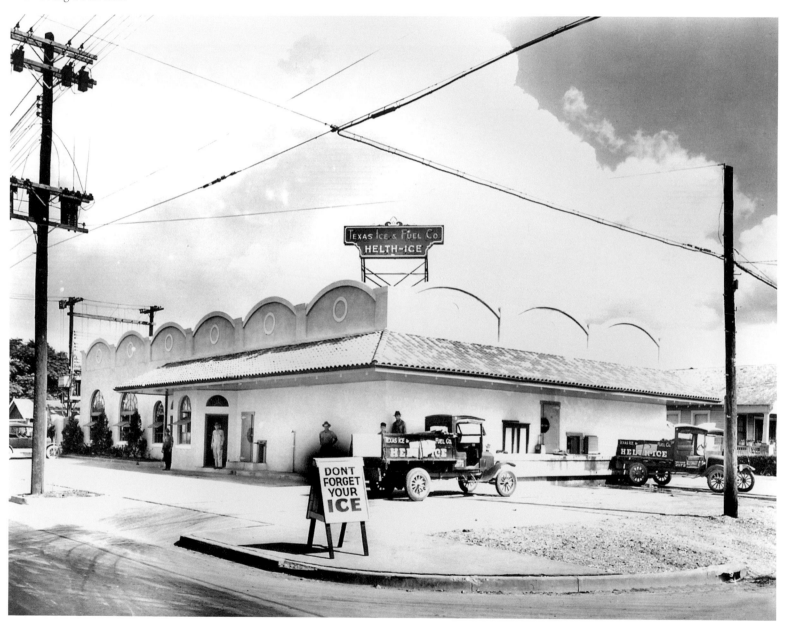

Thousands of delegates packed Sam Houston Hall for sessions
of the Democratic National Convention, June 1928.

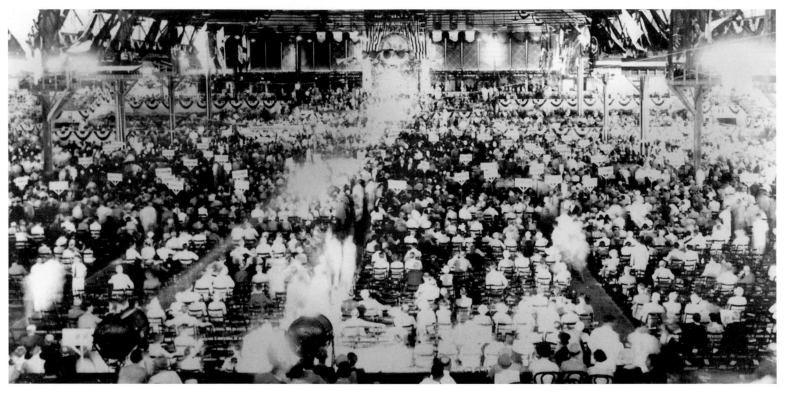

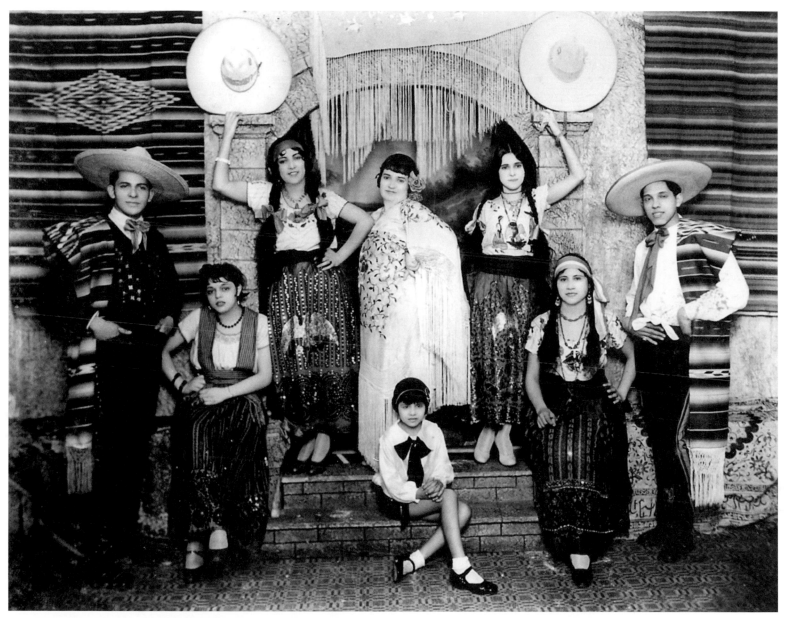

Theatrical group performing in Magnolia
Park neighborhood, ca. 1928.

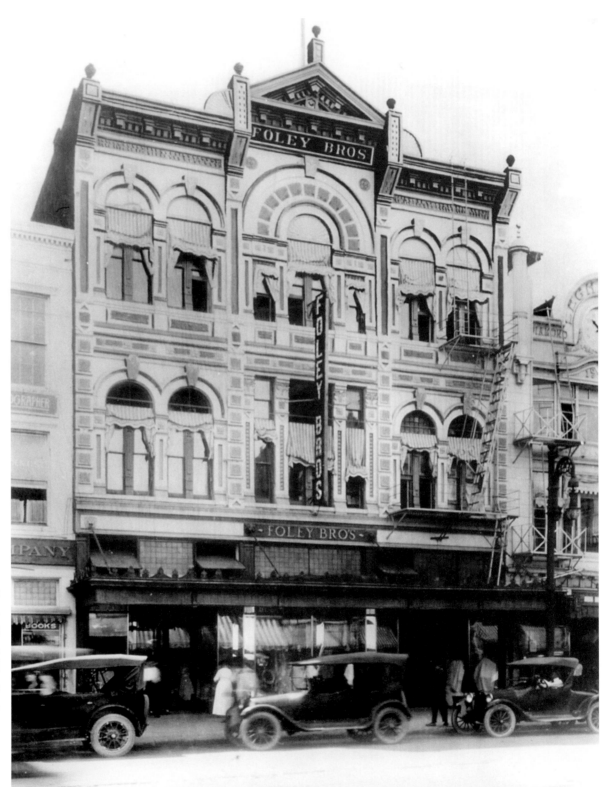

Foley Bros. was founded in 1900 by Pat and Mike Foley. Their store in the 400 block of Main had an auditorium, which doubled as a rehearsal hall for the Houston Symphony Orchestra.

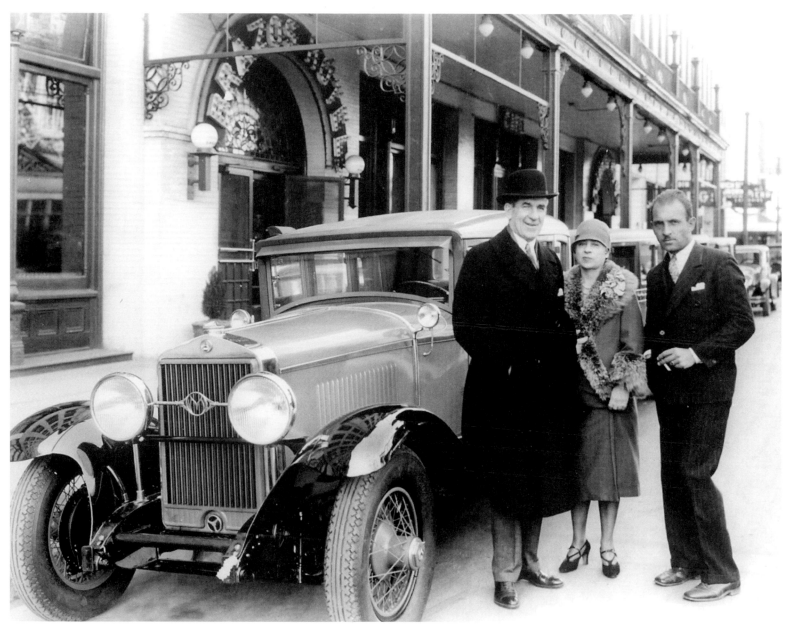

Visitors to Houston arriving at the Brazos Hotel, 1928. The
automobile is a Marmion.

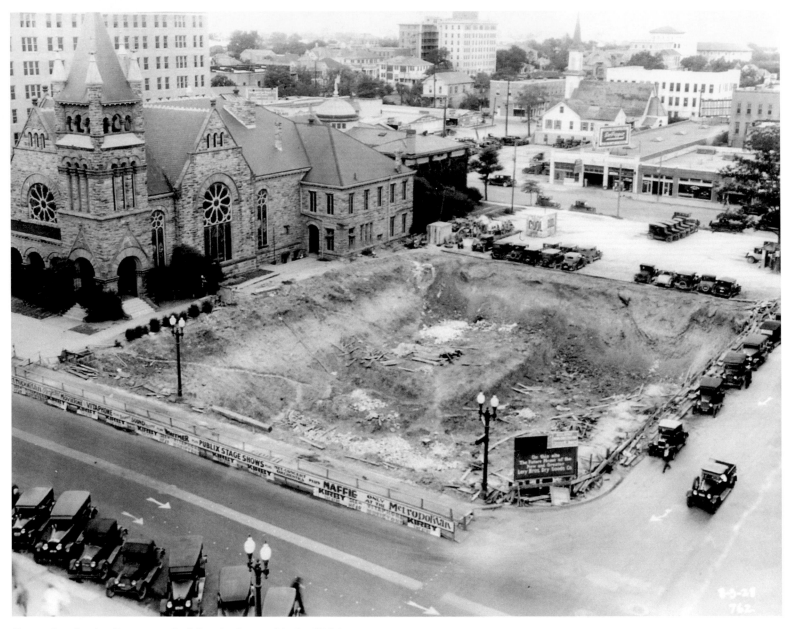

Excavation for the Commerce Building in the 900 block of Main, 1928. Levy Bros. became an anchor tenant, occupying the first five floors.

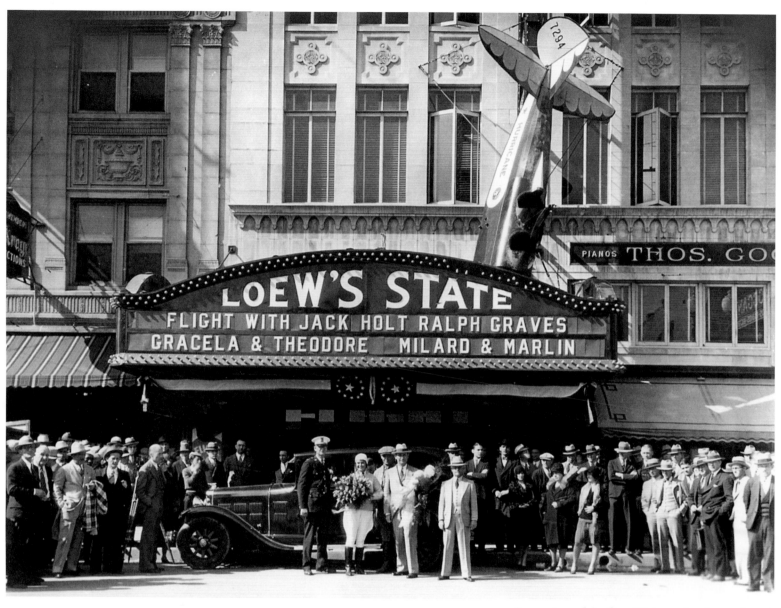

Promotion of the film *Flight,* at the elegant Loew's
State movie palace, 1929.

147

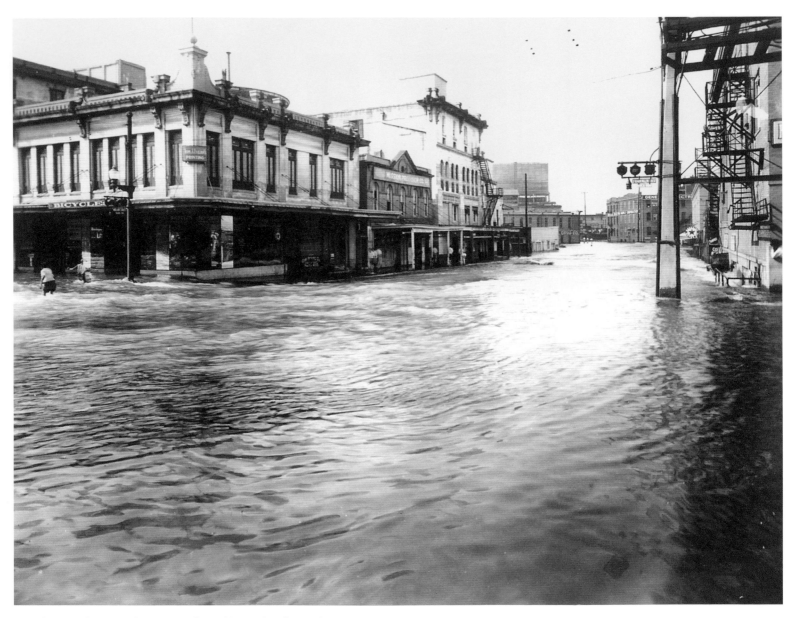

Floodwaters shown at the corner of Franklin and Milam, when a torrential rainfall inundated the downtown area and caused $1.5 million in damages, May 1929.

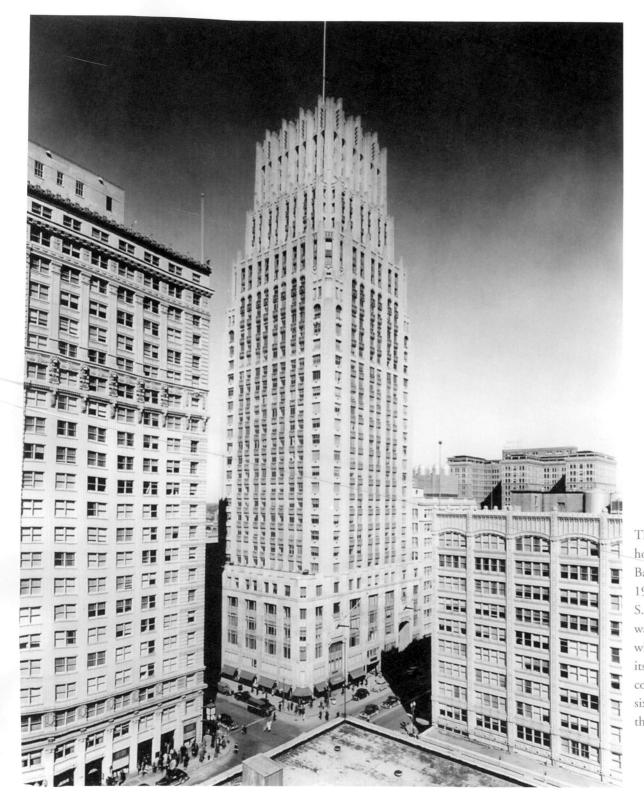

The Gulf Building, now home to JPMorgan Chase Bank, was completed in 1929. Pictured at left is the S. P. Carter Building, which was labeled "Carter's Folly" when erected in 1910 because its 16-story height was considered unsafe. Ironically six more stories were added in the early 1920s.

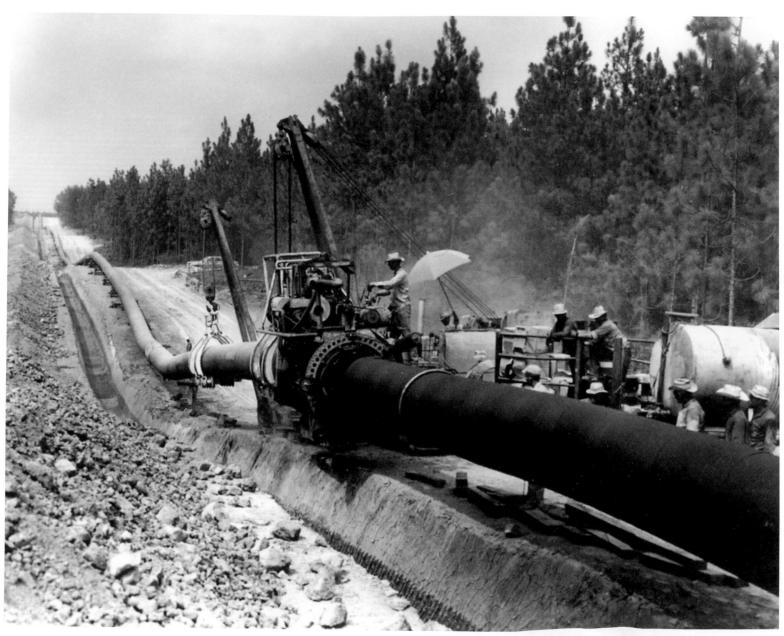

Laying pipelines, a critical component of the
petroleum industry.

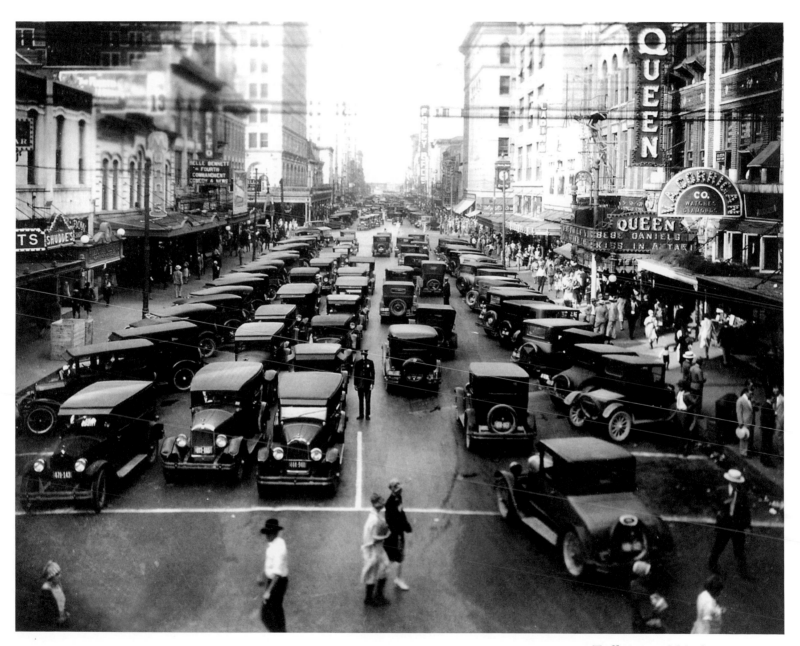

Traffic jam on Main Street, ca. 1930.

Shopping center on Harrisburg Boulevard in
Houston's East End, 1927.

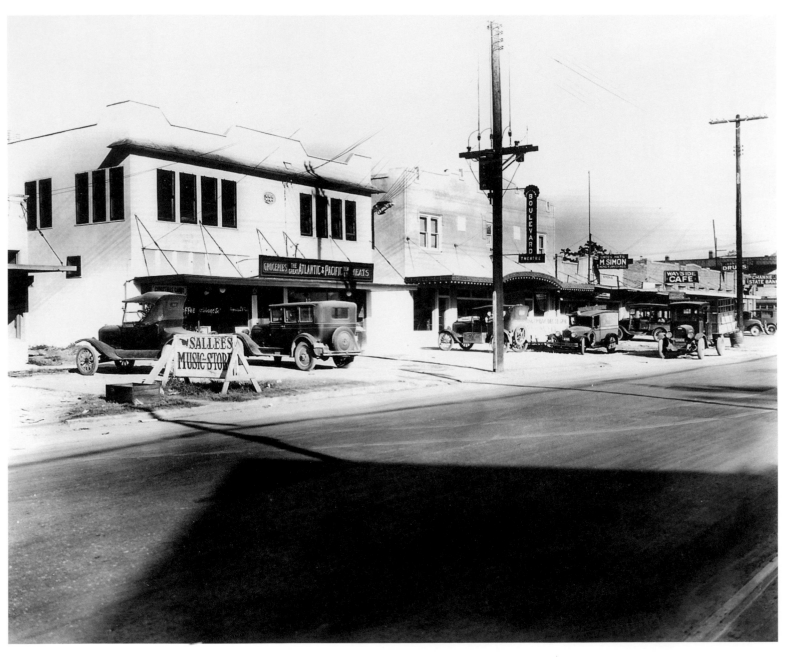

The city's namesake cruiser, *Houston*, visited on October 27, 1930, and its crew (seen here) were presented with a silver coffee service. The vessel was sunk in the Java Sea during World War II.

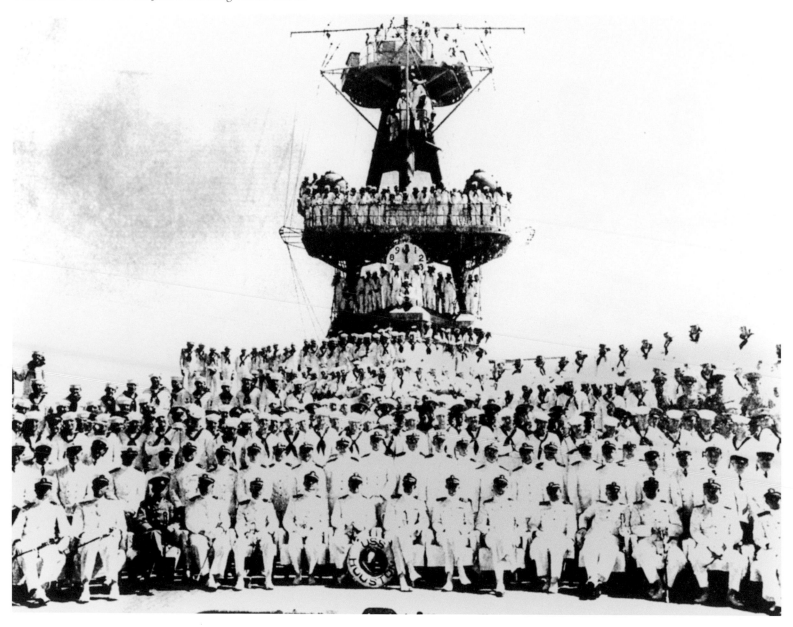

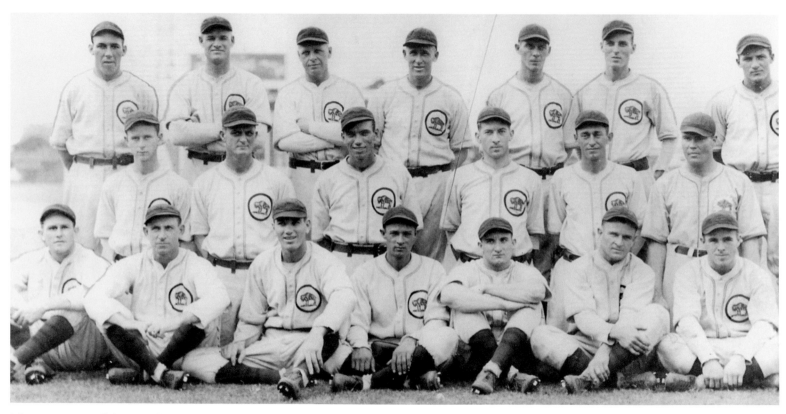

The Houston Buffaloes (Buffs), a farm team of the St. Louis Cardinals, included such legendary players as "Dizzy" Dean, "Ducky" Medwick, and "Tex" Carleton, seen in this 1931 team photograph.

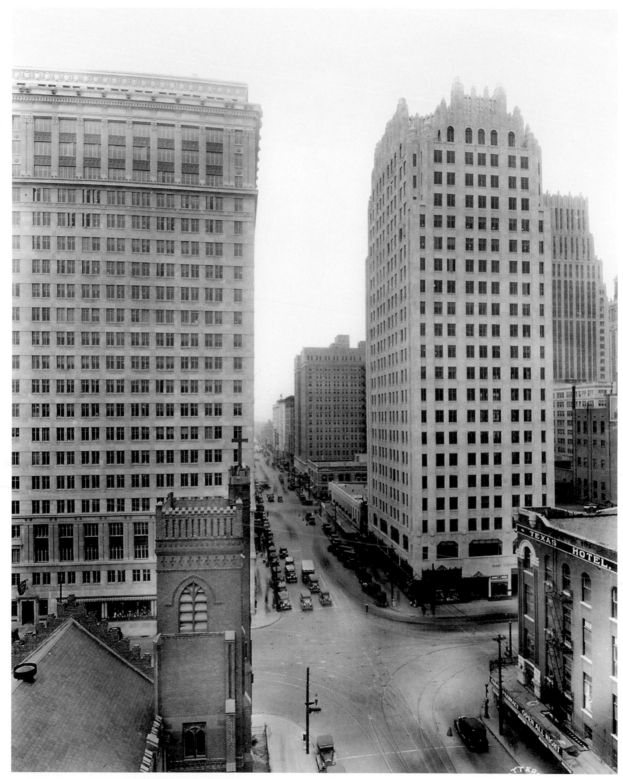

Fannin Street, showing the Post Dispatch Building and the Sterling Building, both constructed by Ross Sterling, ca. 1932.

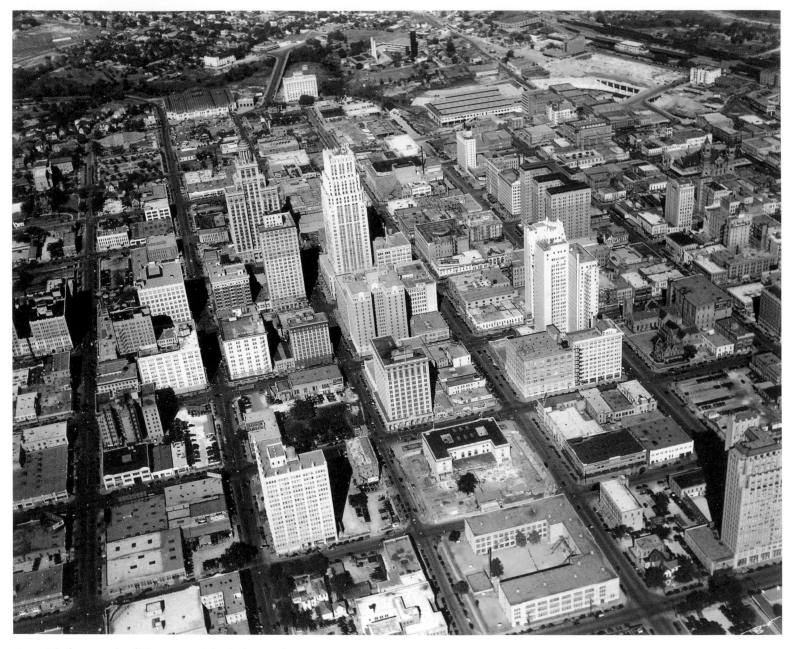

An aerial photograph of Houston as it looked around 1932.

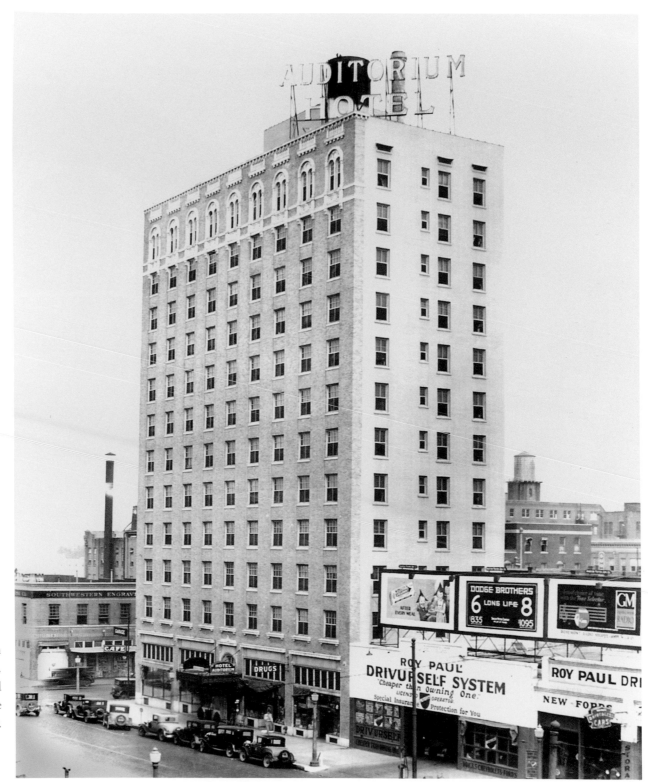

Auditorium Hotel on
Texas Avenue, 1932.
Today the renovated
hotel is known as the
Lancaster.

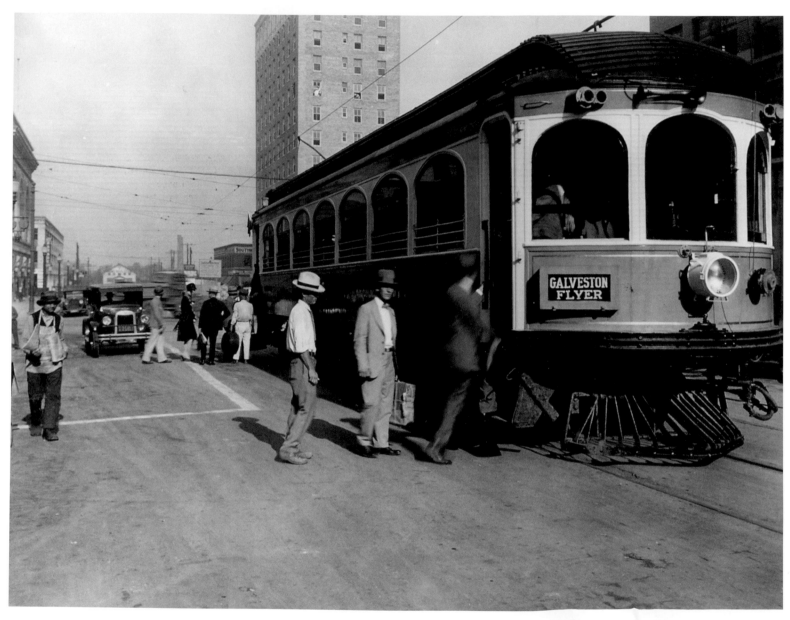

Passengers boarding a car of the Galveston-Houston Interurban line to
make a speedy fifty-five-minute trip to the island city.

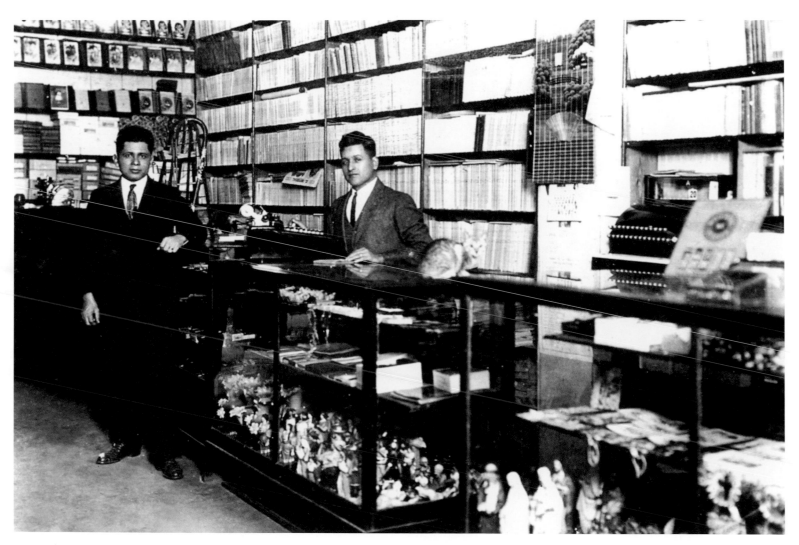

Jose and Socorro Sarabia's bookstore, Hispano
Americano, ca. 1930.

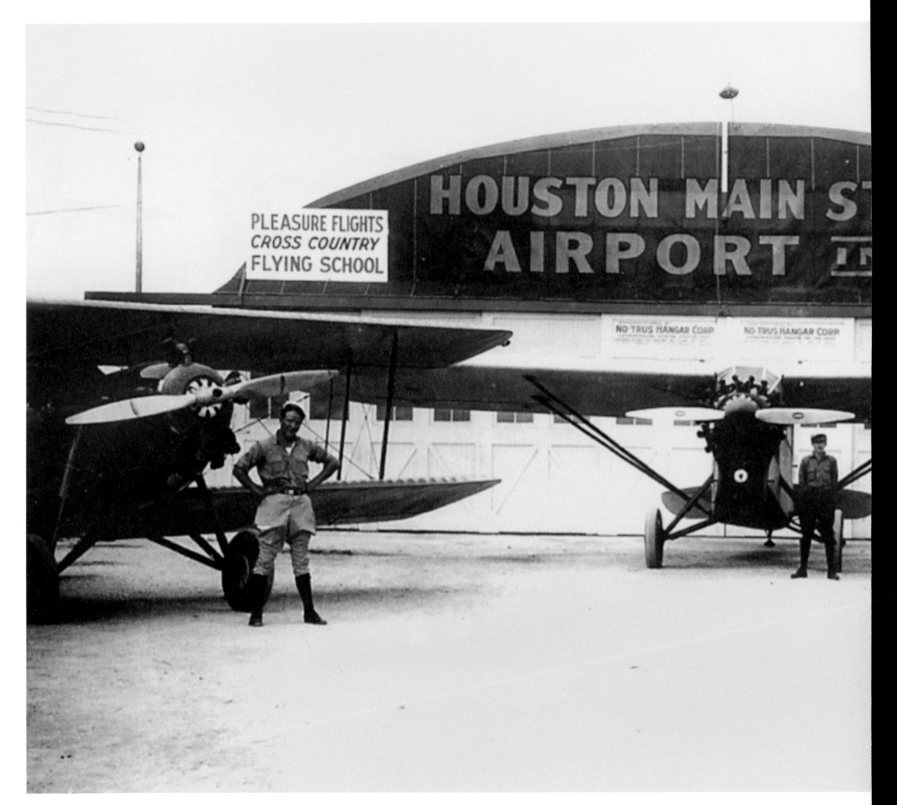

160

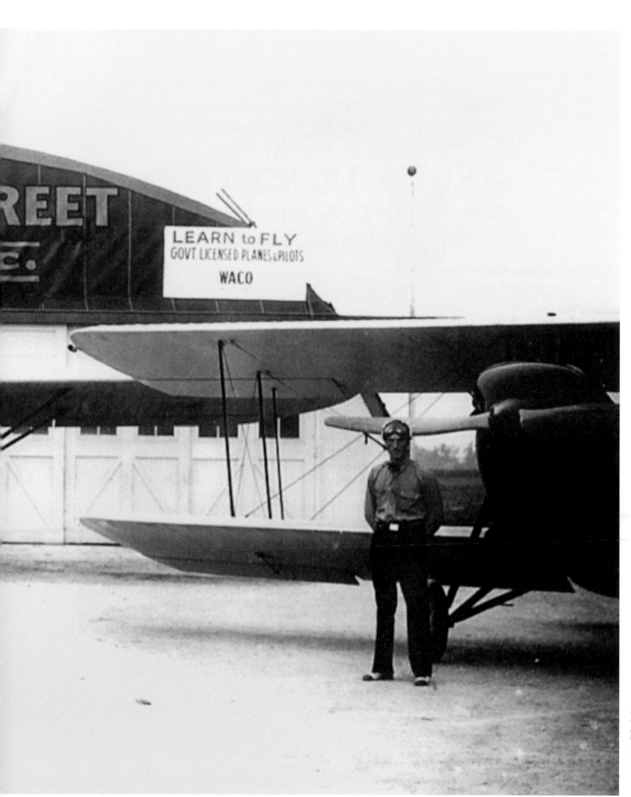

Houston Main Street Airport, located at the end of Main Street, 1935.

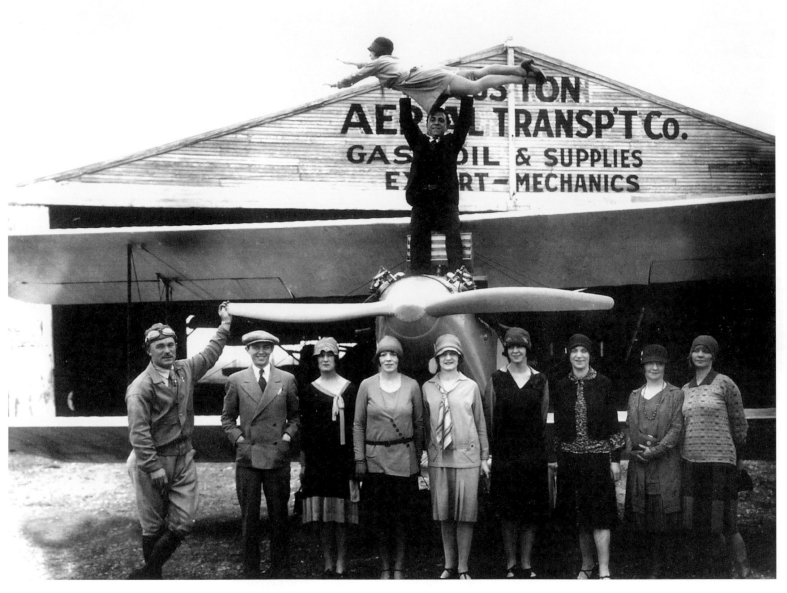

Companies often devised eye-catching publicity shots
to advertise their services.

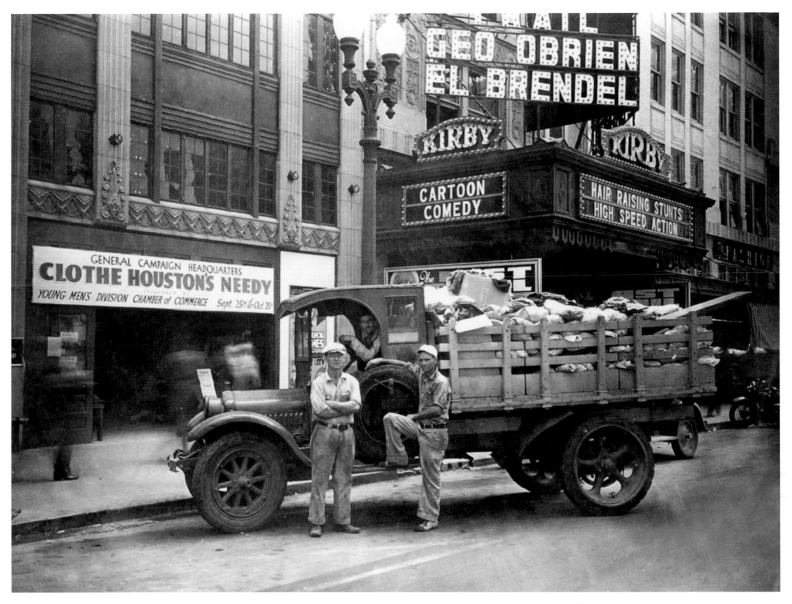

A familiar scene on the streets during the Great Depression.

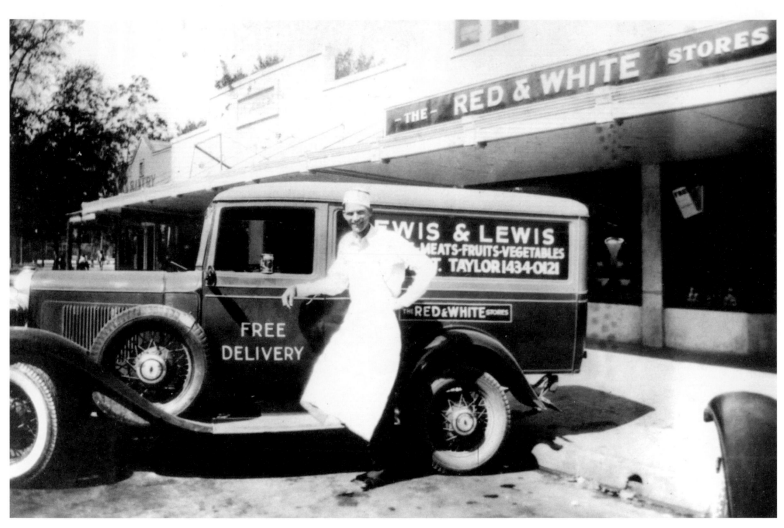

Home delivery by Lewis and Lewis Grocery, located at 411 W. 19th Street in the Houston Heights, 1936.

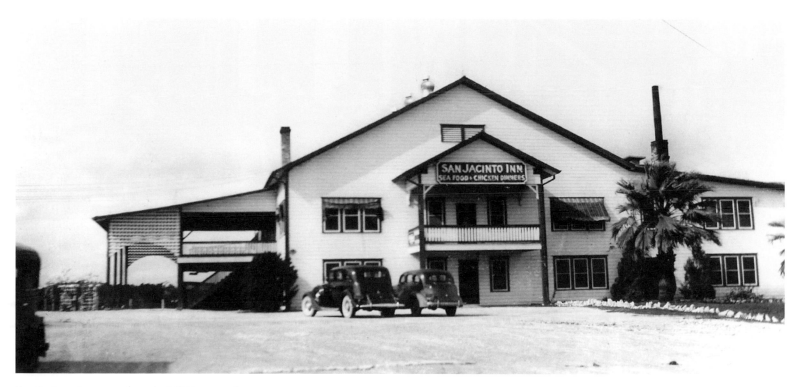

San Jacinto Inn, seen here in 1936, opened on Battleground Road in 1917 and was a popular restaurant getaway for more than fifty years.

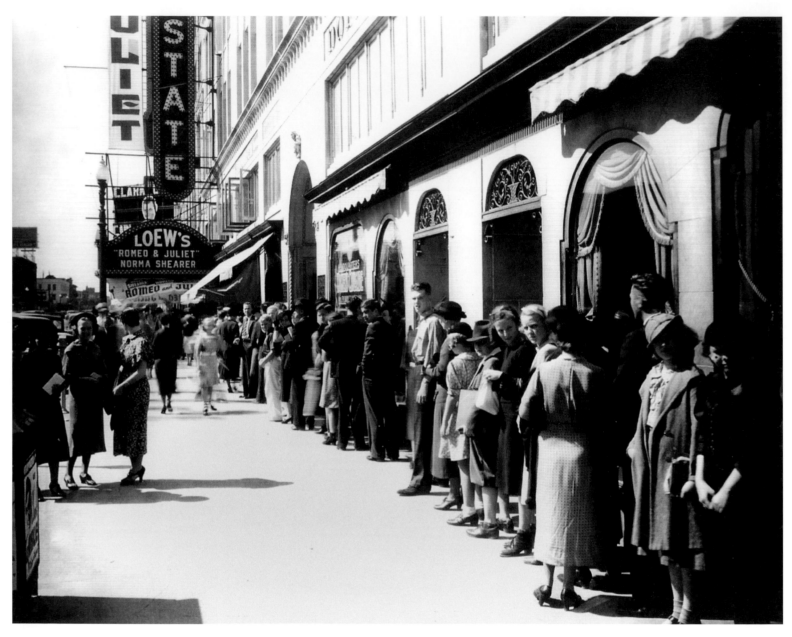

Moviegoers queue up outside Loew's State Theatre, 1936.

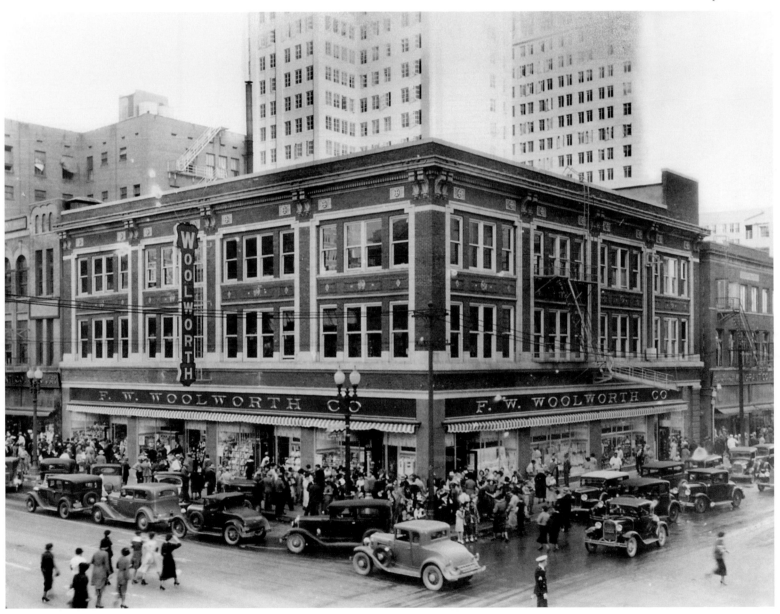

Shoppers hustle and bustle around F. W. Woolworth Co.
at the corner of Main and Capitol, 1935.

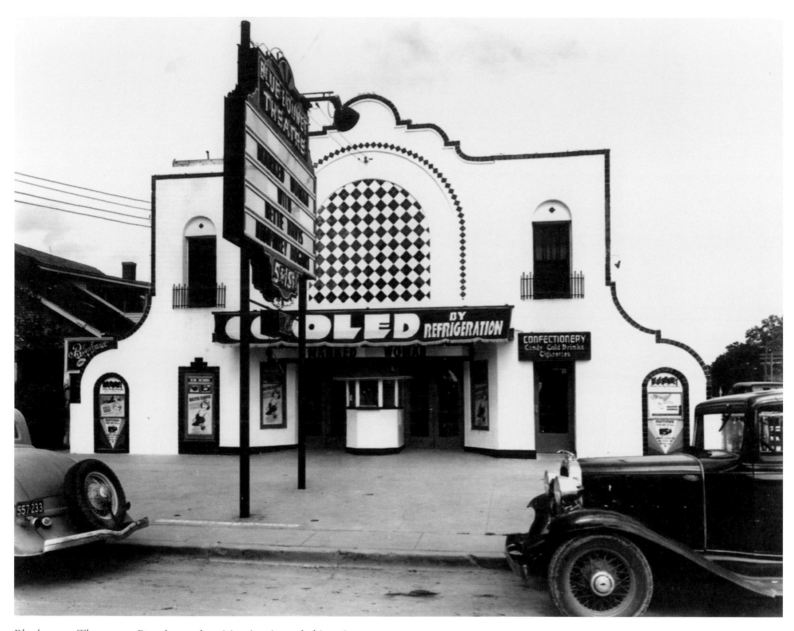

Bluebonnet Theatre on Broadway advertising its air-cooled interior, an
enticing feature for moviegoers in the 1930s.

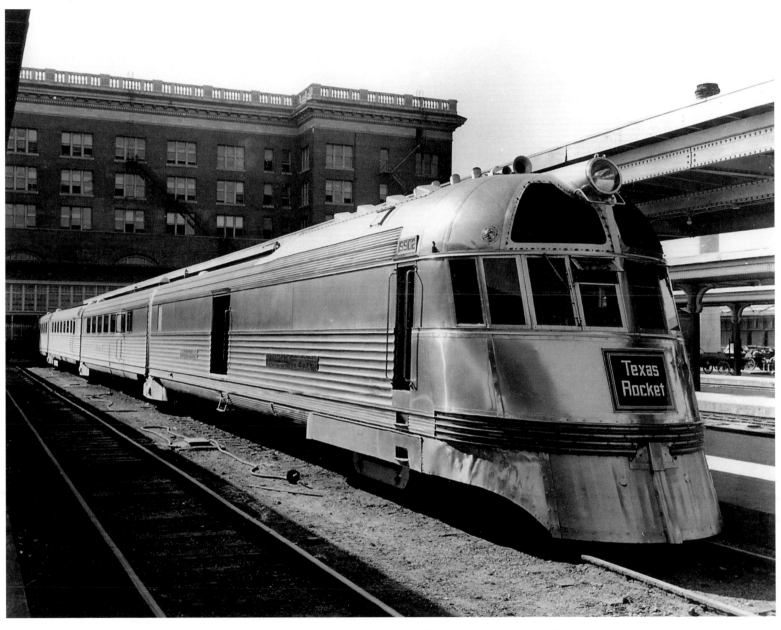

The *Texas Rocket,* owned by the Burlington–Rock Island Railroad, ran between Houston and Dallas in the late 1930s. Union Station, now part of Minute Maid Baseball Park, can be seen in the background.

After setting a round-the-world flight record, Howard Hughes, Jr., returned to his hometown for a ticker tape parade viewed by 250,000 spectators, July 30, 1938.

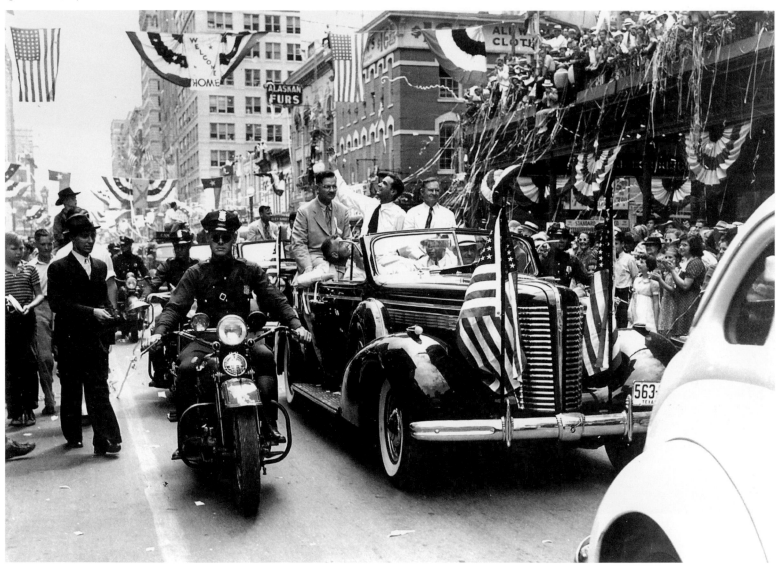

A City Climbs to New Heights

1940–1970

In 1948 Houston received the distinctive title of "fastest-growing city in the nation." World War II propelled this growth, and the postwar years continued to fuel it. Petroleum played a key role in this dynamic expansion. The refineries in the Houston area produced more than half the nation's oil. More wealth left the ground within a 200-mile radius of the city than in any other location of equal size in the world.

Wartime activity also spurred the development of a vast petrochemical industry. Increased industrial activity led to expanded transportation of goods by trucks, railroads, and ships. By 1948 the Port of Houston was second only to New York in total tonnage. Freeways for vehicular traffic were overloaded before they were completed. Houston International Airport, built in 1954, was hard-pressed to handle the increase in air travel.

The postwar years ushered in the wonder of television. Houston's first channel, KLEE-TV (later named KPRC-TV) began operating on January 1, 1949. Four years later KUHT-TV was established as the nation's first educational television station.

An even more amazing forecast for the future occurred in Houston when the nation's Manned Spacecraft Center was placed on the outskirts of the city. On July 20, 1969, the words "Houston, the Eagle has landed" were heard around the world as astronauts Armstrong and Aldrin first landed on the moon.

These years brought other "firsts": professional football, baseball, and basketball teams; resident companies in opera, ballet, and theater; a vast complex of medical facilities which would evolve into the largest medical center in the world; a domed stadium, nicknamed "the Eighth Wonder of the World"; and award-winning architectural gems throughout the city.

Not everything was positive in these years of change. Inequities were present in educational opportunities for racial minorities, and court-ordered integration moved at a snail's pace. Red Scare tactics infiltrated the community, producing tensions and hardships for many citizens. On the positive side, the walls of segregation crumbled in other places when businesses and public facilities were opened to all races after a series of sit-ins and protests. In 1966 voters elected an African American and a Hispanic to the state legislature.

By 1970 the small town on a sleepy bayou had become the sixth largest city in the nation. It had certainly met the expectations of its founders back in 1836.

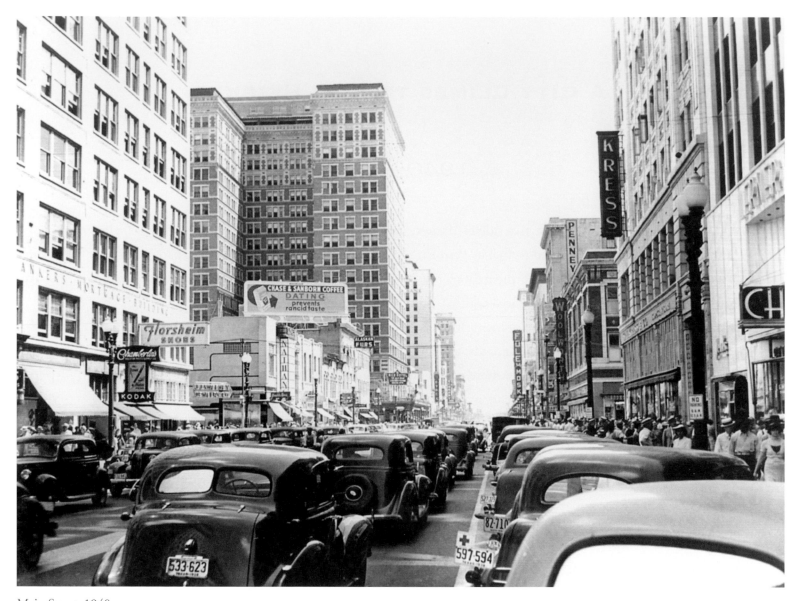

Main Street, 1940.

When City Hall was relocated to its current site in 1939, the former Market House and City Hall was converted to a bus station. Although the building burned in 1961, the Seth Thomas tower clock was restored and placed in a standing tower at the corner of Congress and Travis.

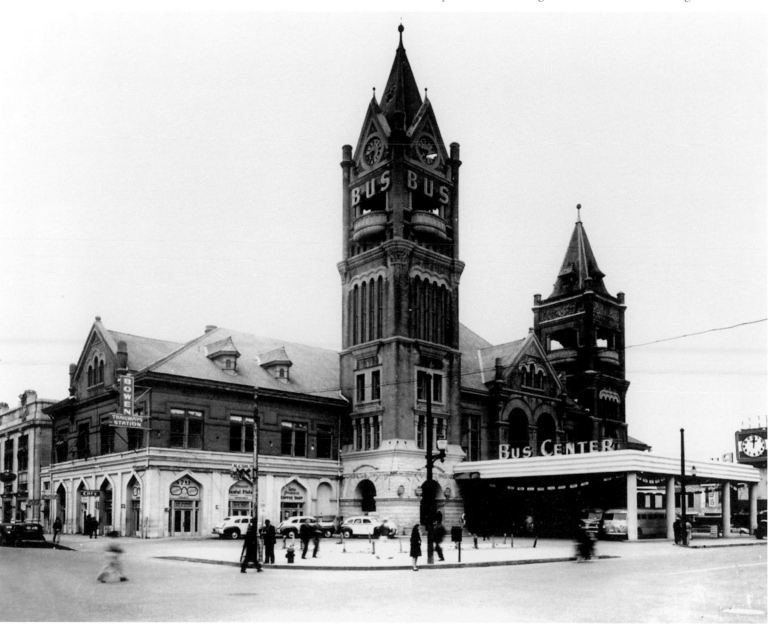

Soldiers being entertained by the Girls Service Organization, an arm of the USO. The jeeps are parked in front of the studio of Joseph Litterst, a commercial photographer responsible for many of the photographs seen here.

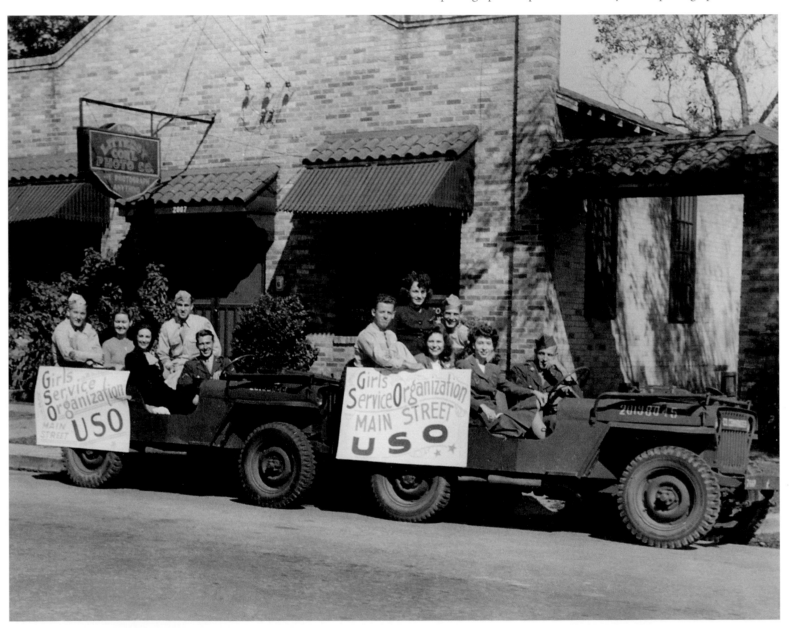

Women employees of Hughes Tool Company machining cones for drill bits
during World War II.

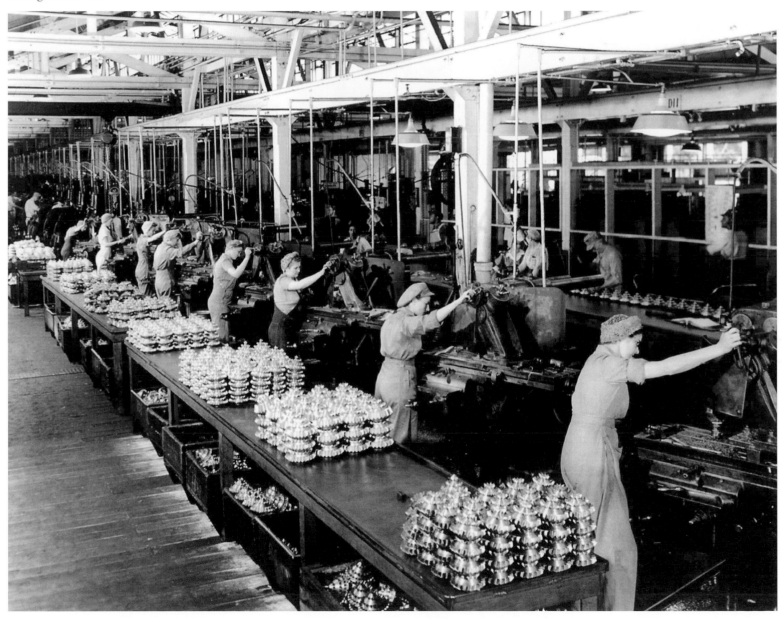

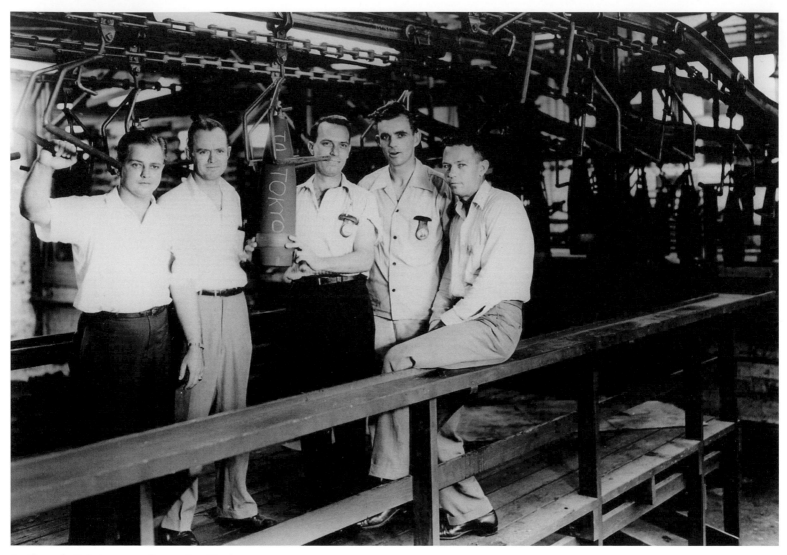

Artillery shells being manufactured at Hughes
Tool Company, 1943.

Yards of the Houston Shipbuilding Corporation during the war.

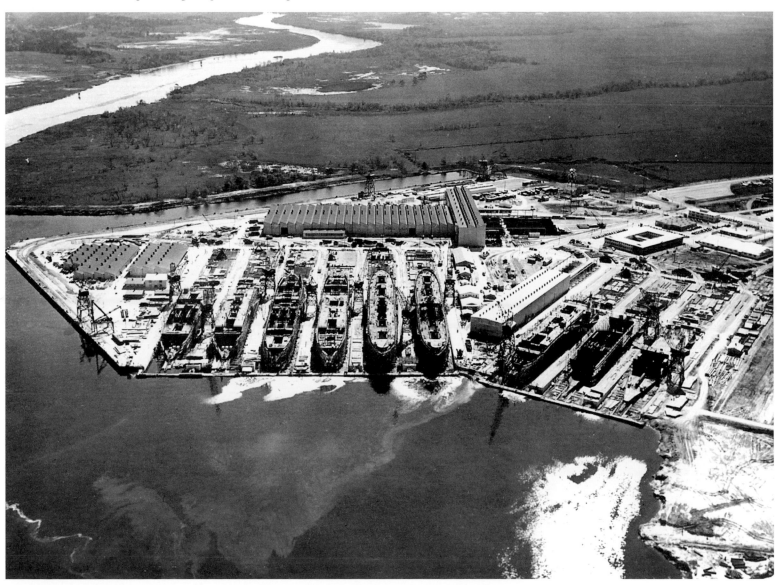

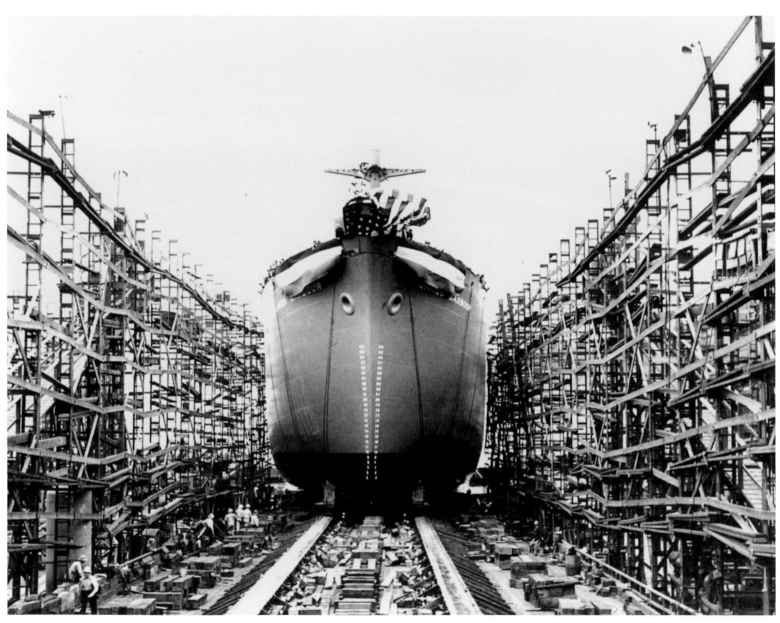

The *James Barbour* being launched only twenty-two days
after the keel was laid, January 10, 1943.

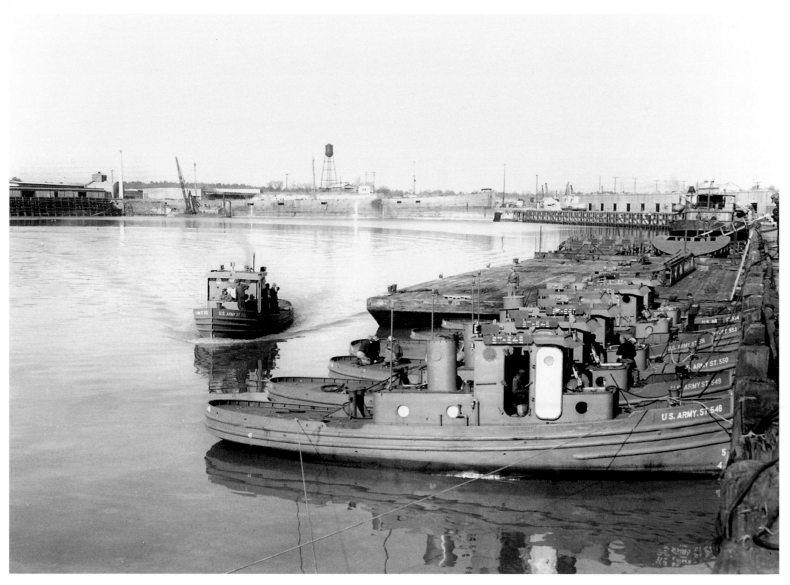

Port of Houston Ironworks turning out U.S. Army tugboats.

Oak Forest, laid out on 1,100 wooded acres in northwest Houston in 1946, was the largest single-family residential development in the nation after World War II.

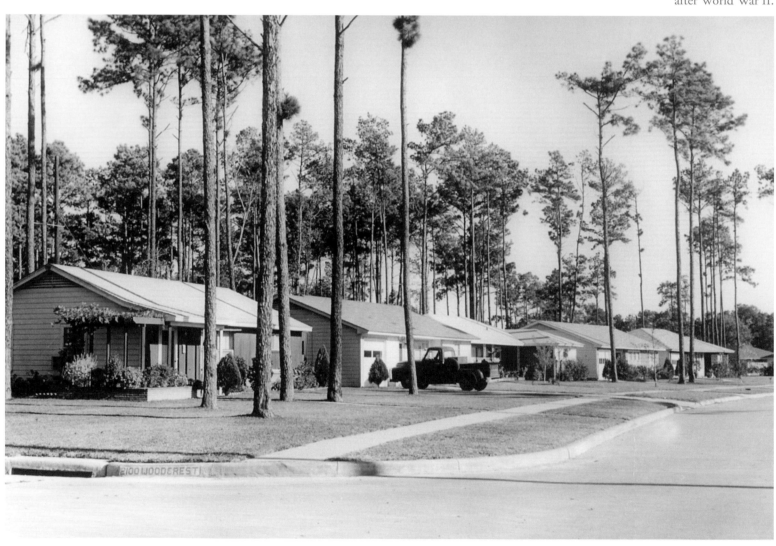

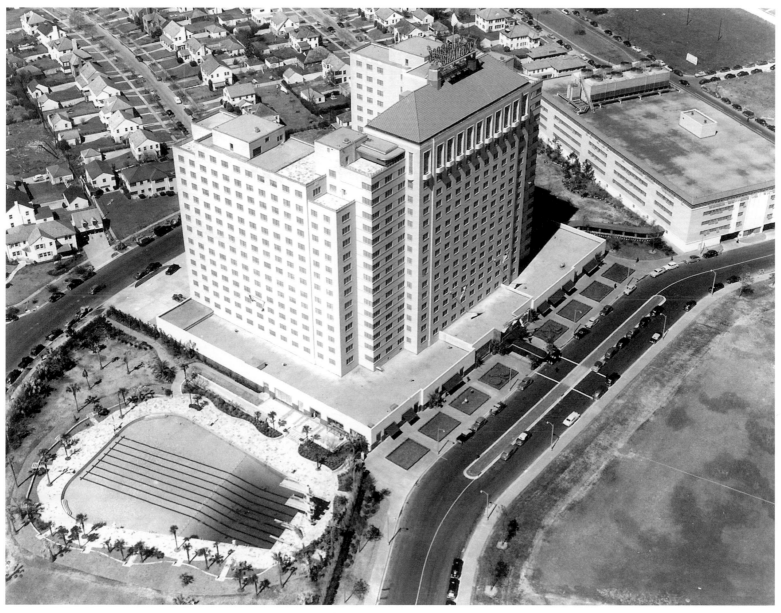

Glenn McCarthy's Shamrock Hotel opened on St. Patrick's Day, 1949. It boasted a
swimming pool large enough for water-skiing, a lobby the size of a football field, and a
television set in every room.

The Airline Drive-In Theatre, ca. 1950.

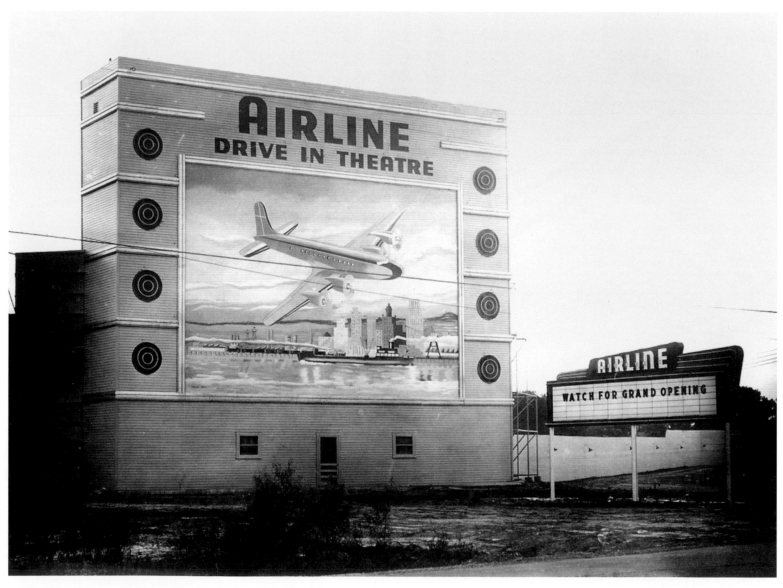

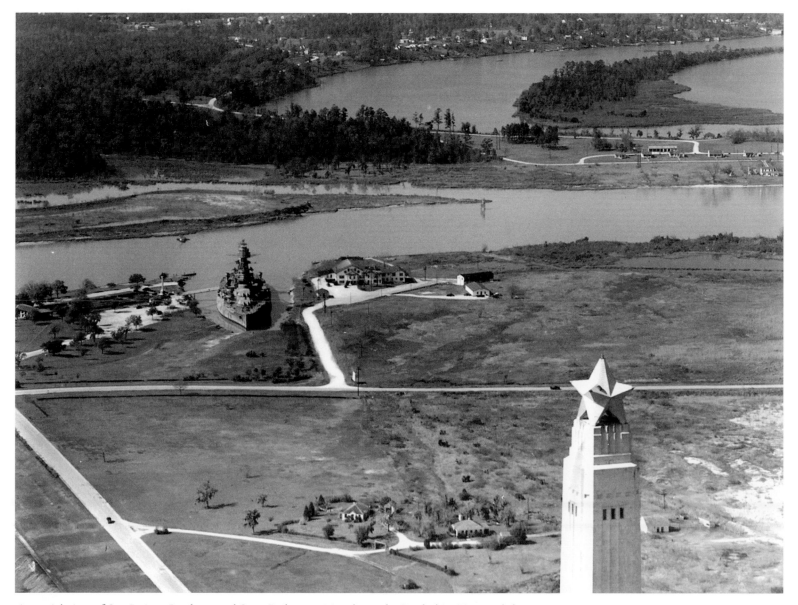

An aerial view of San Jacinto Battleground State Park, ca. 1950, shows the Battleship *Texas* and the San Jacinto Inn with the Houston Ship Channel in the background. The photograph also captures the Lone Star topping the San Jacinto Monument, the world's tallest war memorial column.

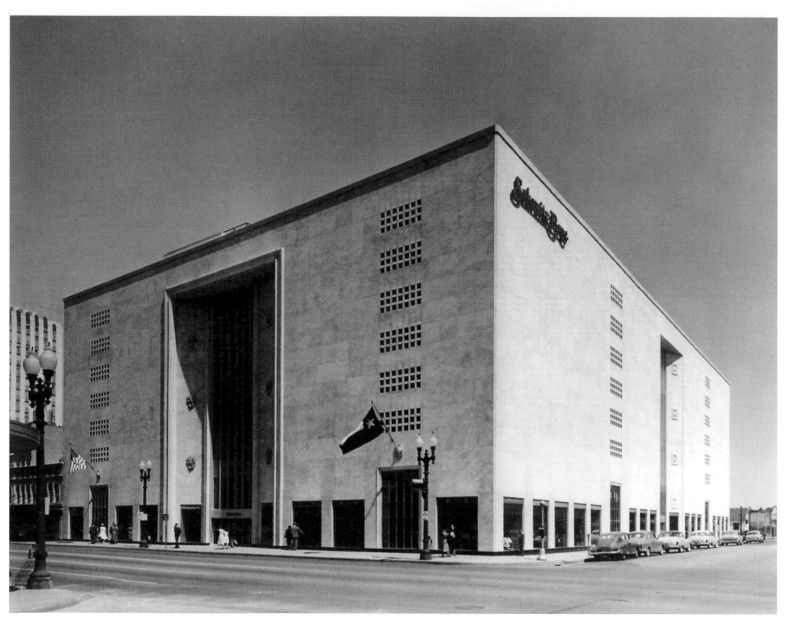

Sakowitz Bros. opens a new store at 1111 Main, 1951.

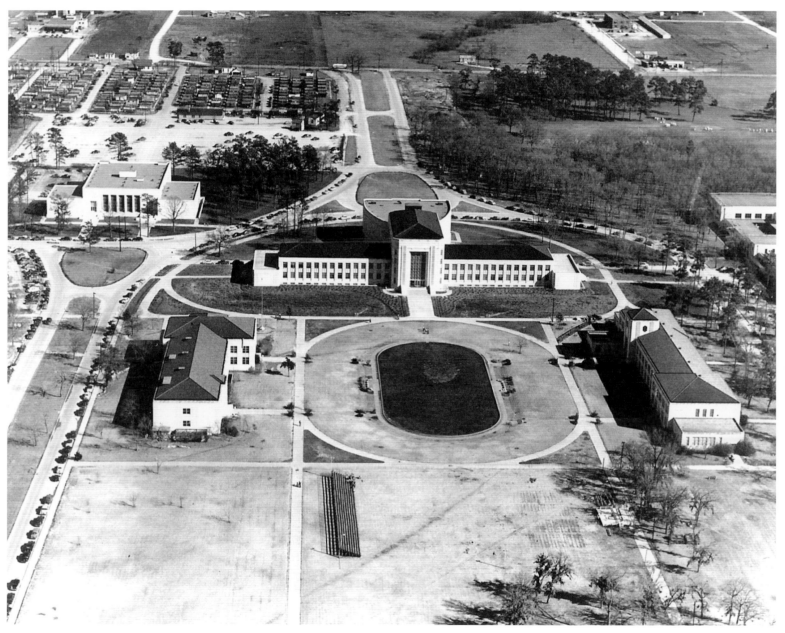

University of Houston campus, showing (clockwise from lower left) the Science Building, M. D. Anderson Library, Ezekiel Cullen Building, and Roy Gustave Cullen Building, ca. 1952.

Trailblazer Monorail on opening day in Arrowhead Park, February 18, 1955. The transit experiment did not prove successful and was soon abandoned.

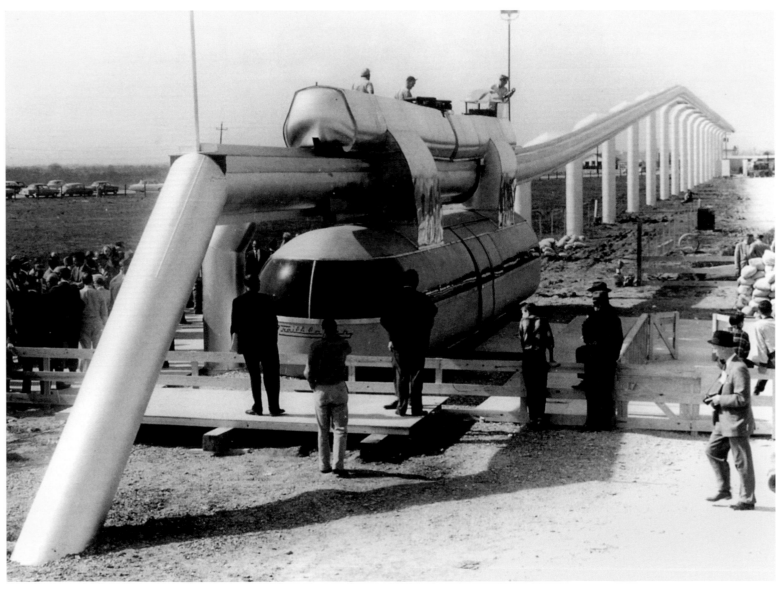

A crowd on the apron at Houston International Airport (now Hobby Airport) celebrating the inauguration of a new flight by American Airlines, January 15, 1956.

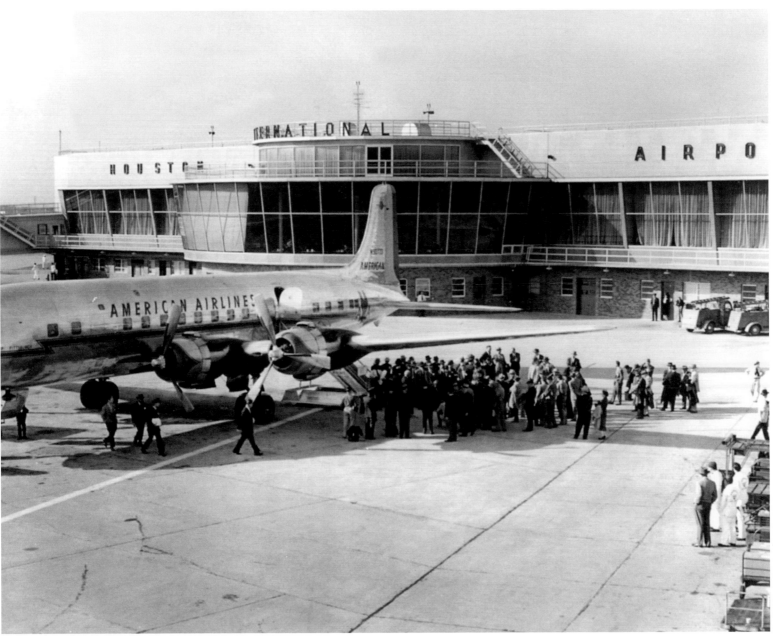

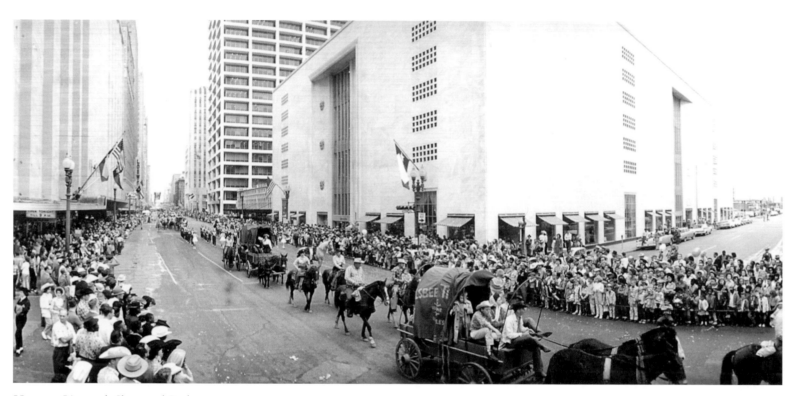

Houston Livestock Show and Rodeo
parade, February 22, 1962.

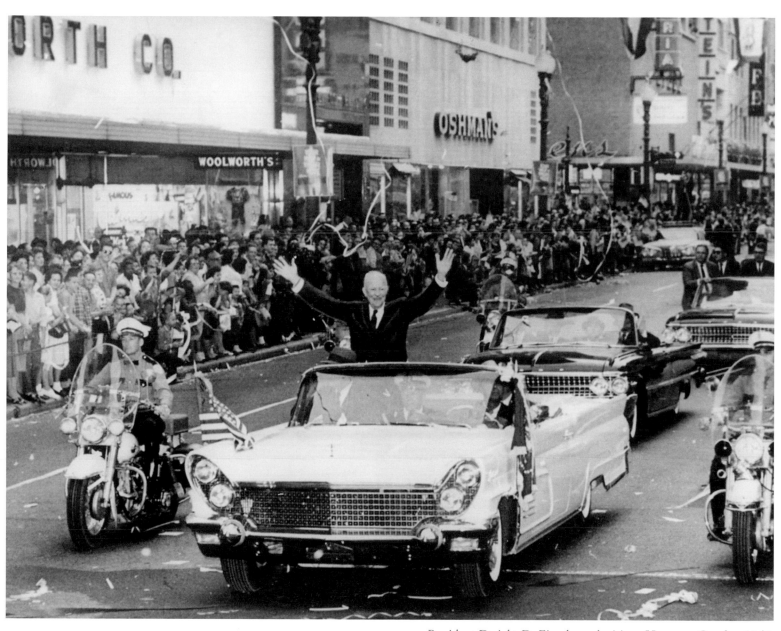

President Dwight D. Eisenhower's visit to Houston, October 1960.

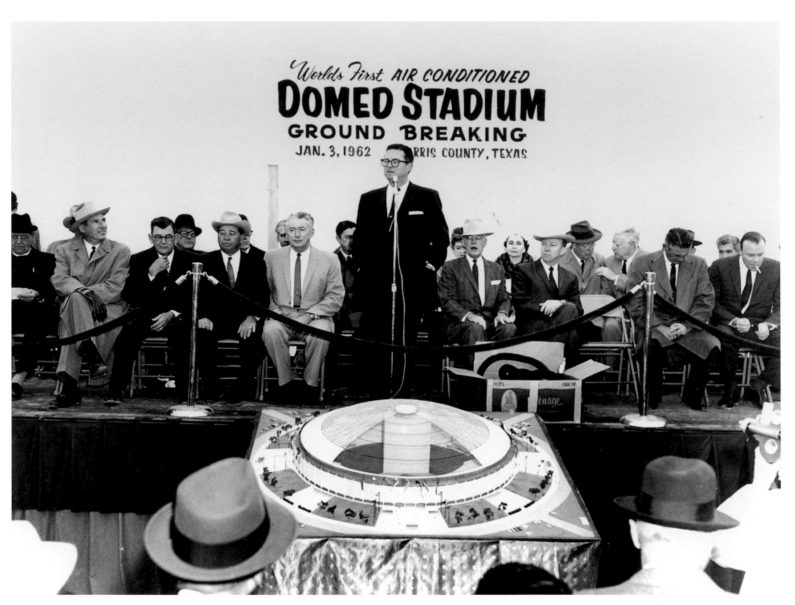

Roy Hofheinz presiding over the groundbreaking ceremony
for the Harris County Domed Sports Stadium, popularly
called the Astrodome, January 3, 1962.

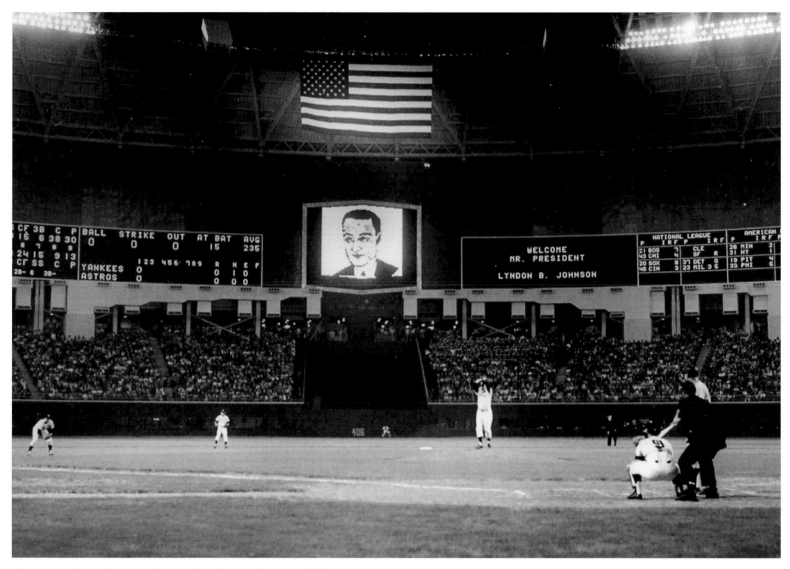

Opening night at the Astrodome when 47,900 fans watched the Astros
defeat the New York Yankees by a score of 2-1, April 9, 1965.

The Humble Oil and
Refining Co. Building (now
ExxonMobil headquarters)
on Bell Street, 1963.

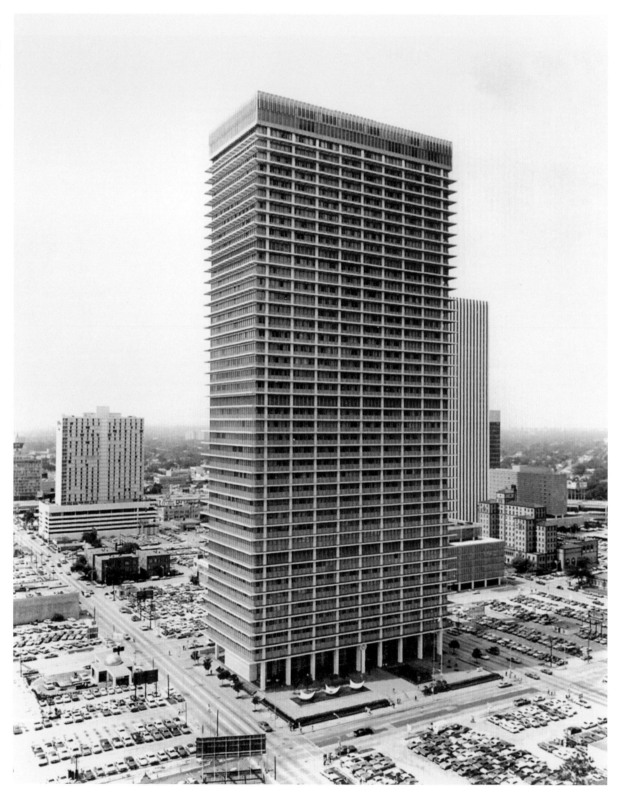

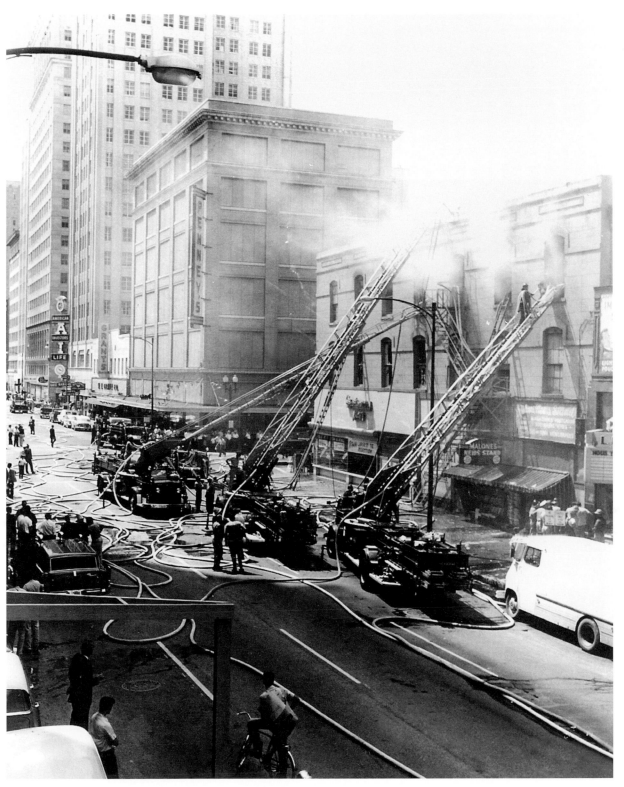

Alaskan Furs fire, June 16, 1961.

The Beatles perform at the Coliseum for frenzied
fans, August 18, 1965.

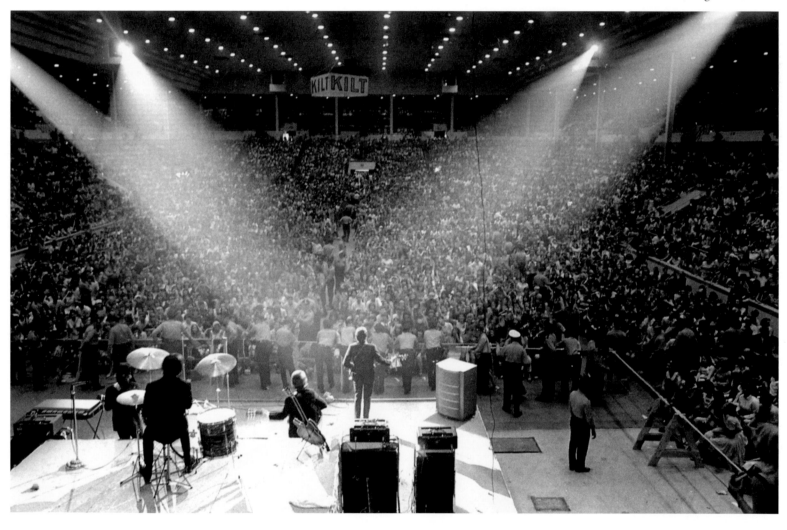

Houston at night, 1960s.

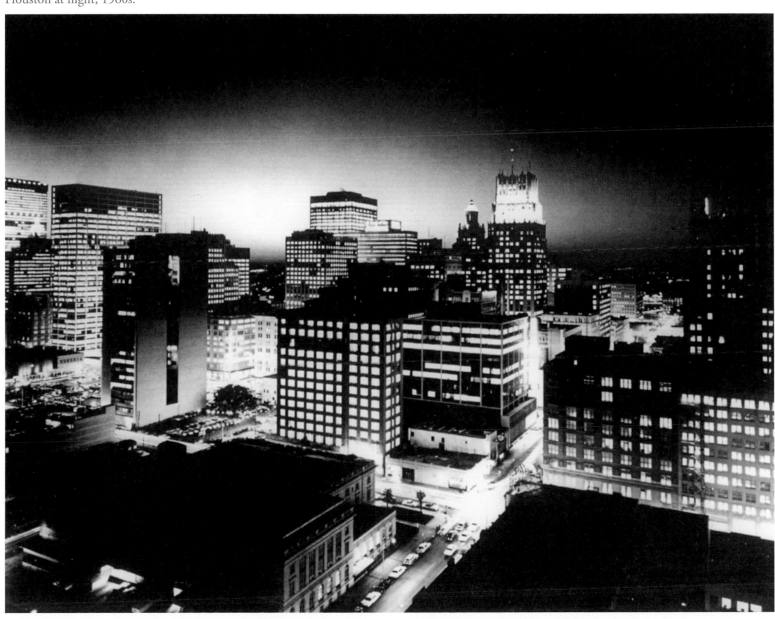

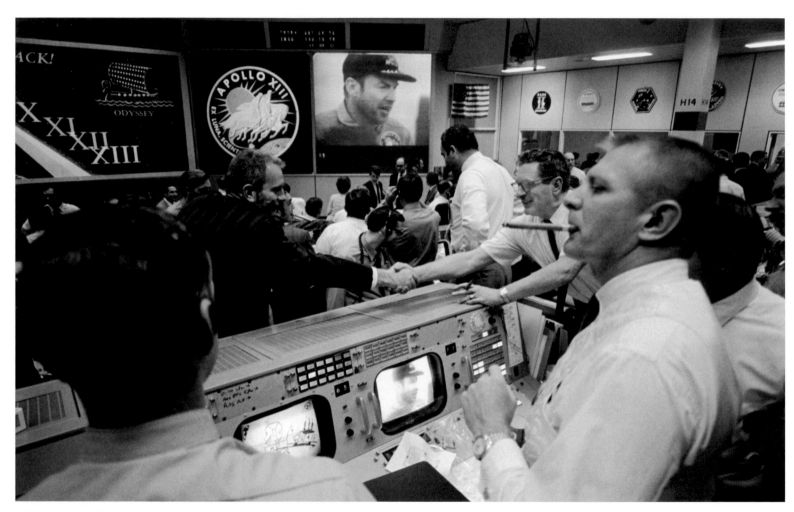

NASA personnel in Mission Control at the Johnson
Manned Spacecraft Center watch ceremonies aboard
the *Iwo Jima* following the splashdown of Apollo 13 on
April 17, 1970.

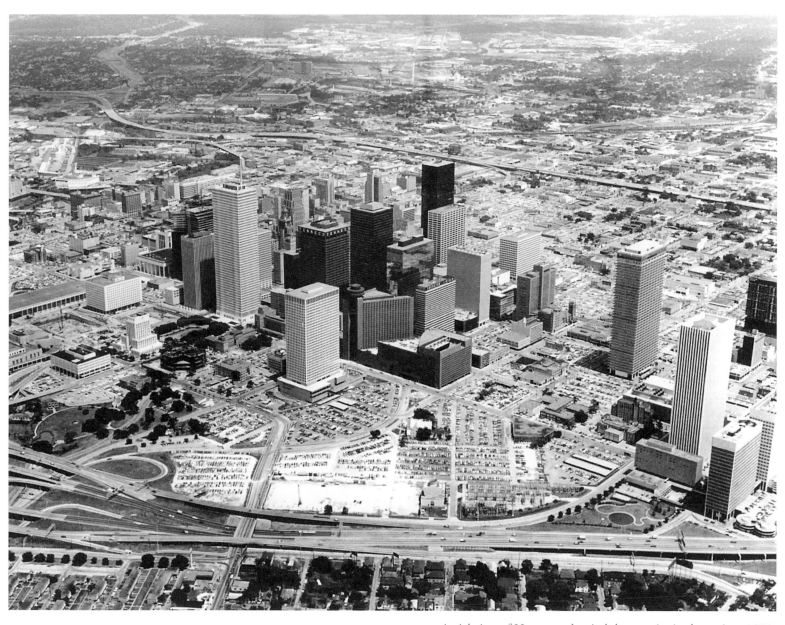

Aerial view of Houston, the sixth largest city in the nation, 1970.

NOTES ON THE PHOTOGRAPHS

These notes, listed by page number, attempt to include all aspects known of the photographs. Each of the photographs is identified by the page number, photograph's title or description, photographer and collection, archive, and call or box number when applicable. Although every attempt was made to collect all available data, in some cases complete data was unavailable due to the age and condition of some of the photographs and records. We would like to recognize Joel Draut, Archival Photographer with the Houston Metropolitan Research Center of the Houston Public Library, for his hard work reproducing all of the photographs seen in this volume in his black and white studio.